THE CONSUMERS' CHOICE

SELECTED PAPERS
ON ANCIENT ART AND ARCHITECTURE

SERIES EDITOR
MIREILLE M. LEE

Number 2
The Consumers' Choice:
Uses of Greek Figure-Decorated Pottery

THE CONSUMERS' CHOICE

Uses of Greek Figure-Decorated Pottery

edited by
Thomas H. Carpenter,
Elizabeth Langridge-Noti,
and
Mark D. Stansbury-O'Donnell

Archaeological Institute of America
Boston, MA
2016

THE CONSUMERS' CHOICE
Uses of Greek Figure-Decorated Pottery

Copyright 2016 by the Archaeological Institute of America

ISBN 978-1-931909-32-7

Library of Congress Cataloging-in-Publication Data

Names: Carpenter, Thomas H. | Langridge-Noti, Elizabeth. |
 Stansbury-O'Donnell, Mark, 1956- | Archaeological Institute of America.
Title: The consumers' choice : uses of Greek figure-decorated pottery /
 edited by Thomas H. Carpenter, Elizabeth Langridge-Noti, and Mark D.
 Stansbury-O'Donnell.
Description: Boston, MA : Archaeological Institute of America, 2016. |
 Series: Selected papers on ancient art and architecture ; number 2 |
 Includes bibliographical references.
Identifiers: LCCN 2015040331 | ISBN 9781931909327 (paper binding : alkaline
 paper)
Subjects: LCSH: Vases, Greek—Congresses. | Vases,
 Black-figured—Greece—Congresses. | Pottery,
Ancient—Greece—Congresses.
 | Painted pottery—Greece—Congresses. | Consumers'
 preferences—Greece—History—Congresses. | Pottery, Greek—Economic
 aspects—History—Congresses. | Pottery, Greek—Social
 aspects—History—Congresses. | Greece—Antiquities—Congresses. |
 Greece—Economic conditions—To 146 B.C.—Congresses. | Greece—Social
 conditions—To 146 B.C.—Congresses.
Classification: LCC NK4645 .C66 2016 | DDC 738.30938—dc23 LC record
available at http://lccn.loc.gov/2015040331

Printed in the United States on acid-free paper.

Contents

Preface

The papers in this volume are elaborations of talks presented at the 2015 Annual Meeting of the Archaeological Institute of America in New Orleans. Five were part of a colloquium, "Consumers' Choice: Uses of Greek Figure-Decorated Pottery," which was sponsored by the Pottery in Context Research Network. This group, formed in 2011–2012 and sponsored by the Institute of Classical Studies at the University of London, supports research on figure-decorated and associated pottery, with particular focus on shape, iconography, and material contexts in the Mediterranean basin of the eleventh to fourth centuries B.C.E. Two additional papers on painted pottery from other AIA sessions are included in this volume. These papers addressed similar themes to that of the colloquium and supplemented the themes of how one might consider a consumer's choice.

INTRODUCTION

As published excavated contexts become more plentiful and as older contexts are reexamined, it has become increasingly possible to discuss Greek figure-decorated pottery from the perspective of its use, and to move from there to the possible meanings images had for the individuals who obtained the objects on which they appear. Each of the papers in this volume explores the relationship between image and use in different contexts with a focus on the consumer rather than on the producer. They pose questions concerning why a consumer might choose a particular pot, why it might be part of an assemblage, or why a particular set of pots might have moved in a particular direction. By looking at pottery found in specific types of contexts, we can consider whether shape or function is more important than subject matter to a consumer, consider the appeal and meaning for unusual subject matter or compositions, and consider alternative functions for some shapes. This framing of purpose incorporates two terms that need to be explored in order to set the stage for the papers within this volume: context and consumer. Both terms can generate a number of possible understandings that lead to different types of interpretive direction.

Defining Context

Webster's defines "context" as "the setting in which something occurs." This setting, when examined with respect to figured pottery, has been defined broadly in practice to include not just the physical findspot, but also the stylistic or iconographic environment of the painter. More recently, however, scholars have recognized the need to be more precise about which types of context or contexts are under consideration. More interest has been taken in the physical aspects of context so that any given figured pot is not seen solely as a member of a disparate and disconnected assemblage of pots disassociated from the physical world. Rather, focus is now being given to the physical and social aspects of "setting" for any given pot and the nuances of interpretation that can result from this study.

Explicit in all of the papers in this volume is the physical context of production; a firm grounding for the fabric from

which the pots were made acts as a foundation for each of the papers. However, while this links pot production to a physical place, it can only serve as a starting point in a volume on consumers and consumption. Today figured pottery from careful, well-recorded excavations often has a detailed physical context and an associated assemblage that can provide evidence for the selection of objects in a setting. For older material, assemblages can sometimes be recovered, as can physical context through research into archives. The placement of a painted pot within a specific building or grave or the association with a specific space and perhaps deity within a sanctuary means that interpretations of both shape and iconography can be grounded much more closely on context than was possible in older publications. This is also true in examining assemblages in which both local and imported, plain and figured pottery are placed together. Sets of equipment can be made up of pieces from more than one origin and made out of more than one material, with each individual geographical place or find context demonstrating, perhaps, a preference for what that combination should be.

Four of the papers included here (Vlachou, Saripanidi, Peruzzi, Bundrick) consider a figured vase from a specific excavated tomb. Each contained Attic pottery that had been transported some distance before being placed in a grave in Marathon, Sindos, Rutigliano, and Spina, respectively. These papers consider the specific assemblage within the physical context of the site where they were found, which helps to provide a pattern for the use of decorated pottery and suggests whether a specific assemblage is normal or special in its selection of objects. In all four cases, pottery has been imported from Athens but is being utilized in non-Athenian or non-Greek cultures.

This same juxtaposition of Attic pottery in a non-Greek context is seen in a fifth paper (Lynch) that examines Attic pottery found in various civic contexts in a non-Greek city, Gordion in Anatolia. This introduces a diachronic element to context by noting changes in the shape and subject matter on imported Attic pottery and shifts in the specific contexts where it is found.

The relationship of workshops and markets can be glimpsed in a sixth paper (Trahey) that tracks the provenances of an ambiguous scene found on numerous black-figure pots and considers the possibility that subject matter reflects an aware-

ness of consumer interests, perhaps through the mediation of traders whose marks are found on some of the objects. At this broader level of context, one can also include religious and ritual practice as the basis for interpreting a scene, and the remaining paper (Jiang), with a focus on a Laconian cup, reminds us that not all figural pottery is Attic.

Defining the Consumer

As interpretations of the archaeological record become progressively more refined, the other term that needs definition is the consumer(s). Although related to, and perhaps strengthened by a focus on physical context, the context and consumer do not entirely overlap. What an emphasis on physical context has given scholars, however, is the opportunity to recognize more clearly the variety of possible consumers for any individual pot, and to reveal ways in which those different consumers can be teased out of the evidence that does exist. Is it the person who buys the pot in Athens, or the person who obtains it at the final destination? Is it the person who chooses the pot to be placed into a grave, sanctuary, or home where it enters the archaeological record? Or is it any one of the various individuals who view the pot somewhere along the path between its production and its placement, perhaps as a participant in a ritual? All of these are possibilities and all are addressed in the papers that follow.

In fact, the idea of a discerning consumer has been recognized in earlier scholarship. Among the most obvious examples are specific shapes such as the Tyrrhenian and Nikosthenic amphorae that have long been recognized as being directed towards or desired by Etruria. The indication that many of these imported forms have local roots, suggests that the import should perhaps be seen as an exotic alternative to a local form, but it also shows that a dialogue existed between producer and consumer for the creation of acceptable products. Recognition of a "home" Athenian market has also long existed for shapes such as the small Brauronian krateriskoi and Athenian white-ground, outline lekythoi among others, forms that can be intimately tied to specific local Athenian ritual and, thus, to a local Athenian consumer. Other figured wares, like Laconian or various southern Italian wares, show restricted movement that implies a desire for these particular wares in specific places or for particular purposes, sometimes in combination with imported wares.

The emphasis on physical context permits scholars to zoom in more closely on specific consumers when considering the life-history/biography of a particular pot. Vlachou, Saripanidi, Bundrick, and Peruzzi focus on material from single graves, permitting speculation about the individual consumer and why a particular vessel might have been deemed appropriate for a specific grave. All, however, also speculate on the possibility of other interpretations for the vases before their placement in the grave and the likelihood, in Saripanidi's and Bundrick's cases, that the scenes on the vases meant something different to the final viewers on the consumption end in Sindos and Spina, respectively, from those on the production end in Athens. This flexibility in the interpretation of the figured scenes from the perspectives of different viewers creates possibilities for a broader approach in how to read/ understand any given scene within a specific context.

The other three papers take a wider-angle view of the consumer. Both Lynch and Trahey examine consumer trends and the trade that supplied these by expanding geographically, chronologically, and methodologically our understanding of how and why figured pottery may have moved around the Mediterranean. They use the contextual data that in the first case comes from recorded excavations and in the second from reexamining both archival and trademark data. Jiang considers the broad context of Spartan ritual as the language for a Laconian cup, reminding us of the challenge of reading a specialized visual image and considering the production and consumption of non-Attic pottery, a point also addressed by Peruzzi.

Reconsidering Handlooms on Athenian Vases

Sheramy D. Bundrick

Abstract

A fifth-century Athenian hydria attributed to the Group of Polygnotos and discovered in Tomb 703 of the Valle Trebba necropolis at Spina features a characteristic scene of women in a domestic setting, but with an unusual central figure: the young woman seated on a klismos busily works on a handloom, observed by two female companions. Women with handlooms on Athenian vases have commonly been identified as prostitutes making hairnets or head coverings in their spare time, perhaps to earn extra money. The Spina hydria, whose imagery fits soundly into the repertoire of "respectable" women on other Polygnotan hydriai, calls this reading into question. Examination of contemporary vases yields a new hypothesis: the women on the Spina hydria and in other scenes seem to be making a mitra (headband) or a girdle as bridal wear at a wedding. The motif of a parthenos tying a girdle around her waist or a mitra around her head has previously and persuasively been given a nuptial interpretation. I demonstrate that the imagery of textile making would be appropriate and meaningful whether the deceased woman whose ashes were interred here was Greek or Etruscan.

During the fifth century B.C.E., the Greco-Etruscan community at Spina on the Adriatic coast received hundreds of figured Athenian vases as imports.[1] The majority of excavated vases come from two cemeteries, neither fully published: the Valle Trebba necropolis, excavated in the 1920s with ca. 1,200 tombs, and the Valle Pega necropolis, excavated in the 1950s and early 1960s with ca. 3,000.[2] This paper focuses on what seems to be a woman's cremation burial from the Valle Trebba necropolis: Tomb 703, discovered in 1927, which contained a red-figure hydria of kalpis shape used as a cinerarium (figs. 1–2) but no other objects.[3] Standing at 36.2 cm, the hydria has been reassembled from numerous fragments, nearly all pieces accounted for except most of the back vertical handle, an area below the back handle, and part

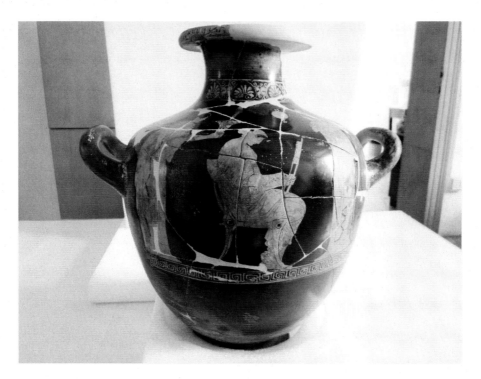

Fig. 1. Attic hydria attributed to the Group of Polygnotos, from Spina, ca. 430 B.C.E. Ferrara, Museo Archeologico Nazionale 2681/T703 (photograph by author, publication courtesy the Ministero dei Beni e delle Attività Culturali e del Turismo—Soprintendenza Archeologia dell'Emilia Romagna).

of the lip.[4] Although over 40 Attic hydriai have been found at Spina, they were relatively uncommon compared to other shapes, especially kraters. Based on the mortuary assemblages containing hydriai, the shape seems to be associated with female burials, mostly inhumation but some cremation, as here.[5] This is the only known example, however, of a hydria being used as the actual ash urn at Spina.

The Tomb 703 hydria dates from ca. 430 B.C.E. and has been attributed to the Group of Polygnotos.[6] It features a female figure seated on a *klismos* between two standing women, a favorite composition for this workshop. The central, seated woman wears a sleeved chiton and a headdress that—although the vase's surface is worn here as it is elsewhere in the scene—appears to be a *mitra*, a length of cloth wrapped around the head to form a turban-like snood.[7] More unusual is the handloom held by this figure. The Spina hydria joins only 20 others depicting handlooms, all dating from the fifth century, seven of them hydriai. Suspended above the woolworker in such a way as to frame her are a mirror and net-like object, which may be a small bag or, more likely, a *kekrypha-los*, a net-like cap that covered most and sometimes all of the

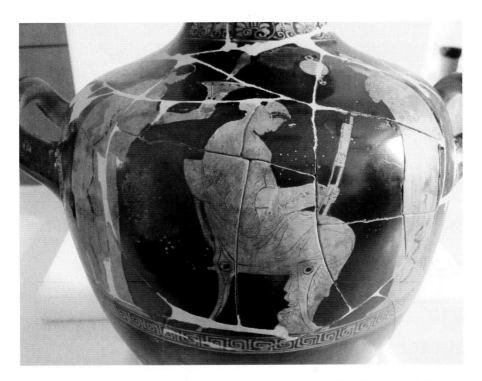

hair.[8] The bareheaded woman at left extends a wool basket (*kalathos*), while the woman at right is wrapped and veiled in her himation, a garment and pose suggesting *aidos* (modesty) and *sophrosyne* (self-control).[9] Because she is veiled where the other two figures are not, she may have just arrived at what appears to be an Athenian house.

The Spina hydria provides an opportunity to reconsider handlooms on Attic vases, which, along with textile production in general, have been the subject of some debate.[10] Its documented findspot contributes to our understanding of not only the intentions of Athenian painters in representing handlooms, but also how the consumers of vases perceived them. Unfortunately, at Spina one cannot be certain whether the deceased was Greek or Etruscan, given that it was a mixed community. This essay demonstrates that the iconography of textile making would be appropriate for a cinerarium in either case, and that for the deceased's family, the hydria's shape and image worked together to create a meaningful statement.

Among the 21 surviving vases showing handlooms, the Spina hydria becomes the fourth to show one in use, rather than being held, carried, or suspended in the background. Both this vase and a so-called kalathoid vase (figs. 3–4, ca.

Fig. 2. Detail of the hydria in figure 1 (photograph by author, publication courtesy the Ministero dei Beni e delle Attività Culturali e del Turismo— Soprintendenza Archeologia dell'Emilia Romagna).

Fig. 3. Attic kalathoid vase, from Athens, ca. 440 B.C.E. Newcastle upon Tyne, Great North Museum, Shefton Collection 853 (photo courtesy Great North Museum).

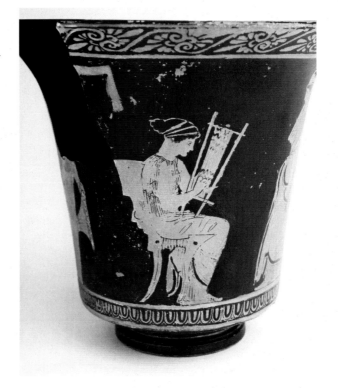

440 B.C.E.) confirm that the women are working in the sprang technique, as opposed to embroidering or working in a tapestry technique.[11] In each scene, the worker interlaces threads at the bottom of the semi-elastic fabric having completed part of the top half, a back-and-forth method typical of sprang work. On the Spina hydria, the loom is turned realistically towards the worker, whereas on the kalathoid vase, the loom faces outward. Less realistic is the fact the Spina woolworker grasps one of the loom's arms; the kalathoid vase more correctly depicts the loom clenched between the knees as the weaver twists with two hands. On the kalathoid vase and possibly the Spina hydria (the pot's surface being worn in that area), the fabric in progress has a zigzag pattern, while elsewhere the fabric on handlooms features zigzag and/or horizontal lines, or no discernible pattern. Variations in the representation of handlooms and textiles could reflect painters' lack of familiarity with these objects or a desire to privilege composition over accuracy.

In previous discussions of handlooms on Athenian vases, it has been suggested that the weavers are making *sakkoi*,

Fig. 4. Rollout drawing of the kalathoid vase in figure 3 (after Stackelberg 1837, pl. 33).

kekryphaloi, or another type of head covering.[12] Certainly the sprang technique was ideal for such work, and a netlike object that could be a *kekryphalos* appears on the Spina hydria. However, fabric produced with the sprang technique could also be used for bags and for sashes, fillets, and belts of various kinds. Belts made with the sprang technique are known from northern Europe in ancient times, while as recently as the mid-twentieth century, sprang belts known as *zonari* were worn by married women in some villages of the eastern Peloponnese. Modern Greek *zonari* were regarded as fertility aids and apotropaic devices.[13]

Related to the question of what the women are making is the question of who the women are.[14] The most pervasive theory argues that women with handlooms are prostitutes (*hetairai*), who make head coverings (*sakkoi* or otherwise) for sale or personal adornment, and pass the time between customers with this activity.[15] Cited evidence includes the over 100 loomweights found in Building Z of the Athenian Kerameikos, thought at some point to have been a brothel, and the so-called manumission inscriptions, where women named as woolworkers have been identified as liberated prostitutes.[16] The manumission inscriptions, however, date from the late fourth century and so are difficult to apply to fifth-century vases. Similarly, Building Z may not have become a brothel until the mid-fourth century (phase Z3), and may have served as a private residence in the fifth (phases Z1 and Z2). The particular task of working upon a handloom is irrelevant in any case. Building Z's loomweights come from standing, warp-weighted looms (*histoi*), while the manumission inscriptions use the generic word *talasiourgos*, "woolworker" without specifying a technique.

Iconographic evidence has also been cited to link hand-looms with prostitutes. Several scholars, including Marina Fischer in a recent article, have identified a brothel on a hydria attributed to the Leningrad Painter (fig. 5), a customer affectionately greeting a favorite girl as others watch.[17] Fischer likewise questions the scene on a now-lost hydria, claiming that the woman with *kalathos* is a *hetaira* and Eros, who holds a handloom and aulos case (*sybene*), is a "personification of the woman's profession."[18] One could, however, see a comic scene on the Leningrad Painter's hydria: an industrious, virtuous wife catching her wayward and possibly drunk husband with a servant.[19] As for the lost hydria, the depicted couple could easily be wife and husband, or bride and groom, given Eros' frequent appearance in nuptial imagery.[20] In this reading, the handloom and *kalathos* suggest the wife's contributions to the *oikos*, complemented by the husband with money pouch. Since weaving and music are often metaphorically linked in Greek texts, the resemblance between handloom and chelys lyre in the scene is significant.[21] Eros literally holds *harmonia* in his hands.

Unlisted and unconsidered in previous discussions of handlooms, the Spina hydria contributes to old questions in new ways. It features the first-known handloom scene at-

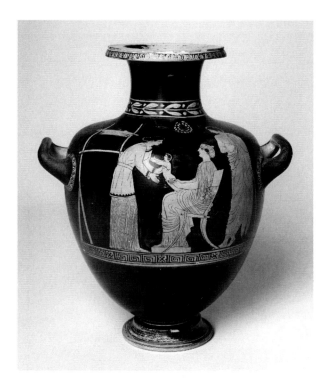

Fig. 6. Attic hydria attributed to the Group of Polygnotos, ca. 430 B.C.E. Harvard Art Museums/Arthur M. Sackler Museum, Bequest of David M. Robinson, 1960.342 (courtesy Imaging Department, © President and Fellows of Harvard College).

tributed to the Polygnotan workshop, which specialized in domestic imagery, especially for hydriai. On another hydria attributed to the Group of Polygnotos (fig. 6), a woman sitting beside a warp-weighted loom hands a male child to a servant or relative as the likely husband and father watches.[22] Whether she does the weaving herself or supervises the work of others, the *histos* emblematizes her household role. Textile production scenes appear on contemporary hydriai by other painters as well.[23] Particularly when children are included, these are clearly not scenes of prostitution; fifth-century hydriai convey genteel domesticity while promoting a feminine ideal. The Spina hydria makes it difficult to assert, as Fischer does based on other representations, that work on a handloom was "demeaning."[24]

The Spina hydria's documented context is also key, for it seems unlikely the deceased's family would choose a vase showing prostitutes. Among other vases with handlooms, only one has a secure findspot: a hydria attributed to the Hephaistos Painter, from Tomb 592 of the Contrada Pezzino necropolis of Akragas.[25] If we presume that this is a woman's grave, again, it seems unlikely a scene of prostitution would

7

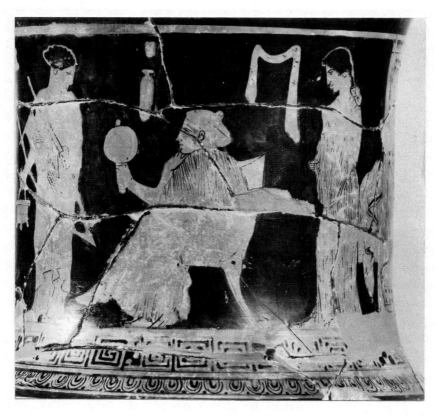

Fig. 7. Attic pyxis attributed to the Phiale Painter, ca. 430 B.C.E. Vienna, Kunsthistorisches Museum 3719 (© KHM–Museumsverband).

be selected. Men appear in this scene, including one with a money pouch, a prime example of the type of image that would otherwise be interpreted by many scholars as depicting a brothel.[26] Although the findspot of the so-called kalathoid vase (figs. 3–4) remains unknown, it too had a funerary context, said to have been discovered in a grave on the Mouseion in Athens.[27] Both the shape and iconography of this vase suggest a woman's tomb.

A specific figure on the kalathoid vase (fig. 4) can be used to resurrect the question of "what are the women weaving." Although the relevant fragments of her face are missing on the original vase, the woman marked "d" on Otto Magnus von Stackelberg's drawing should be tying her belt, likely holding the overfold of her chiton in her teeth as seen in other examples.[28] Based on iconographic and textual evidence, this motif has been interpreted as a bride preparing for her wedding.[29] Inventories from the sanctuary to Artemis at Brauron, which record dedications to the goddess, list three belts, the word

Fig. 8. Attic lebes gamikos attributed to the Washing Painter, ca. 425–420 B.C.E. Athens, National Archaeological Museum 14790 (photograph by Eva-Maria Czakó, courtesy Deutsches Archäologisches Institut, Abteilung Athen, neg. NM 4712).

used there being *zoma*.[30] Given the juxtaposition between the woman with handloom and woman tying her belt on the kalathoid vase, one can speculate whether the woolworker is making a *zoma* instead of a head covering. On a pyxis attributed to the Phiale Painter (fig. 7), a woman with handloom is similarly juxtaposed with woman tying her belt.[31] While this example is unprovenanced, red-figured pyxides tend to be associated with female graves in Attica and often have strong nuptial undertones.[32] Of the 21 scenes including handlooms, four appear on pyxides.

Even if we are to understand the handloom workers as making head coverings as has been proposed, these too could have a nuptial interpretation instead of referencing prostitution. Contemporary with the Spina hydria are images of women binding their hair (fig. 8), which, like scenes of women tying their belts, appear on wedding vases such as lebetes gamikoi.[33] The Brauron inventories reference a type of headband known as an *anadema* and further described as *poikilos* (patterned or many-colored); compare, for instance, the spotted headband being donned by a bride on a lebes gamikos from the Kerameikos cemetery and the zigzag pattern of the fabric being made on the kalathoid vase and possibly the Spina hydria.[34] The terms *tainia* and *sphendone* are also used to refer to women's hairbands in the literary sources. The Kerameikos lebes gamikos comes from an offering trench with an assemblage of vases and other objects likely dedicated to a young woman who died before marriage, an *aoros*.[35]

To an Athenian painter and Athenian viewer, the representation of handlooms might conjure a plethora of meanings. As belts and certain types of headwear are associated with weddings, they may have had nuptial associations. They may have also had funerary associations; the fillets brought by women to the cemetery on vases and used to decorate tombs could have been made with handlooms.[36] When a vase referencing any kind of textile production—whether a woman is spinning, weaving with a handloom or warp-weighted loom, or sitting with a *kalathos*—was placed into a tomb, it implied the female deceased's industry and virtue, whether she were married or a girl who died prematurely. The hydria with *histos* discussed above (fig. 6) is said to come from a grave at Vari in Attica, and one can compare slightly later Attic gravestones depicting spinning women.[37] If the deceased woman in Tomb 703 at Spina were Greek, a scene of textile production on her cinerarium would have similar associations.

The hydria shape itself had meaning for Athenian and other Greek viewers, both nuptial and funerary. Like loutrophoroi, hydriai seem to have been linked to the bridal bath; they were also associated with the purification of and offerings for the dead in Greek communities.[38] The hydria with *histos* (fig. 6) is said to have been found with another hydria on which women prepare for funerary ritual: the central figure holds a basket filled with myrtle branches, sashes, and lekythoi, a large hydria at her feet.[39] Hydriai are carried by mourners or left at graves on many white-ground lekythoi; worth mentioning is an example by the Klügmann Painter where a woman ties her *zoma*, the overfold of her chiton clenched in her teeth, before a stepped tomb on which stands a large hydria.[40]

As noted at the beginning of this essay, the deceased in Tomb 703 may have been Etruscan rather than Greek; although this grave contained no secure evidence either way, it has been suggested on epigraphic and other grounds that the majority of tombs uncovered thus far in the Spina necropoleis belonged to Etruscan residents. No handlooms have survived in Etruria to confirm their usage nor that of the sprang technique, although Etruscan art depicts headwear and other garments that could have been produced with this method. It is possible that an Etruscan viewer would interpret the activity taking place on the Spina hydria as tablet weaving rather than sprang work, given the loom is shown in profile and its structure difficult to discern. Tablet weaving was used to

make narrow fabric bands such as belts, as well as colored and patterned borders that, when sewn to the edges of garments, broadcast the wearer's social status.[41]

More important than the specific technique, perhaps, is the long history of textile-production scenes in Etruscan art, and the equally long history of textile tools being deposited in tombs and dedicated in sanctuaries.[42] Textile production had elite associations in Etruria from earliest times; one of the earliest surviving images, a late seventh-century bronze *tintinnabalum* from a woman's tomb in Bologna, shows women weaving with a warp-weighted loom on one side and spinning on the other.[43] The deposition of textile tools in graves—including spindles and distaffs in valuable materials like bronze, silver, and amber, and especially during the eighth and seventh centuries B.C.E.—signaled women's contributions to their households and larger communities.[44] Such associations likely aided the later popularity of imported Athenian vases with textile-production scenes among Etruscan consumers. One notes, for example, a black-figure, late sixth-century lebes from an unpublished tomb at Cerveteri with a gathering of woolworking women, and a black-figure amphora with similar scene from a tomb at Vulci.[45]

If the deceased woman in Tomb 703 at Spina were Etruscan, her family would have been drawn to the Polygnotan hydria because of the positive meanings for textile production. This possibility is strengthened by the discovery of bone distaffs in some Spinetic tombs, placed in or near a deceased woman's hand in inhumation burials and sometimes included in children's graves.[46] While not numerous in proportion to the quantity of burials, these date from the Late Archaic through Hellenistic periods and suggest the locally symbolic nature of textile making. Tomb 1096 of the Valle Trebba necropolis, from the first quarter of the fifth century B.C.E., included not only a distaff in the deceased adult woman's hand but also spindle whorls in ceramic and glass.[47] The remainder of the assemblage comprised local and imported vases, including Attic black-figure lekythoi and oinochoai, as well as bronze fibulae and remnants of a glass and amber necklace. In Tomb 125 from the same period, the female deceased was cremated, her remains kept in a large, black-glazed Attic amphora whose lid features black-figure vine decoration and is topped by a pomegranate-shaped knob.[48] Other grave goods included a small Attic black-figure hydria with Dio-

nysos and a satyr; two Attic black-figure oinochoai; an Attic black-figure cup, a so-called Floral Band Cup; small dishes of Athenian and local manufacture; and, importantly for the present discussion, a bone distaff.[49] This latter tomb, marked with a river pebble as a gravestone, is the only case in the Valle Trebba necropolis of a cremation burial placed in a figured vessel (even if its decoration is floral) until the last third of the fifth century, around the time of Tomb 703.[50]

Regardless of the ethnic identity of the deceased of Tomb 703, the hydria-cinerarium exemplifies the agency of the local consumer(s) in selecting this vase for deposition. The many variations in mortuary practice among Spinetic tombs reveal the multiple choices the deceased's family would have made, beginning with the decision to cremate rather than inhume the body: among 1,213 graves in the Valle Trebba necropolis, 489 were cremations.[51] Cremated remains could be contained in local (usually nonfigured) or imported (usually Athenian) ceramic vessels, a wooden box, stone chest, some combination of these, or simply wrapped in a textile and laid upon the ground, inspiring another sequence of choices. More than half of the Valle Trebba cremation burials featured some manner of assemblage—objects kept either inside or outside the cinerarium—but 211 of them, including Tomb 703, lacked any accompanying objects.[52] Particularly given the cemetery's lack of full publication, it is difficult to discern patterns among the graves and thus what governed a family's choices. Age, gender, and/or economic status do not seem to have been determining factors for any particular mode of burial, at least based on preliminary information.

As noted at the beginning of this essay, Tomb 703 is the only known instance in either the Valle Trebba or Valle Pega necropoleis where an Athenian figured hydria was employed as the ash urn.[53] Hydriai do seem to have been associated with female burials, so the selection of shape would be logical, particularly if hydriai had connections to the bridal bath at Spina or other customs beyond simply carrying water. Supporting this latter possibility is the vase itself: at 36.2 cm in height and weighing about four or five pounds when empty, it seems unlikely to have been used for everyday tasks. In her analysis of hydriai at Spina, Cecilia De Meo observed that when these vessels were accompanied by other objects, they were contemporary in date; this contrasts with other large Athenian vases like kraters, which in fifth-century Spinetic

graves were typically much older than the objects placed with them. The implication is that whereas kraters were previous possessions of the deceased or family, Athenian figured hydriai were acquired specifically for the grave.[54]

Even so, the decision to repurpose an Athenian hydria as an ash urn was not an obvious one. Not only was this rare at Spina, it was rare in Etruria, based upon documented cremation burials at such sites as Bologna, Tarquinia, and Cerveteri, where kraters and amphorae were the norm. A hydria attributed to the Niobid Painter and depicting the death of Orpheus held a fifth-century cremation burial in a tomb at the small Tuscan site of Foiano della Chiana; mention of a carnelian scarab among the ashes inside, an ornament exclusive to Etruscan men, demonstrates the deceased was male, contrary to the frequent assumption that hydriai were exclusive to female association and use.[55] The narrow neck that made hydriai ideal for transporting water presumably made them difficult to use as cineraria, so when they were used, the symbolic nature of their shape and/or imagery must have transcended any impracticality.

In the case of the Spina hydria, the vase may have been deliberately rendered nonfunctional; most of the back vertical handle was missing upon excavation, aside from part of the top attachment. One might presume this accidental (especially given that an area below the back handle is also missing), except that at least three other cinerary urns in the Valle Trebba necropolis are missing one of their handles.[56] The volute krater by the Boreas Painter used as the cinerarium in Tomb 749 lacks both its handles, despite many ancient repairs to its body showing someone's desire to otherwise preserve it.[57] Precedents for this practice can be found throughout northern and central Italy in the eighth century B.C.E., where one finds deliberately broken handles on the majority of so-called Villanovan cinerary urns.[58] Given strong Etruscan belief in the cinerarium as representative of the deceased's reconstituted body, this was at least partially intended to prevent thieves from carrying the urns away. However, examples of intentional mutiliation, perhaps even ritual killing, are found elsewhere in Etruscan material culture; for example, bronze mirrors could be forcibly folded, hammered, gouged with spikes, or written across their reflective faces with the word *suthina*, "for the tomb," rendering them unusable before deposition.[59] Although examples of ritual killing exist among

Greek objects and graves, it is possible that the Spina hydria's broken handle, if purposeful, confirms the deceased's Etruscan identity.

The family of the woman interred in Tomb 703 at Spina had many options for their loved one's burial. Given all the possibilities inherent in local mortuary practice—not to mention the large numbers of Athenian vases locally available—it seems clear that both the shape and image of the hydria they chose inspired its usage as a cinerary urn. Some scholars have presumed that shape trumped image at Spina and elsewhere in Etruria, meaning that a family might select (for example) an Athenian figured krater for a grave assemblage primarily because it was a krater, and less because of the image upon it.[60] In the case of Tomb 703, however, one can presume that shape and image were equally significant, both intended to communicate aspects of the deceased's identity that her family believed essential.

Notes

[1] Many thanks to Mark Stansbury-O'Donnell, Thomas Carpenter, and Elizabeth Langridge-Noti for the invitation to participate in the AIA colloquium and for shepherding the succeeding publication, and to the anonymous reviewers for their feedback and suggestions. Special thanks are due to Luigi Malnati of the Soprintendenza Archeologia dell'Emilia Romagna and Caterina Cornelio of the Museo Archeologico Nazionale di Ferrara for permission to study, photograph, and publish the hydria, and Mario Cesarano and Elena Bottoni for facilitating my visit to the museum. For other assistance with photographs and permissions, many thanks to Paolo Boccuccia (Soprintendenza Archeologia dell'Emilia Romagna); Isabella Donadio (Harvard University Art Museums); Joachim Heiden (DAI Athens); Florian Kugler (Kunsthistorisches Museum Wien); Jackie Maman (Art Institute of Chicago); and Andrew Parkin and Sally Waite (Great North Museum).

[2] See Aurigemma 1960 and 1965 for some Valle Trebba tombs.

[3] Ferrara, Museo Archeologico Nazionale 2681/T703, De Meo 1998–99, 49–51 and 71, fig. 1; Gilotta 2004, 148 and 151, fig. 58; not included in the Aurigemma volumes, Beazley's catalogues, or *BAPD*.

[4] De Meo 1998–99, 62 n. 11.

[5] De Meo 1998–99, especially the table at p. 73. Cf. also Berti 1994, 194–95.

[6] De Meo 1998–99, 51.

[7] For *mitrai*, Llewellyn-Jones 2003, 26–27; Cleland, Davis, and Llewellyn-Jones 2007, 127; Fischer 2013, 224; Lee 2015, 159, all with further references.

[8] Llewellyn-Jones 2003, 30–31; Cleland, Davis, and Llewellyn-Jones 2007, 103, with references to the term in literary sources; also Fischer 2013, 224.

[9] For veiling, see, e.g., Llewellyn-Jones 2003 and Lee 2015, 154–57.

[10] Bundrick 2008 for textile production on Athenian vases, with further references.

[11] Newcastle Upon Tyne, Great North Museum, Shefton Collection 853: *BAPD* 9115, Stackelberg 1837, pl. 33; Williams 1961 (with attribution to the Barclay Painter); Waite forthcoming, agreeing with me that "the presence of the sprang frame should not automatically identify a woman as a prostitute." I thank Sally Waite for sharing a copy of her article with me in advance of publication. On sprang-work identification for handloom iconography, see Six 1919; Clark 1983; Jenkins and Williams 1985; Barber 1991, 122–24, among others.

[12] E.g., in Jenkins and Williams 1985 and Fischer 2013.

[13] Welters 1999; also discussed in Fischer 2013, 255 (to different ends).

[14] For the identity of woolworkers on Athenian vases generally, see Bundrick 2008.

[15] E.g., Jenkins and Williams 1985 and Fischer 2013.

[16] Kerameikos Building Z, e.g., Knigge 2005; Wrenhaven 2009, 378; Glazebrook 2011. Manumission inscriptions, e.g., Wrenhaven 2009 and Fischer 2013, 246–48.

[17] Chicago, Art Institute 1911.456: *ARV²* 572.88; *BAPD* 206580; Bundrick 2008, 298, fig. 7. Brothel, e.g., Jenkins and Williams 1985; Glazebrook 2011, 36; Fischer 2013, 236.

[18] Fischer 2013, 235. Hydria, once Stettin (Szczecin), Vogell collection, now lost: *ARV²* 1116.47; *BAPD* 214773; Cramer 1908, 114–15, cat. 110, pl. 3.28; Bundrick 2008, 323, fig. 15.

[19] See Bundrick 2008, 298–99. His wreath implies he has come from the symposion; see Glazebrook 2011, 36 (but with a different overall reading).

[20] See Bundrick 2008, 323–24.

[21] See Bundrick 2008, 322–24.

[22] Cambridge, MA, Harvard University Art Museums 1960.342, from Vari, *BAPD* 8184; Bundrick 2008, 316–17, fig. 13.

[23] E.g., hydria akin to the Clio Painter, Munich, Antikensammlungen SL476: *ARV²* 1083.2; *BAPD* 214538; Bundrick 2008, 284, fig. 1.

[24] Fischer 2013, 232.

[25] Braccesi, Franchi, and Franchi dell'Orto 1988, 379.

[26] Bundrick 2008, 299–301 for the imagery of money pouches, with earlier references.

[27] Stackelberg 1837, 28, and see Waite, forthcoming.

[28] Williams 1961, 29, and see Waite, forthcoming, who notes that the kalathoid vase has been broken at least twice since von Stackelberg's publication. Comparanda: Athens, Agora Museum P6053,

ARV² 1149.24; *BAPD* 215235; Sabetai 1997, 322, fig. 5 (manner of the Kleophon Painter), and Paris, Petit Palais 330, *ARV²* 1068.20; *BAPD* 214392; Sabetai 1997, 322, fig. 6 (Barclay Painter).

²⁹ Sabetai 1997, 321–28; also Oakley and Sinos 1993, 14–20, and Brøns 2015, 60–61, on bridal adornment and offerings. Brøns observes that "relatively few" belts and sashes are recorded in sanctuary inventories despite their mention in the literary sources and attributes the discrepancy to "their low value" compared to other types of garments.

³⁰ Cleland 2005, 68, 129. *Zone* is used elsewhere for this garment; see Lee 2015, 135–36.

³¹ Vienna, Kunsthistorisches Museum 3719: *BAPD* 31334; Oakley 1990, 90, cat. 144 bis, pls. 118–19.

³² Cf. Schmidt 2009, further suggesting that pyxides served as wedding gifts.

³³ E.g., Oakley and Sinos 1993, 17 and Sabetai 1997, 329–30. Lebes gamikos attributed to the Washing Painter, from Attica: Athens, National Museum 14790, *ARV²* 1126.4; *BAPD* 214884; Oakley and Sinos 1993, 64, fig. 23.

³⁴ Cleland 2005, 68, 108. Lebes gamikos by the Washing Painter: Athens, Kerameikos Museum, *Paralipomena* 454; *BAPD* 276110 (with photograph of vase). It is worth noting that *kekryphaloi*, the open-work snoods or hairnets such as might hang in the background of the Spina hydria, are likewise listed in the Brauron inventory as well as that of the Heraion of Samos (Brøns 2015, 53 and 60), showing that this garment is not exclusively associated with prostitutes as implied in Fischer 2013.

³⁵ Knigge 1991, 148, fig. 143 for photograph of the assemblage.

³⁶ E.g., white-ground lekythos by the Vouni Painter, New York, Metropolitan Museum of Art 35.11.5, *ARV²* 744.1; *BAPD* 209194. For funerary textiles generally, see Closterman 2014.

³⁷ Stears 2001.

³⁸ For the various uses of hydriai, see, e.g., Diehl 1964 and Trinkl 2009; also Alexandridou 2014 for early uses of hydriai in Attic funerary cult. Given that loutrophoroi seem to have been largely associated with Athens and Attica, one may speculate whether hydriai were the primary vessels of the bridal bath elsewhere.

³⁹ Cambridge, MA, Harvard University Art Museums 60.341, *ARV²* 617.13; *BAPD* 207134. A red-figured hydria whose fragments are divided between the Benaki Museum (inv. 35414) and National Museum in Athens (inv. 17283) uniquely depicts a visit to a woman's tomb, with Viktoria Sabetai suggesting it was intended at production as a funerary offering (Sabetai 2004, 25–31, fig. 12).

⁴⁰ Munich, Antikensammlungen 7663, *ARV²* 1200.40; *BAPD* 215874.

⁴¹ Gleba 2008, 138–53.

⁴² In tombs, e.g., Gleba 2008, 171–78 and Lipkin 2013, both

with earlier references. In sanctuaries, e.g., Gleba 2008, 178–87 and Meyers 2013.

[43] Bologna, Museo Civico Archeologico 25676, Gleba 2008, 30, fig. 8. See a relief of women at their looms on the so-called Throne of Verucchio from the eighth century, Gleba 2008, 29, fig. 7.

[44] E.g., Gleba 2011, with earlier references.

[45] The unpublished lebes is displayed in the Museo Nazionale Cerite in Cerveteri. Amphora attributed to the Three-Line Group from Vulci, Paris, Musée du Louvre F224, *ABV* 320.5; *BAPD* 301676.

[46] Parrini 2009.

[47] Parrini 2009, 683–84 and Desantis 1993, 35.

[48] Amphora said to be near the Kleophrades Painter by Beazley, Ferrara, Museo Archeologico Nazionale 244/T125, *ARV*² 194; *BAPD* 201806; Aurigemma 1965, 3, and pls. 2–3; Berti and Guzzo 1993, 275, cat. 144, and for the other tomb objects, 275–76, cat. nos. 141–50.

[49] Parrini 2009 does not include Tomb 125 in the discussion of Spinetic distaffs, and in Berti and Guzzo 1993, 276, cat. 150, the object is identified only as a "cilindretto d'osso" (it is not mentioned at all in Aurigemma 1965, 3). However, in the label accompanying the display of the tomb assemblage in the Museo Archeologico Nazionale di Ferrara (current as of June 2015), it is described as a distaff.

[50] Berti, Bisi, and Camerin 1993, 32.

[51] Berti, Bisi, and Camerin 1993, 9. For cremations at Spina generally: Berti, Bisi, and Camerin 1993; for burial practices in the Valle Trebba necropolis generally, Berti 1994 (esp. 183–91 for cremations).

[52] Berti, Bisi, and Camerin 1993, 11; Berti 1994, 185.

[53] By contrast, at least a dozen Attic kraters of different shapes were used for cremations in the Valle Trebba necropolis; see the preliminary analysis in Berti 1994, 188.

[54] De Meo 1998–99, 48.

[55] Boston, Museum of Fine Arts 90.156, *ARV*² 605.62; *BAPD* 207002. Firsthand account of the tomb and its contents given in Helbig 1879; see analysis in Bundrick 2014.

[56] Berti, Bisi, and Camerin 1993, 10, noting the cineraria of Tombs 740, 920, and 940 and suggesting purposeful removal.

[57] Ferrara, Museo Archeologico Nazionale 2739/T749, *ARV*² 536.1, 1658; *BAPD* 206067; Aurigemma 1960, 74–77, pls. 76–88 for the vase and its tomb (the damage and repairs noted at p. 74).

[58] E.g., de Grummond 2009, 175–76 and Tuck 2012, 42–43, with further references.

[59] De Grummond 2009, with lists. Some Athenian vases from sites beyond Spina were inscribed with *suthina* during the fifth century B.C.E., but not in such a way as to make them unusable.

[60] E.g., Blinkenberg 1999 on the primary of shape. Nilsson 1999 is more noncommittal, observing that shapes were "of primary impor-

tance" and adding that "it is difficult to say whether [motifs on the figured pottery] were of any importance to the potential buyer" (16).

References

Alexandridou, A. 2014. "De l'eau pour les défunts. Les hydries à décor peint en contexte funéraire attique de l'âge du Fer à l'époque archaïque." *Pallas* 94:17–38.

Aurigemma, S. 1960. *La necropoli di Spina in Valle Trebba, 1.* Rome: L'Erma di Bretschneider.

———. 1965. *La necropoli di Spina in Valle Trebba, 2.* Rome: L'Erma di Bretschneider.

Barber, E.J.W. 1991. *Prehistoric Textiles: The Development of Cloth in the Neolithic and Bronze Ages with Special Reference to the Aegean.* Princeton: Princeton University Press.

Berti, F. 1994. "Spina: Analisi preliminare della necropoli di Valle Trebba." In *Nécropoles et sociétés antiques, Actes du Colloque International, Lille, 1991,* 181–202. Rome: L'Erma di Bretschneider.

Berti, F., F. Bisi, and N. Camerin. 1993. "Revisione critica della necropoli di Valle Trebba: Le cremazioni." In *Studi sulla necropoli di Spina in Valle Trebba, Convegno 15 ottobre 1992,* 8–53. Atti dell'Accademia delle Scienze di Ferrara, Supplemento 69. Ferrara: Accademia delle Scienze di Ferrara.

Berti, F., and P.G. Guzzo. 1993. *Spina: Storia di una città tra Greci ed Etruschi. Ferrara, Castello Estense, 26 settembre 1993–15 maggio 1994.* Ferrara: Comitato Ferrara Arte.

Blinkenberg, H.H. 1999. "La clientèle étrusque des vases attiques a-t-elle acheté des vases ou des images?" In *Céramique et peinture grecques: Modes d'emploi,* edited by M.-C. Villanueva-Puig, F. Lissarrague, P. Rouillard, and A. Rouweret, 439–43. Paris: Documentation française.

Braccesi, L., R. Franchi, and L. Franchi dell'Orto, eds. 1988. *Veder Greco: Le necropoli di Agrigento, Mostra internazionale, Agrigento, 2.maggio–31.luglio 1988.* Rome: L'Erma di Bretschneider.

Brøns, C. 2015. "Textiles and Temple Inventories: Detecting an Invisible Votive Tradition in Greek Sanctuaries in the Second Half of the First Millennium B.C." In *Tradition: Transmission of Culture in the Ancient World,* edited by J. Fejfer, M. Moltesen, and A. Rathje, 43–83. *Acta Hyperborea* 14. Copenhagen: Museum Tusculanum Press.

Bundrick, S.D. 2008. "The Fabric of the City: Imaging Textile Production on Athenian Vases." *Hesperia* 77:283–334.

———. 2014. "Under the Tuscan Soil: Reuniting Attic Vases with an Etruscan Tomb." In *Athenian Potters and Painters,* vol. 3, edited by J. H. Oakley, 11–21. Oxford: Oxbow Books.

Clark, L. 1983. "Notes on Small Textile Frames Pictured on Greek Vases." *AJA* 87:91–96.

Cleland, L. 2005. *The Brauron Clothing Catalogues: Text, Analysis, Glossary, and Translation*. Oxford: John and Erica Hedges.

Cleland, L., G. Davies, and L. Llewellyn-Jones. 2007. *Greek and Roman Dress from A to Z*. London: Routledge.

Closterman, W. E. 2014. "Women as Gift Givers and Gift Producers in Ancient Athenian Funerary Ritual." In *Approaching the Ancient Artifact: Representation, Narrative, and Function. A Festschrift in Honor of H. Alan Shapiro*, edited by A. Avramidou and D. Demetriou, 161–74. Berlin: de Gruyter.

Cramer, M. 1908. *Griechische Altertümer südrussischen Fundorts aus dem Besitze des Herrn. A. Vogell, Karlsruhe. Versteigerung zu Cassel in der Gewerbehalle, Friedrich-Wilhelmsplatz 6, 26–30. Mai 1908*. Kassel: Cramer.

de Grummond, N.T. 2009. "On Mutilated Mirrors." In *Votives, Places, and Rituals in Etruscan Religion: Studies in Honor of Jean MacIntosh Turfa*, edited by M. Gleba and H. Becker, 171–80. Religions in the Graeco-Roman World 166. Leiden: Brill.

De Meo, C. 1998–99. "Hydriai attiche a figure rosse dalla necropoli di Spina. Mito e mondo femminile." In *Studi archeologici su Spina*, 45–75. Atti dell'Accademia delle Scienze di Ferrara, Supplemento 76. Ferrara: Accademia delle Scienze di Ferrara.

Desantis, P. 1993. "Oggetti dal mondo muliebris nei corredi di Spina." In *Due donne dell'Italia antica: Corredi da Spina e Forentum*, edited by D. Baldoni, 33–41. Padua: Signum Arte.

Diehl, E. 1964. *Die Hydria. Formgeschichte und Verwendung im Kult des Altertums*. Mainz: von Zabern.

Fischer, M. 2013. "Ancient Greek Prostitutes and the Textile Industry in Attic Vase Painting." *CW* 106:219–59.

Gilotta, F. 2004. "Il mondo delle immagini." In *Spina tra archeologica e storia*, edited by F. Berti and M. Harari, 132–56. Storia di Ferrara 2. Ferrara: G. Corbo.

Glazebrook, A. 2011. "*Porneion*: Prostitution in Athenian Civic Space." In *Greek Prostitutes in the Ancient Mediterranean, 800 B.C.E.–200 C.E.*, edited by A. Glazebrook and M.M. Henry, 34–59. Madison: University of Wisconsin Press.

Gleba, M. 2008. *Textile Production in Pre-Roman Italy*. Ancient Textiles Series 4. Oxford: Oxbow Books.

———. 2011. "The 'Distaff Side' of Early Iron Age Aristocratic Identity in Italy." In *Communicating Identity in Italic Iron Age Communities*, edited by M. Gleba and H. W. Horsnaes, 26–32. Oxford: Oxbow Books.

Helbig, W. 1879. "Scavi e viaggi in Etruria-Fojano." *BdI*:242–49.

Jenkins, I., and D. Williams. 1985. "Sprang Hair Nets: Their Manufacture and Use in Ancient Greece." *AJA* 89:411–18.

Knigge, U. 1991. *The Athenian Kerameikos: History, Monuments, Excavations*. Trans. J. Binder. Athens: Deutsches Archäologisches Institut, Athenische Abteilung.

———. 2005. *Kerameikos, Ergebnisse der Ausgrabungen XVII: Der Bau Z*. Munich: Hirmer.

Lee, M.M. 2015. *Body, Dress, and Identity in Ancient Greece*. Cambridge: Cambridge University Press.

Lipkin, S. 2013. "Textile Making in Central Tyrrhenian Italy: Questions Related to Age, Rank, and Status." In *Making Textiles in Pre-Roman and Roman Times: People, Places, Identities*, edited by M. Gleba and J. Pásztókai-Szeőke, 19–29. Ancient Textiles Series 13. Oxford: Oxbow Books.

Llewellyn-Jones, L. 2003. *Aphrodite's Tortoise: The Veiled Women of Ancient Greece*. Swansea: The Classical Press of Wales.

Meyers, G.E. 2013. "Women and the Production of Ceremonial Textiles: A Reevaluation of Ceramic Textile Tools in Etrusco-Italic Sanctuaries." *AJA* 117:247–74.

Nilsson, A. 1999. "The Function and Reception of Attic Figured Pottery: Spina, A Case Study." *AnalRom* 26:7–23.

Oakley, J.H. 1990. *The Phiale Painter*. Mainz: von Zabern.

Oakley, J.H., and R.H. Sinos. 1993. *The Wedding in Ancient Athens*. Madison: University of Wisconsin Press.

Parrini, A. 2009. "Ω ΦΙΛΕΡΙΘ ΑΛΑΚΑΤΑ, ΔΩΡΟΝ ΑΘΑΝΑΑΣ ΓΥΝΑΙΖΙΝ... Donne filatrici a Spina." In *Etruria e Italia Preromana, Studi in onore di Giovannangelo Camporeale*, edited by S. Bruni, 2:673–86. 2 vols. Studia erudita 4. Pisa: Fabrizio Serra.

Sabetai, V. 1997. "Aspects of Nuptial and Genre Imagery in Fifth-Century Athens: Issues of Interpretation and Methodology." In *Athenian Potters and Painters: The Conference Proceedings*, edited by J.H. Oakley, W.D.E. Coulson, and O. Palagia, 319–35. Oxford: Oxbow Books.

———. 2004. "Red-Figured Vases at the Benaki Museum: Reassembling *Fragmenta Disjecta*." *Mouseio Benaki* 4:15–37.

Schmidt, S. 2009. "Between Toy Box and Wedding Gift: Functions and Images of Athenian *Pyxides*." *Mètis* 7:111–30.

Six, J. 1919. "Altgriechische 'durchbrochene Arbeit.'" *ÖJh* 19–20:162–66.

Stackelberg, O.M. von. 1837. *Die Gräber der Hellenen*. Berlin: Reimer.

Stears, K. 2001. "Spinning Women: Iconography and Status in Athenian Funerary Sculpture." In *Les pierres de l'offrande: Autour de l'oeuvre de Christoph W. Clairmont*, edited by G. Hoffmann and A. Lezzi-Hafter, 107–14. Zurich: Akanthus.

Trinkl, E. 2009. "Sacrificial and Profane Use of Greek Hydriai." In *Shapes and Uses of Greek Vases (7th–4th Centuries B.C.)*, *Proceedings of the Symposium Held at the Université Libre de Bruxelles, 27–29 April 2006*, edited by A. Tsingarida, 153–71. Brussels: CReA-Patrimoine.

Tuck, A. 2012. "The Performance of Death: Monumentality, Burial Practice, and Community Identity in Central Italy's Urban-

izing Period." In *Monumentality in Etruscan and Early Roman Architecture: Ideology and Innovation*, edited by M.L. Thomas and G.E. Meyers, 41–60. Austin: University of Texas Press.

Waite, S. Forthcoming. "An Attic Red-Figure Kalathos in the Shefton Collection." In *On the Fascination of Objects: Greek and Etruscan Art in the Shefton Collection*, edited by J. Boardman, A. Parkin, and S. White. Oxford: Oxbow Books.

Welters, L. 1999. "The Peloponnesian 'Zonari': A Twentieth-Century String Skirt." In *Folk Dress in Europe and Anatolia: Beliefs about Protection and Fertility*, edited by L. Welters, 53–70. Oxford: Berg.

Williams, R.T. 1961. "An Attic Red-Figure Kalathos." *AntK* 4:27–29.

Wrenhaven, K.L. 2009. "The Identity of the 'Wool-Workers' in the Attic Manumissions." *Hesperia* 78:367–86.

KARNEIA AND KITHAROIDOS: REREADING A LACONIAN CUP IN THE MICHAEL C. CARLOS MUSEUM

An Jiang

Abstract

In Attic vase painting, representations of cultic activities are plentiful and have long been studied, but very few such scenes have been securely identified on Laconian painted pottery. This article focuses on the iconography of one such rare example in the Michael C. Carlos Museum. The scene in the tondo of this Laconian drinking cup depicts a large standing figure holding a lyre in the center, surrounded by six smaller figures, three on each side and arranged on two levels. This unusual, if not unique, image has been formerly interpreted as a Dionysian celebration with Dionysos and komast dancers. However, it is difficult to reconcile the problematic combination of the wine god and the lyre. This paper offers a new interpretation: this image may be understood as a visual synthesis of one of the most celebrated festivals in the Archaic Laconia, namely the Karneia. This sophisticated composition may be read vertically in three parts, of which each evokes one major religious component of the festival: the footrace, the music contest, and the dance. This scene is thus an important document of the religious life of the ancient Laconians, which provides us a rare opportunity to look into how they may have visualized their own cultic experience.

IN ATTIC VASE PAINTING, REPRESENTATIONS OF CULTIC activities are plentiful and have long been studied, but very few such scenes have been securely identified on Laconian painted pottery. One rare example is a Laconian black-figure drinking cup in the Michael C. Carlos Museum (figs. 1–2), dated to ca. 570–560 B.C.E. and attributed to the Rider Painter.[1] The exterior of the cup is lavishly decorated with bands of geometric and floral motifs, which are common on Laconian painted pottery of this period.[2] The interior of the cup (fig. 1) is extraordinary, with an unusual image that has received much scholarly attention.[3] The tondo shows a large standing figure who faces to the right with a columnar

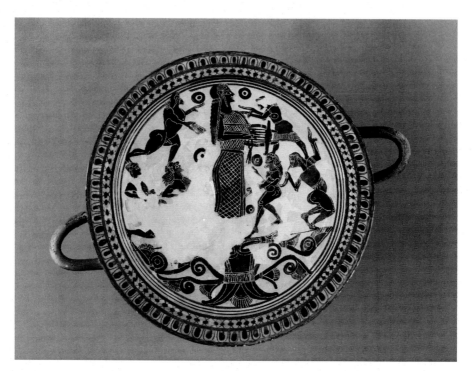

Fig. 1. Laconian cup attributed to the Rider Painter, ca. 570–560 B.C.E. Atlanta, Michael C. Carlos Museum 2003.8.19 (photograph © Michael C. Carlos Museum, Emory University. Photo by Bruce M. White, 2006).

appearance and plays a lyre in the center of the composition. He is surrounded by six smaller figures, three on each side, with one on the upper level and two on the lower. All face towards the central figure, though they are depicted in various actions. This figural scene is set upon a ground line under which an elaborate lotus-palmette composition fills the exergue.

Lyre players in Laconian painted pottery have been associated with Apollo in early scholarship.[4] However, such a straightforward connection between lyre players and the god has been challenged in more recent studies.[5] In deciphering our unusual picture on the Carlos cup, two main interpretations have been proposed.[6] Conrad Stibbe has tentatively interpreted the central figure as Dionysos.[7] He rejected the intuitive identification as Apollo with the lyre, because he believed the figure was flanked by *komast* dancers, which would be "ein krasser Widerspruch."[8] In particular, he suggested that the figure on the far right holds a drinking horn, which would indicate a Dionysian context. In explaining the unusual combination of Dionysos with a lyre, he asserted that the iconography of Dionysos in early archaic Laconian art had not yet been fully established. In Laconian vase painting in particular,

Fig. 2. Profile Drawing of figure 1 (drawing by author).

lyre players appear several times with *komast* dancers[9] (fig. 3), who are sometimes found in other Dionysian contexts. The tondo of the Carlos cup, then, as Stibbe argued, might represent a Dionysian celebration.

The identification of the four figures on the lower level as generic *komast* dancers should, however be questioned. The two figures (fig. 4) to the left of the central figure should be understood not as dancers, but as runners, as is clearly indicated by their hair and pose. The hair, which is best preserved on the second figure, is shown being blown back by the wind, indicating that the person is in a vigorous running motion. This detail in the hairstyle is different from that of *komast* dancers, whose hair naturally falls down the back in Laconian vase painting (fig. 3). The two figures are shown with their heads slightly tilted back and arms held at waist level, which is a typical pose for runners. While there is no securely identified representation of runners in Laconian vase painting known to me, this suggestion is strengthened by similar representations of runners on Panathenaic amphorai.[10] The common "bottom slapping" and other established gestures that are usually associated with Laconian *komast* dancers are not recognizable on these two figures.[11] In addition, the fact that the painter places the figures overlapping in basically identical poses may suggest that they are two runners in a foot race.

Moving to the other side of the central figure, the identification of the object held by the lower right individual (fig. 5) as a drinking horn may also be open to question. This can be illustrated by comparing this detail with the drinking horn

25

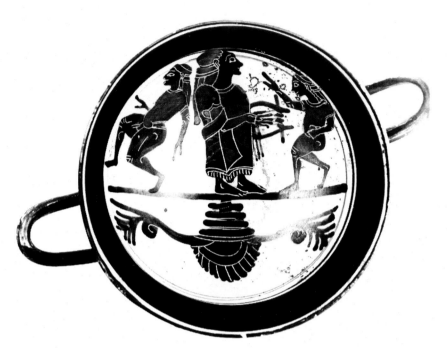

Fig. 3. Laconian cup attributed to the manner of the Hunt Painter, ca. 550–530 B.C.E. Vatican Museum, Guglielmi Collection B9 (photograph Conrad M. Stibbe Photo Archive, Michael C. Carlos Museum, Emory University).

on another Laconian cup decorated by the same painter (fig. 6).[12] Here, the pronounced widening at the top of the drinking horn is particularly emphasized by horizontal incised lines and two added red stripes. These details are all missing on the object depicted on the Carlos cup, indicating that the painter probably meant to show something different. After examining this cup under magnification in the Museum's Parsons Conservation Laboratory, I am able to make the following observations. This object is held in the right hand of the bearded figure; its lower section begins at left near the neighboring figure's back and extends upwards in a double curve. Above, it continues in a similar profile towards the face of the figure at right, and terminates, I would argue, in front of the figure's forehead, where a small triangular patch of glaze is discernable. This small area of black glaze might be explained as a result of imprecise drawing, but if it indeed belongs to the object, then it has a double curvature, which seems to suggest a bow. If this object is a bow, then the activity of the figures as *komast* dancers on our cup is minimized, as is the "stark contradiction" between Apollo and the *komast* dancers. We therefore need to seek other possible explanations for these figures and try to understand how their activities relate to the central one.

Fig. 4 (left). Two runners. Detail of figure 1.

Fig. 5 (right). Dancing figure. Detail of figure 1.

Before venturing a new interpretation, we need to examine the second theory that has been proposed by Maria Pipili. She was inclined to see the principle figure as a mortal musician. She went on to associate the entire scene with a real-life cult celebration. Since several fragmentary Laconian cups with depictions of a lyre player have been found near the Heraion on Samos, she argued that the scene probably captured a musician performing at the Heraia.[13] Unfortunately, the provenience of this cup is unknown. As all of the fine Laconian pottery found on Samos is very fragmentary, the relative completeness of the Carlos cup suggests that it comes from a grave and therefore a different type of archaeological context. As for the iconography, the scenes with a lyre player on other Laconian cups all show major differences from the Carlos cup. One cup found in Taranto (fig. 7) shows a lyre player in the middle of the upper register of the tondo, seemingly playing music to the reclining *symposiast* on the right.[14] Here the scene is likely to be a symposium or perhaps ritual dining. This different context lends very little strength to a justifiable analogy of the central figure with the Carlos cup. The identification of the lyre player in this "*sympotic*" scene is also a vexing question.[15]

Perhaps the closest comparison to the Carlos cup in terms of the composition is the fragmentary cup from Samos also attributed to the Rider Painter (fig. 8).[16] Although the lyre player is only half preserved, his central position and large scale resemble the Carlos central figure. However, several differences are also evident. The scale of this lyre player is the

Fig. 6. Laconian cup attributed to the Rider Painter, ca. 550–540 B.C.E. London, British Museum B3 (photograph © Trustees of the British Museum).

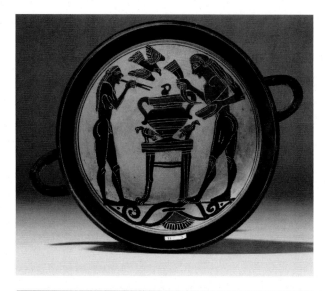

Fig. 7. Laconian cup attributed to the Rider Painter, ca. 545–535 B.C.E. Taranto, Museo Nazionale Archeologico 20909 (photograph © DeA Picture Library, licensed by Alinari).

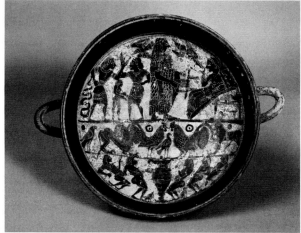

same as the outer dancer on his left, so he is not set apart in the same manner as the Carlos lyre player is in the composition. He wears a short plain dress to his knees. In sharp contrast, the long dress of the Carlos lyre player has carefully hatched decoration. There, a cock is depicted adjacent to his lyre, something absent on the Carlos cup. The surrounding dancing figures all face one direction instead of converging to the central lyre player. The entire design on the Samos cup hence appears different in spirit.

The importance of the central figure on the Carlos cup can be inferred from the way he dwarfs all the surrounding figures and receives the utmost attention from them. His sleeveless

Fig. 8. Laconian Cup Attributed to the Rider Painter, ca. 560–550 B.C.E. Samos Museum K2522 (photograph Conrad M. Stibbe Photo Archive, Michael C. Carlos Museum, Emory University).

long chiton with cross-hatched decoration further distinguishes him from the others. It seems to be a full-length chiton, though the lower section and his feet are not preserved. His upper torso is shown with a three-quarter view, whereas the lower torso is in profile view. In rendering this profile view, the painter clearly delineates three vertical pleats at the back with added red. This detail of the dress seems to be especially reserved for divine beings in archaic Laconian art. For example, similar triple profile pleats can be seen on Athena's dress on another Laconian cup in New York (fig. 9).[17] A Laconian bronze statuette with a secure identification as Artemis also shows identical back pleats on her dress.[18] Both the scale and the dress suggest, then, that the columnar central figure on the Carlos cup should be divine. Since Dionysos is not a satisfactory candidate for the lyre player, I would like to reconsider the possibility of Apollo, particularly regarding the importance of his cults in Laconia in the sixth century B.C.E. Three major festivals associated with Apollo are prominently documented in ancient literature: the Hyakinthia, the Gymnopaidiai, and the Karneia.

The Hyakinthia is the one we know best, both from ancient literary sources and the archaeological material from the Amyklaion where, according to Pausanias, the festival took place.[19] Polykrates, the historian, provides us a relatively detailed account about this festival in his *History of Sparta*,

29

Fig. 9. Laconian cup attributed to the Boreads Painter, ca. 570–560 B.C.E. New York, Metropolitan Museum of Art 50.11.7 (photograph: The Metropolitan Museum of Art, Rogers Fund, 1950; OASC public domain, image source: www.metmuseum.org).

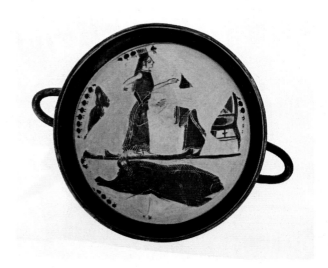

transmitted through Athenaios.[20] He states that the celebration of Hyakinthia lasted for three days, during which various rituals were performed that included mourning, singing, ritual feasting and a chariot race. There were two stages of the festival: the former was filled with mourning for Hyakinthos who had tragically died at the hands of Apollo, the latter a celebration of Apollo's epiphany. Two different kinds of sacrifice were involved: an "ἐναγισμός" offered to Hyakinthos, and a "θυσία" for Apollo.[21] These double features and the related religious activities of Hyakinthia are not recognizable in the Carlos image.

The Gymnopaidiai was deemed by Pausanias to be the festival that the Spartans took "more seriously than any other."[22] The core of the Gymnopaidiai involved choirs of boys singing paeans to Apollo, and Plato records in the *Laws* that the singing especially concerned the concepts of bravery and endurance, which was connected closely with the military culture in Sparta.[23] There was likely a *choreia* contest under the extreme summer heat when the festival annually took place.[24] There was also a dance performed by naked boys in honor of Apollo.[25] What we know about this festival cannot readily be associated with the scene on the Carlos cup either.

The festival of Apollo Karneios is no less ambiguous to us than the Gymnopaidiai regarding our knowledge from ancient authors.[26] However, its significance in Sparta was unequivocal. In several narratives of wars in the writings of

Herodotus and Thucydides, the Karneia was of such importance to the Spartans that they would rather delay their military campaigns until the celebration of the Karneia was over. The Battle of Marathon is a prime example.[27] Additionally, we know some aspects of the principle rituals, which may shed some light on the image of the Carlos cup. A curious foot race called *Staphylodromoi* (Σταφυλοδρόμοι) involved a man wrapped up in "στέμματα," who was pursued by νέοι.[28] If they caught him, this was considered to mean good fortune for the city; if not, the opposite. According to Hesychios, the *Staphylodromoi* were chosen by lot among a group of men called καρνεᾶται, who were unmarried men in the service of Apollo Karneios.[29] Inscriptions recording "Karneia runners" also confirm such an event during the festival.[30]

I suggest that this may be the foot race depicted on the left side of the central figure on the Carlos cup. The two beardless runners on the lower level can be read as the young runners in the *Staphylodromoi*. Although their torsos are only partially preserved on the cup, their bodies appear to be slender and soft, suggesting youthfulness. The nudity of the figure above the two runners may suggest that his role is also related. One possibility is that he represents another runner, who pours a libation from a ribbed *phiale* in his right hand and expresses his reverence to the god by the gesture of his left hand. If he is another runner, his activity in this image may be explained as he is pouring a libation before the race in hopes of receiving Apollo's favor. Perhaps more likely, this figure could represent the "ἀγήτης" or the leader, since the stouter body of this figure seems to distinguish him as an older male from the two running adolescents. Hesychios tells us that there was an "ἀγήτης" serving as a priest at the Karneia.[31] We do not know what specific role this "leader" played in the festival, but it is possible to think that he directed certain religious activities during the Karneia including the *Staphylodromoi*.[32] He thus may be the appropriate person to perform the ritual libation prior to the race to pray for Apollo's favor. This could be the moment captured in this picture. The left side of the tondo scene on the Carlos cup may thus be understood as a succinct rendition of the *Staphylodromoi* at the Karneia.

The three figures on the other side present a greater iconographical challenge. The two figures at the lower level seem to be in a joyful dance. The aspect of dancing at the Karneia is mentioned by Kallimachos.[33] This element in the festival

is also documented in several vase paintings associated with Apollo Karneios.[34] The most important example is the well-known Lucanian volute krater, the name piece of the Karneia Painter.[35] On its reverse, two dancers in the middle of the lower register are shown in a peculiar dance. The setting of this dance is made explicit by a pillar labeled "Karneios" standing at the far left of the scene, which confirms that dancing was an integral component of the ritual activity at the festival.[36] The pirouetting female-looking figure with the elaborate *kalathiskos* and the diaphanous dress is especially impressive.[37] I suggest that the two dancers on the right side of the central figure on the Carlos cup may represent this aspect of dancing during the Karneia. The figure on the right is shown dancing perhaps with a bow in his hand, an appropriate attribute for a festival of the god Apollo. Their dancing poses, even if generic, could evoke the particular dance that they performed in the Karneia in sixth-century Laconia.

The figure above the two dancers venerates the god by his outstretched arms. This has been identified as female, due to the skirt and the concentric circles that may indicate breasts.[38] In Laconian vase painting, female figures are often depicted in outline technique to approximate their "white" skin color, but our figure is clearly painted black like all the others, suggesting it too is male. However, a skirt reaching to knee level is an unusual costume for both male and female figures in archaic Laconian art. It is not the long female dress reaching down to the feet, yet it is clearly not the short *chitoniskos* usually worn by male hunters or warriors.[39] This unusual skirt is occasionally used in depicting female athletes, as on two small bronze female figurines; however, the gesture and the pose of our figure rule out the possibility of a female athlete.[40] It is also sometimes worn by flying demons, as on a Laconian cup in Villa Giulia showing the Boreads chasing the Harpies;[41] even closer are the small demons on the name vase of the Naukratis Painter.[42] The hems of their skirts are also decorated with vertical lines, resembling the same detail on our figure. Our figure does not have wings, so he cannot be identified as one of those mythological creatures, but the half-length skirt truly distinguishes him from the usual depictions of ordinary Spartan men and women in archaic Laconian art. One way to reconcile the discrepancy between a demon's skirt and a male worshipper's look is to read this figure as a male priest, a person who stands in the nexus between gods and mortals.

This priest should be associated closely with the two dancers underneath him, mirroring the relationship of the figure on the upper left. The priest's veneration towards Apollo may well be a ritual act at a certain stage of the dance depicted beneath him. If he represents a priest, this solution would also work very effectively in regards to the entire composition. Both leaders are placed in the upper level of the composition, which seemingly indicates their importance in the rituals and likely their higher status in the context of the Karneia.

The final question in deciphering the whole picture on the Carlos cup comes down to the representation of Apollo: namely, could this Apollo *kitharoidos* shown in the center be coherently associated with Apollo Karneios, for whom the *Staphylodromoi* and the special dance were performed? The epithet of Apollo Karneios is well known from both literary and epigraphical sources. Pausanias mentioned Apollo Karneios five times, three of which were images.[43] However, representations of Apollo Karneios have not been securely identified in Greek art. Pausanias recounted that the image of Apollo Karneios at Kardamyle was made according to a Dorian custom.[44] This brief comment has been taken by some scholars to suggest that the image of Apollo Karneios may have been a theriomorphic conception that could account for the absence of artistic renditions.[45] A potential etymological connection between Karneios and the word "κάρνος" has also been suggested. Apollo Karneios is thus sometimes interpreted by some scholars as "the ram Apollo" or "the horned Apollo."[46] Since no such example is yet known in the realm of archaic Laconian vase painting, a theriomorphic divine image is unlikely. Without a firm pictorial tradition of Apollo Karneios to serve as a comparison for the figure on the Carlos cup, one has to return to the attributes of this figure to see if they agree with what we know of the festival.

The lyre held in his left hand, the most distinguishable attribute of this figure, not only is the typical attribute for Apollo, but also embodies the musical aspect of the festival. We are told by the Laconian historian Sosibios that in the twenty-sixth Olympiad (676–672 B.C.E.) a musical contest was instituted during the Karneia in Sparta.[47] Athenaios, quoting Hellanikos's work on victors during the Karneia, reported that Terpander was the first to win a victory at the Karneia.[48] The famous seventh-century poet and *kitharoidos* Terpander was especially known for his innovation in the lyre music by

Fig. 10. Laconian cup attributed to the workshop of the Naukratis Painter, ca. 570 B.C.E. Florence, Museo Archeologico Nazionale 3882 (photograph © Firenze, Museo Archeologico Nazionale).

establishing a "*kitharoidic nomos.*"[49] The musical aspect of the Karneia is also mentioned by Euripides in his play *Alkestis.*[50] In this light, an image of Apollo *kitharoidos* seems particularly appropriate in a shorthand depiction of the festival on this Laconian cup.

One final detail is worth noting: the five decorative circles, each with a dot in the center. They seem to be symmetrically arranged surrounding Apollo: perhaps there were originally six in total, three on each side. Previous commentators see these decorative elements as space fillers; however, this quantity and arrangement on the Carlos cup stand out, particularly considering that the tondo is already a crowded composition. They function probably as a pictorial device to distinguish and evoke the sacredness of the central figure. Noticeably, a similar use of this motif also appears on another cup in Florence depicting a lyre player in the center (fig. 10).[51] This is very similar to the Carlos composition. The Florence lyre player has volutes sprouting from his head, a detail that elevates this lyre player from the mortal realm.[52] This comparison may further support the identification of the Carlos lyre player as the divine musician Apollo.

I believe therefore that we can divide the unusual image on the Carlos cup vertically and read the scene on each side of the central figure as one main religious component of the Karneia: the *Staphylodromoi* on the left and the "Karneia dance" on the right. With a careful design, the Rider Painter bridged the mortal and the divine by placing the "ἀγήτης" and the priest at the upper level and showing them performing rituals directly to Apollo who is majestically standing in the center

of the picture. Apollo is shown as Apollo *kitharoidos* in this context of the Karneia as a way to incorporate yet another aspect of the festival, the musical contest. Apollo *kitharoidos* with his symbolism of harmony further interweaves the different aspects of the Karneia into one picture of a festive celebration. This unusual image should thus be understood as a visual synthesis of one of the most celebrated festivals in archaic Laconia, that of Apollo Karneios.

Notes

[1] My first debt of thanks is to Mark Stansbury-O'Donnell, Thomas Carpenter, and Elizabeth Langridge-Noti for kindly inviting me to participate in this volume. I am very grateful to Jasper Gaunt who greatly facilitated my study of the cup in the museum and read various versions of this paper. I am also indebted to Bonna Wescoat, Jenifer Neils, Conrad Stibbe, Maria Pipili, Gerald Schaus, and Renée Stein for sharing many valuable suggestions, which have greatly improved this article. For photographs, I would like to thank Joan Mertens, Mario Iozzo, and Jasper Gaunt. Special thanks to the two anonymous reviewers and the editors who offered constructive comments and brought to my attention additional references.

I would also like to thank the Andrew W. Mellon Foundation for supporting me to work in the Conrad M. Stibbe Photo Archive, Atlanta, the Michael C. Carlos Museum 2003.8.19.

[2] For images of the exterior, see Stibbe 2004, pls. 49–50. The decorative scheme resembles some early cups by the Naukratis and Boreads Painters, see Stibbe 2004, 79 for several comparanda.

[3] For previous discussions of the image, see Stibbe 1990, 11, fig. 12; 1992, 139–45, pl. 25; Schäfer 1997, 33–34, pl. 8; Pipili 1998, 91–92, fig. 8.12; Smith 1998, 78; Förtsch 2001, 149–52, fig. 132; Stibbe 2004, 224, no. 182, pls. 49–50; Gaunt 2005, 16, fig. 8; Coudin 2009, 244–45, fig. 14; Smith 2010, 124, n. 31.

[4] For a discussion of the early studies in the iconography of lyre players in Laconian vase painting, see Pipili 1987, 51–52, nn. 505 and 506. For a cultural interpretation of music scenes in Laconian vase painting, see Powell 1998, 122–23.

[5] Pipili 1987, 50–52, followed by Smith 1998, 78; 2004, 14–15.

[6] Supra n. 3.

[7] Stibbe 1992, 139–44. For a detailed study on the iconography of Dionysos in Sparta, see Stibbe 1991, 1–44.

[8] Stibbe 1992, 141.

[9] Vatican, Guglielmi Collection B9 (Stibbe 1972, 284, no. 272, pls. 90–91; Pipili 1987, no. 205c). Twelve Laconian vases bear an image of a lyre player in various contexts: Florence 3882 (Stibbe 1972, no. 71; Pipili 1987, no. 205a); Samos K2522 (Stibbe 1972, no. 293; Pipili 1987, no. 205d); Samos K1960 (Stibbe 1972, no. 315; Pipili 1987, no. 205e); Samos K1428 (Stibbe 1972 no. 102;

Pipili 1987, no. 164); Samos fr. (Stibbe 1972 no. 247; Pipili 1987, no. 205b); Vatican, Guglielmi Collection B9 (Stibbe 1972, no. 272; Pipili 1987, no. 205c); Syracuse 9320 (Stibbe 1972, no. 238; Pipili 1987, no. 143); Taranto 20909 (Stibbe 1972, no. 312; Pipili 1987, no. 198); Taranto fr. (Stibbe 2004, no. 341); Taranto fr. (Stibbe 2004, no. 342); a cup once in the Sinopoli collection (Stibbe 2004, no. 337), and our cup.

[10] For similar running poses in Attic vase painting, see especially two Panathenaic amphorai: Norwich 26.49 by the Kleophrades Painter (*ABV* 404.16, BAPD 303057, Bentz 1998, pl. 45) and Malibu, Getty 76.AE.5 (BAPD 28845, Bentz 1998, pl. 134).

[11] For a detailed discussion of common poses and gestures of Laconian *komast* dancers, see Smith 2010, 129–33.

[12] London, BM B3 (Stibbe 1972, 286, no. 308, pl. 109; Pipili 1987, no. 206d).

[13] Pipili 1998, 91–92 and n. 11. This suggestion has been followed by Smith, see Smith 1998, 78 and 2004, 14–15. For further discussions of Laconian painted pottery found on Samos, see Stibbe 1997, 25–142; Pipili 2001, 17–102 and Pipili 2006, 75–83.

[14] Taranto, Museo Nazionale 20909, see Pelagatti 1955–56, 36–39, fig. 37; Stibbe 1972, 286, no. 312 with early references and Pipili 1987, 51, 118, no. 198.

[15] Lane identified the lyre player as Apollo (Lane 1933–34, 152–53), while Pipili took him as an ordinary lyre player (Pipili 1987, 51–52, n. 506). Richer recently interpreted the image as an evocation of the Apollo Hyakinthia (Richer 2004, 86–88).

[16] Samos K2522; Stibbe 1972, 285, no. 293, pls. 97–99; Pipili 1987, no. 205d.

[17] New York, MMA 50.11.7 (Stibbe 1972, 276, no. 140, pl. 44; Pipili 1987, no. 23, fig. 16).

[18] Boston, MFA 98.658. The statuette bears the inscription "Chimaridas [dedicated this] to [Artemis] Daidaleia." This inscription and the bow in her left hand confirm the identity of the statuette as Artemis. For discussion of this bronze, see Herfort-Koch 1986, 25, pl. 5; Kozloff and Mitten 1989, 62–65; Kaltsas 2006, 168, no. 71.

[19] Pausanias 3.19.1–5.

[20] *FGrH* 588 and Athenaios 4.139c–f.

[21] Pausanias 3.19.3. For a detailed discussion of the ancient accounts on the Hyakinthia and the various ritual activities involved in this festival, see Mellink 1943, 5–46; also see Richer 2004, 79–82.

[22] Pausanias 3.11.9.

[23] Plato *Laws* 1.633c.

[24] Pettersson 1992, 45–55.

[25] Athenaios 15.678b–c.

[26] Different theories have been proposed to explain the nature of the Karneia. Some scholars think that the festival is one of vegetation and harvest, while others see the festival as a local celebration and the Apollonian connections are only later imposed after the es-

tablishment of the Herakleid foundation at Sparta; see Bölte 1929, 141–43; Burkert 1985, 234–36; Pettersson 1992, 57–72; Malkin 1994, 149–52; Robertson 2002, 36–74; Richer 2009, 213–23; also Papadopoulos 2014, 404–12, n. 112.

[27] Because of the celebration of the Karneia, Sparta sent no force to Marathon (Herodotus 6.106.3–107.1), and sent no sufficient force to Thermopylae (Herodotus 7.206.1). For the same reason, the Spartans held back each year during the fighting in 419 and 418 B.C.E. (Thucydides 5.75.2–3).

[28] Bekker *Anecdota* I, 305 s.v. σταφυλοδρόμοι.

[29] Hesychios s.v. καρνεᾶται, σταφυλοδρόμοι.

[30] The clearest example is: "Agloteles, running the Karneia, was the first to fête the assembly, on the twentieth—the son of Enipantidas and Lacarto (*IG* 12.3 Suppl. 1324)." For discussion of the inscription, see Robertson 2002, 54, n. 140.

[31] Hesychios s.v. ἀγήτης; also see Pettersson 1992, 57.

[32] For a detailed discussion of the ἀγήτης in the Karneia, see Robertson 2002, 63–67.

[33] Kallimachos *Hymn to Apollo*, 71–87.

[34] Athens, Agora P1457; St. Petersburg, Hermitage W781; Taranto 8263; Leiden, Rijksmuseum Rsx 4 and Atlanta, Michael C. Carlos Museum 1993.1.

[35] For various interpretations and discussions of this Lucanian krater, see Arias, Hirmer, and Shefton 1962, 386–88; Trendall 1967, 55, 280; Trendall 1974, 24; Taplin 2007, 34–35; Ferrari 2008, 135–50; Hart 2010, 15–16 with a comprehensive bibliography.

[36] According to Trendall, this scene on the Karneia Painter's name vase is likely modeled on a late fifth-century Attic vase painting that would have shown an Athenian version of the celebration of the Apollo Karneios. For the relationship between the images on early Lucanian vases and the Athenian models, see Trendall 1974, 1–13 and Trendall 1989, 18–23.

[37] The figure has been variously interpreted as either a female dancer or a male dancer dressed in female clothes. The gender ambiguity is not apparent on this Lucanian krater, but seems to be puzzling in the other depiction on the Lucanian bell krater in Leiden (Leiden, Rijksmuseum Rsx 4). For recent discussions of the so-called *kalathiskos* dance, see Ferrari 2008, 135–50 and Papadopoulos 2014, 404–9.

[38] Stibbe 1992, 139; Stibbe 2004, 79, n. 312.

[39] For the dress of Spartan women, see Pomeroy 2002, 134–35. For a good representation of the *chitoniskos* in Laconian vase painting, see Louvre E670 (Stibbe 1972, no. 220, pl. 78; Pipili 1987, no. 69, fig. 33).

[40] London, BM 208 and Sparta, Arch. Mus. 3305, see Herfort-Koch 1986, 27–29, pl. 6.2 and pl. 6.4.

[41] Stibbe 1972, no. 122, pl. 41; Pipili 1987, 20–21, no. 65, fig. 31.

[42] London, BM B4; Lane 1933–34, 139, no. 1; Shefton 1954,

303, no. 3; Stibbe 1972, 211, no. 23, pl. 12; Pipili 1987, 40–42, no. 101, fig. 54.

[43] One "*agalma*" of Apollo Karneios was at Gythion (3.21.8); two "*xoana*" were respectively at Oitylos (3.25.10) and Leuktra (3.26.5); a sanctuary (ἱερόν) of Apollo Karneios was at Kardamyle (3.26.7) and a temple (ναός) of Apollo Karneios was located near Las, on the mountain Knakadion (3.24.8).

[44] "καθὰ Δωριεῦσιν ἐπιχώριον" (Pausanias 3.26.7).

[45] See Pettersson 1992, 61–62.

[46] For a detailed discussion see Pettersson 1992, 59–61, and also see Hesychios s.v. κάρνος.

[47] Athenaios 14.635e–f.

[48] Athenaios 14.635e–f.

[49] Suda T345 and *Marm. Par.* Ep. 34.

[50] Euripides, *Alkestis* 445–51.

[51] Florence 3882 (Stibbe 1972, no. 71; Pipili 1987, no. 205a).

[52] Because of the sprouting volutes, the lyre player on the Florence cup has been generally accepted as Apollo. For a discussion and a comprehensive bibliography about this cup, see Pipili 1987, 51, n. 505, no. 205a.

References

Arias, P.E., and M. Hirmer. 1962. *A History of Greek Vase Painting.* Translated and Revised by B.B. Shefton. London: Thames & Hudson.

Bentz, M. 1998. *Panathenäische Preisamphoren: Eine athenische Vasengattung und ihre Funktion vom 6.–4. Jahrhundert v. Chr.* Basel: Vereinigung der Freunde Antiker Kunst.

Bölte, F. 1929. "Zu lakonischen Festen." *RhM* 78:124–43.

Burkert, W. 1985. *Greek Religion.* Cambridge: Harvard University Press.

Coudin, F. 2009. "Les vases laconiens entre orient et occident au VIᵉ siècle av. J.-C.: Formes et iconographie." *RA*:227–63.

Ferrari, G. 2008. *Alcman and the Cosmos of Sparta.* Chicago: The University of Chicago Press.

Förtsch, R. 2001. *Kunstverwendung und Kunstlegitimation im archaischen und frühklassischen Sparta.* Mainz: von Zabern.

Gaunt, J. 2005. "New Galleries of Greek and Roman Art at Emory University: The Michael C. Carlos Museum." *Minerva* 16.1:13–17.

Hart, M. 2010. *The Art of Ancient Greek Theater.* Los Angeles: J. Paul Getty Museum.

Herfort-Koch, M. 1986. *Archaische Bronzeplastik Lakoniens.* Münster: Archäologisches Seminar der Universität.

Kaltsas, N.E., ed. 2006. *Athens-Sparta.* New York: Alexander S. Onassis Public Benefit Foundation.

Kozloff, A., and D.G. Mitten, ed. 1989. *The Gods Delight: The Hu-*

man Figure in Classical Bronze. Cleveland: The Cleveland Museum of Art.

Lane, E.A. 1933–34. "Lakonian Vase-Painting." *BSA* 34:99–189.

Malkin, I. 1994. *Myth and Territory in the Spartan Mediterranean.* Cambridge: Cambridge University Press.

Mellink, M.J. 1943. *Hyakinthos.* Utrecht: Kemink.

Papadopoulos, J.K. 2014. "The Motya Youth: Apollo Karneios, Art and Tyranny in the Greek West." *The Art Bulletin* 96: 395–423.

Pelagatti, P. 1955–56. "La ceramica laconica del Museo di Taranto." *ASAtene* 33/34:7–44.

Pettersson, M. 1992. *Cults of Apollo at Sparta: The Hyakinthia, the Gymnopaidiai and the Karneia.* Stockholm: Åströms.

Pipili, M. 1987. *Laconian Iconography of the Sixth Century B.C.* Oxford: Oxford University Committee for Archaeology.

———. 1998. "Archaic Laconian Vase-Painting: Some Iconographic Considerations." In *Sparta in Laconia: Proceedings of the 19th British Museum Classical Colloquium Held with the British School at Athens and King's and University Colleges, London, 6–8 December 1995*, edited by W.G. Cavanagh and S.E.C. Walker, 82–96. London: British School of Athens.

———. 2001. "Samos, the Artemis Sanctuary: The Laconian Pottery." *JdI* 116:17–102.

———. 2006. "The Clients of Laconian Black-Figure Vases." In *Les clients de la céramique grecque: Actes du colloque de l'Académie des Inscriptions et Belles-Lettres, Paris, 30–31 janvier 2004*, edited by J. de La Genière, 75–83. Cahiers du CVA 1. Paris: Académie des Inscriptions et Belles-Lettres.

Pomeroy, S. 2002. *Spartan Women.* Oxford: Oxford University Press.

Powell, A. 1998. "Sixth-Century Lakonian Vase-Painting: Continuities and Discontinuities with the 'Lykourgan' Ethos." In *Archaic Greece: New Approaches and New Evidence*, edited by N. Fisher, H. van Wees, and D. Boedeker, 119–46. London: Duckworth.

Richer, N. 2004. "The Hyakinthia of Sparta." In *Spartan Society*, edited by T. Figueira, 77–102. Swansea: The Classical Press of Wales.

———. 2009. "Les Karneia de Sparte (et la date de la bataille de Salamine)." In *Sparta and Laconia: From Prehistory to Premodern*, edited by W.G. Cavanagh, C. Gallou and M. Georgiadis, 213–23. London: British School at Athens.

Robertson, N. 2002. "The Religious Criterion in Greek Ethnicity: The Dorians and the Festival Carneia." *AJAH* 1:5–74.

Schäfer, A. 1997. *Unterhaltung beim griechischen Symposion: Darbietungen, Spiele und Wettkämpfe von homerischer bis in spätklassische Zeit.* Mainz: von Zabern.

Shefton, B.B. 1954. "Three Laconian Vase-Painters." *BSA* 49:299–

310.

Smith, T.J. 1998. "Dances, Drinks and Dedications: The Archaic Komos in Laconia." In *Sparta in Laconia: Proceedings of the 19th British Museum Classical Colloquium Held with the British School at Athens and King's and University Colleges, London, 6–8 December 1995*, edited by W.G. Cavanagh and S.E.C. Walker, 75–81. London: British School of Athens.

—————. 2004. "Festival? What Festival? Reading Dance Imagery as Evidence." In *Games and Festivals in Classical Antiquity: Proceedings of the Conference Held in Edinburgh 10–12 July 2000*, edited by S. Bell and G. Davies, 9–23. Oxford: Archaeopress.

—————. 2010. *Komast Dancers in Archaic Greek Art*. Oxford: Oxford University Press.

Stibbe, C.M. 1972. *Lakonische Vasenmaler des sechsten Jahrhunderts v. Chr.* Amsterdam: North-Holland.

—————. 1990. "A Laconian Volute Krater from Sicily." *Xenia* 19:5–18.

—————. 1991. "Dionysos in Sparta." *BABesch* 66:1–44.

—————. 1992. "Dionysos mit einer Kithara?" In *Kotinos: Festschrift für Erika Simon*, edited by H. Froning, T. Hölscher and H. Mielsch, 139–45. Mainz: von Zabern.

—————. 1997. "Lakonische Keramik aus dem Heraion von Samos." *AM* 112:25–142.

—————. 2004. *Lakonische Vasenmaler des sechsten Jahrhunderts v. Chr.: Supplement*. Mainz: von Zabern.

Taplin, O. 2007. *Pots and Plays: Interactions between Tragedy and Greek Vase-Painting of the Fourth Century B.C.* Los Angeles: J. Paul Getty Museum.

Trendall, A. 1967. *The Red-Figured Vases of Lucania, Campania and Sicily*. Oxford: Clarendon.

—————. 1974. *Early South Italian Vase-Painting*. Rev. ed. Mainz: von Zabern.

—————. 1989. *Red Figure Vases of South Italy and Sicily: A Handbook*. London: Thames & Hudson.

Gordion Cups and Other Attic Black-Figure Cups at Gordion in Phrygia

Kathleen M. Lynch

Abstract

Excavators at Gordion have recovered fragments of a minimum of 20 mid-sixth-century B.C.E. Attic black-figure cups, many from the fortified barracks used by the Lydians to defend the city against the Persians. Vases attributable to Lydos, Kleitias and Ergotimos, and Sondros indicate that quality pottery workshops served the Gordion market. Since no black-figure cups are found farther inland in Turkey, Gordion must have been the destination for the trade. The predecessor to the Persian Royal Road, which started at Sardis and ran through Gordion, was the main trade route in the sixth century B.C.E. Excavations at Sardis, the Lydian capital, found a similar number of Attic cups. It seems plausible that the users of the mid-sixth-century black-figure cups at Gordion were Lydian, not Phrygian, and wished to distinguish themselves from native Phrygians through use of imported Greek objects in Lydian drinking or dining activities. The kylix shape may have appealed to Lydians because of their own tradition of stemmed dishes. The rarity of imported or local kraters and oinochoai from the assemblage, however, indicates that the Lydians were not holding Greek-style symposia.

In 1900, two German archaeologists and brothers, Gustav and Alfred Körte, explored the site of Gordion, excavating several tumuli and on the citadel. In an unlooted tumulus (Tumulus K-V, for Körte, tumulus number five)[1] they discovered two Attic black-figure cups that subsequently became the eponymous exemplars for the "Gordion Cup" type.[2] These well-preserved examples are two of about 50 fragments of Athenian black-figure cups of the mid-sixth century B.C.E. found at the site of Gordion, the capital of the Phrygian culture in central Anatolia. Included in this number is one other well-preserved Gordion cup signed by Sondros as potter found in the settlement area.[3] This essay will consider what the archaeological contexts for Archaic Athenian pottery at

Gordion can tell us about the earliest trade in Attic pottery and the consumers of that pottery.[4]

Historical Context and History of Excavations

The site of Gordion lies about 100 km southwest of modern Ankara in central Anatolia. Gordion reached its height as the capital or cultural center of the Phrygians, an Iron Age civilization over which a King Midas ruled (fig. 1).[5] The Phrygians were a Near Eastern culture that looked both eastward and westward. While aspects of their culture and religion drew from Hittite and Assyrian traditions, the historical King Midas, who reigned in the late eighth century B.C.E., married a Greek princess from the Ionian city of Kyme, and was the first foreign king to make a dedication at Delphi.[6] Midas entered Greek mythology as the tempter of Silenos and a man of proverbial wealth.[7] The peak of Phrygian culture and dominance in central Anatolia spanned from the ninth to late seventh centuries B.C.E. During this period the Phrygians built—then rebuilt after a devastating fire—a walled citadel with a lower city, itself encircled by a 14 m-high wall punctuated with forts.[8] The countryside around the site bristles with over 100 burial tumuli, almost all of which date to the period of Phrygian dominance.[9]

The Phrygians ruled until sometime early in the sixth century, probably until ca. 580 B.C.E., when the site of Gordion came under Lydian control as King Alyattes II expanded his empire.[10] The Lydian phase of occupation was brief: in 546 B.C.E. the Lydian capital Sardis was taken by Persian King Cyrus II, and as Cyrus' forces consolidated his control over the former Lydian territory, a battle and siege followed at Gordion.[11] The Persians controlled Gordion from around 540 until 333 B.C.E. when Alexander the Great arrived to cut the Gordian knot.[12] During this period of Persian political control, the character of the main excavation area, the former Phrygian power center of the citadel, underwent transformation.[13] Phrygian megara were modified for domestic and industrial purposes, and new architectural structures were appended to them. It is during the periods of Lydian and Persian control that trade in Attic pottery occurred.[14] My hypothesis is that interest in Attic pottery began with the presence of the Lydians at the site; they had used Attic pottery already at Sardis, but it is not clear whether the first Attic cups arrived at Gordion through actual trade with Athens or because the Lydians had brought them. The taste for

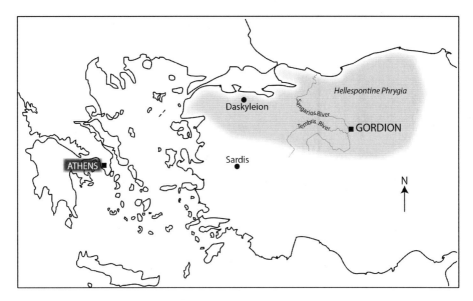

Athenian pottery continued under the Persians, when we can certainly speak of full-fledged trade.

Three subsequent campaigns of excavations followed those of the Körte brothers.[15] Nevertheless, only about one-third of the citadel area of the site has been excavated, and much from the first two campaigns remains unpublished.[16] Several other impediments affect any discussion of archaeological context: Rodney Young's excavations occurred when artifact context recording was not rigorous; Young's curation policies usually resulted in the discard of nondiagnostic fragments; Voigt used an entirely different recording system; there is no unified trench plan, and no unified site plan existed until recently;[17] and lastly the site experienced much deconstruction and rebuilding during the sixth to fourth centuries B.C.E. Collectively, these factors make it difficult to identify primary contexts and nearly impossible to reconstruct the original artifact assemblage. Nevertheless, even though the imported pottery is usually highly fragmentary and is found in secondary or even tertiary contexts, it is inherently datable; thus, the imported pottery allows us to map the ebb and flow of trade. Young and many of his excavators had worked at the excavations of the Athenian Agora and at Corinth, so their appreciation for Attic pottery gives us confidence that they saved figured fragments, no matter how small. Finally, a few relatively solid find contexts provide valuable insight into the users of the pottery and their preferences.

Fig. 1. Map of the eastern Mediterranean showing sites mentioned in this essay. Gray indicates the general area of the Persian satrapy of Hellespontine Phrygia (author).

43

The Pottery and Its Find Contexts

The earliest imported Greek pottery at Gordion dates to the eighth century B.C.E. including a Euboean or imitation Euboean pendant semicircle skyphos (YH 42423) and a few Corinthian kotylai.[18] These few eighth-century pieces may have been personal objects or gifts, but a larger number of imported vessels in the seventh century, especially from "East Greece," Corinth, and Lakonia, indicates a pattern of organized trade from Greek production sites.

The earliest Athenian imports arrive in the second quarter of the sixth century B.C.E. The most spectacular is a hydria (originally described as an amphora, P 2074), but fragments of komast cups also appear (P 2418).[19] Again, the quantities are small, but the hydria, dated about 575 B.C.E., is extraordinary for several reasons (fig. 2). First, the predominant sixth-century Attic import is the cup. Large, closed Athenian vessels never found a market at Gordion, although lekythoi did. Second, the hydria's shape has no precise parallels but borrows features from other contemporary hydriai and amphorai. It appears that the rim and neck had broken, and the neck was roughly smoothed just above a raised ring marking the junction of neck and shoulder. Finally, the hydria has a secure find context. Excavators found its fragments on the clay floor of Building M—a megaron built towards the end of the period of Phrygian power. The vessel was crushed as the roof of the building collapsed in a fire. No other Greek pottery accompanied it, but dug into the same floor were four deep pits, in turn filled with over 50 complete local storage jars. One of the local jars bore a graffito of a Phrygian name.[20] The function of the Attic hydria remains unclear, but its modification means it probably had a long life, and its association with the jar with the Phrygian name in a building form associated with Phrygian power makes it possible that it was originally used by a Phrygian.

With the exception of the Attic hydria, the other Attic pottery from Gordion dating to the middle of the sixth century B.C.E. consists of kylikes, including eponymous Gordion cups. Despite the disturbed contexts, fragments of cups are not distributed evenly throughout the excavated area. Instead, they concentrate in several areas of the site, and a closer look at these contexts may inform the question of use and possibly may help identify their users.

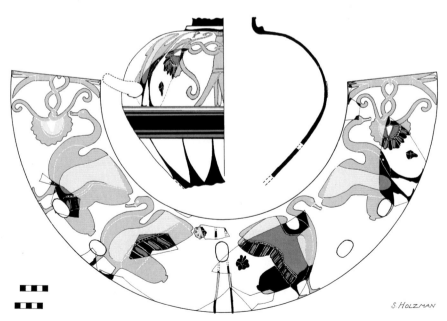

S.HOLZMAN

Fig. 3. Gordion cup from tumulus K-V, signed by Ergotimos as potter and Kleitias as painter, ca. 560–540 B.C.E. Berlin, Antikensammlung 4604. A) profile, side B with signature of Kleitias. B) tondo with dolphins and fish (photos: bpk, Berlin/ Antikensammlung, Staatliche Museen/Art Resource, NY).

Tumuli

Of the dozens of tumuli with preserved grave goods at Gordion, only Tumulus K-V contained Attic pottery, the two eponymous Gordion cups. About five tumuli of the late seventh and sixth centuries have Greek pottery, including Ionian bird bowls (H), Corinthian aryballoi (F and K-I), and East Greek pottery (A, J, K-II), but imports are far out numbered in the burial assemblages by local pottery, metal, and wooden artifacts. Tumulus K-V with the Gordion cups is a cremation in a pit, so the grave goods, including the Gordion cups are fragmentary, burnt, and dispersed.[21] The cup with three dolphins and a fish in the tondo (Berlin 4604) is signed by Kleitias as painter and Ergotimos as potter—as on the François Vase (fig. 3).[22] The other with a youth on horseback coursing a hare (Berlin 4605) is unsigned, but H.A.G. Brijder propos-

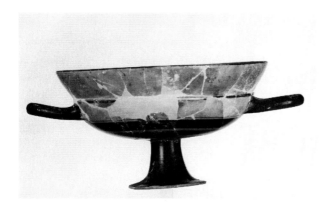

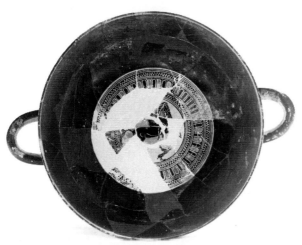

Fig. 4. Gordion cup from tumulus K-V, unsigned, ca. 560–540 B.C.E. A) profile. B) tondo with youth on horseback. Berlin, Antikensammlung 4605 (photos: bpk, Berlin/Antikensammlung, Staatliche Museen/Art Resource, NY).

es Ergotimos as potter and places it in the Kleitias-Ergotimos workshop (fig. 4).[23] Beazley called its "shape and patternwork connected with Berlin 4604." Thus we should consider the two Gordion cups in tumulus K-V a pair that arrived to the site at the same time.

Gordion cups have been found in both the eastern and western Mediterranean, and Gordion is their farthest, eastern findspot.[24] Several have been found in Etruria or are said to have come from Etruria, including the sanctuary at Gravisca. The farthest western find spot is Huelva in Spain (Brijder no. G9). In the east, the only site to exceed Gordion in the number of Gordion cups or fragments is Naukratis in Egypt, where the Gordion cups were also dedicated in a sanctuary. Altogether there are about 60 known Gordion cups, and their production was short, from about 560–540 B.C.E. The mid-sixth century was a period of ferment and experi-

47

mentation in the Athenian Kerameikos with a great variety of cup forms being produced simultaneously or for a short duration, so the lifespan and distribution of the Gordion cup may have more to tell us about the pottery business in Athens than consumer taste in the east.[25]

The other objects associated with the cremation in Tumulus K-V reported by the Körte brothers were fragments of one or two Lydian lekythoi, a Phrygian black-polished fineware vessel, a wooden cosmetics container, and two pieces of bone inlay.[26] They report fragments of bronze and animal bones around the pit, over which the mantle of the tumulus was piled.

The K-V assemblage stands out from the other unlooted sixth-century B.C.E. tumuli by its sparseness. Another cremation burial (Tumulus F) dating about 60 years earlier included a feasting set of bronze for cooking and dining, along with 16 ring handles for the bier, an ivory box, gold jewelry and appliques, and various pottery including two Corinthian aryballoi of the last decades of the seventh century B.C.E. This earlier assemblage followed Phrygian burial practice, visible in both inhumation and cremation tumuli graves.[27] In contrast Tumulus K-V stands out for the matched set of Athenian Gordion cups and its modest goods. Perhaps its occupant was not Phrygian. Whereas Lydian lekythoi alone cannot be used to ascribe ethnicity, if vase scholars with a specialty in cups are correct, then the date of the Gordion cups in K-V, late in the 560s or 560 B.C.E., would place this tumulus to a period when the Lydian overlords at Gordion would have been at their height. A tumulus sends a clear message of everlasting power, which burial rituals, including grave goods, must have emphasized, even though the form on the landscape mimics that of Phrygian tumuli. If Lydian, the funeral that resulted in Tumulus K-V would have sent messages of domination but also of differentiation through rites and grave offerings. Although not a large tumulus itself, it is located on the northeast ridge among the largest of the Phrygian tumuli, including Tumulus MM.

Tumulus A, built slightly later than Tumulus K-V in about 540–530 B.C.E. (on the basis of East Greek and Corinthian imports), provides more insight into the social and political role of tumuli. The grave goods in Tumulus A were fantastically elaborate with gold, silver, and ivory objects and the entire funerary cart thrown onto the cremation—including

sacrificed horses.[28] The funeral must have been a spectacle. While there are some similarities with Phrygian burial practice, such as the cart and bier, numerous lydions (perfume jars) also point to Lydian influence. Perhaps Tumulus A was a last, futile expression of Lydian identity in the face of growing Persian dominance, and thus puts Tumulus K-V's confidence and modesty in context.

The Küçük Höyük Fort

The clearest context for the Attic cups is a fort destroyed by the Persians during their siege of the citadel in ca. 540 B.C.E. The fort located closest to the citadel is now called Küçük Höyük, "small hill" in Turkish, and excavations in the 1950s revealed a burnt four-story mud-brick structure built up against the interior of the fortification wall (see fig. 5).[29] Machteld Mellink supervised rigorous excavations of the Küçük Höyük, which means we have atypically thorough records for this area and its fiery destruction despite the fact that it remains unpublished. Mellink proposed that a Lydian garrison manned the fort because she found numerous Lydian-style pots including Lydian lekythoi and lydions.[30] However, the fort also preserved several Attic black-figure Little Master cups and undecorated Ionian cups of similar shape, which dated the destruction to the third quarter of the sixth century B.C.E.[31] If we follow Mellink, the occupants of the fort, the Lydians, were the ones using these cups.

Fragments of two Attic cups illustrate the finds. A lip cup fragment with a siren, P 2339,[32] may be dated to the third quarter of the sixth century on the basis of its hasty execution, although sirens were popular for much of the production period (fig. 6). Joining and nonjoining fragments (P 2304 a, b)[33] of another lip cup preserve two of four handle palmettes and part of nonsense inscriptions that once framed a figure on the lip:].ΠΟΙΛΧΣ angled downward to the left and]ΧΣΛ also angled downward and to the left (fig. 7). Inscriptions around the lip figure are not common on lip cups, and the few that do have them are not attributed.[34] The palmette suggests a date in the third quarter of the sixth century B.C.E.[35] A cup of Little Master lip shape, but in a non-Attic fabric (P 2271), is one of several of the same date.[36]

Fig. 5. Plan of Gordion citadel and Küçük Höyük fort with known general findspots of sixth century B.C.E. Attic cup fragments. Citadel area shows most excavated areas and a plan of Middle Phrygian buildings. The line of megara divide into a palatial sector on the east, and a production sector under control of the palace to the west. After plans, by permission of the Gordion Excavations, University of Pennsylvania.

A Persian Destruction Deposit

Another closed, but more ambiguous context probably documents clean-up of domestic and industrial structures also damaged during the sack by the Persians. In an area of the citadel about 200 m from the palatial buildings, excavators found a 5 x 5 m square pit filled with debris they associate with the Persian sack.[37] The pit contains large, complete, local coarseware storage pots along with luxury goods, including gold filament and fine horse trappings. Preliminary study of the local burnished black pottery also indicates an impressive array of the finest of local fine ware—a class as yet unstudied. The date of the deposit is given by a few pieces of Greek pottery. The debris contained fragments of a krater attributed to near Lydos; interestingly one fragment of this

Fig. 6. Fragment of an Attic Little Master lip cup with siren from Küçük Höyük destruction, P 2339, third quarter of sixth century B.C.E. (photo by permission of the Gordion Excavations, University of Pennsylvania).

krater was found over 200 m away.[38] The pit contained another Gordion cup, this one signed by Sondros as potter, the most complete cup by the potter known at this time (fig. 8).[39] H.A.G. Brijder dates the Sondros Group of Gordion cups slightly later ("belong to the decade 560/50 BC") than the two from Tumulus K-V associated with Kleitias and Ergotimos ("560s or c. 560"),[40] and Pieter Heesen agrees, but allows the Sondros potter's cups to span 560–540 B.C.E.[41] Sondros was also influenced by the Kleitias/Ergotimos workshop if not a member himself.[42] Thus, it is possible that all three cups arrived at Gordion at the same time, either through trade with Athens or with the arrival of the Lydians.[43] Other Attic fragments from this deposit are black-gloss.

Study of the Persian destruction deposit is underway, and my comments here are preliminary. The deposit does contain some Lydian pottery, but the proportion of Lydian and Attic appears to be lower than at the Küçük Höyük fort. In contrast, the amount of local fine ware is much higher, whereas there was little at all in the Küçük Höyük destruction. The pit is so large that it was probably the repository for debris from a number of use contexts including several houses perhaps occupied by both Phrygians and Lydians. It would be nice to be able to make a connection between an Athenian krater by "Lydos" and the Lydians, and there is an amphora fragment from Sardis that Nancy Ramage has attributed to Lydos,[44] but this may be asking too much of the evidence.

Fig. 7. Fragments of an Attic Little Master lip cup from Küçük Höyük destruction, P 2304 a,b, third quarter of sixth century B.C.E. (photo by permission of the Gordion Excavations, University of Pennsylvania).

The Citadel

The distribution map of Attic cups at the site of Gordion shows that they have been found infrequently in the old Phrygian palatial and production zone on the citadel, despite the thorough excavation of this area (see fig. 5). Three cup fragments, however, were found outside the citadel wall, which is also the context of the stray Lydos krater fragment (fig. 9).[45] These fragments may have been redeposited as trash over the wall. Even with later construction disruptions to the main citadel area, we would expect more residual fragments found in higher strata, especially if the Lydians used Attic cups while occupying the megara. It is not clear how to interpret this evidence, but the context outside the wall seems to have been created in the early fifth century. The Persians may have discarded "trash" left over from the period of Lydian control as they, the Persians, remodeled and repurposed the old Phrygian megara.

Similarly, another concentration of mid-sixth century Athenian cups occurs in the Northwest Quadrant, excavated by Mary Voigt. At least three fragments of Siana or Little Master cups survive along with east Greek Ionian cups,[46]

Fig. 8. Gordion cup signed by Sondros as potter found in a Persian destruction dump in the southwest area of the citadel, SF 96-269, ca. 560–540 B.C.E. A) profile. B) tondo with sphinx (photos by permission of the Gordion Excavations, University of Pennsylvania).

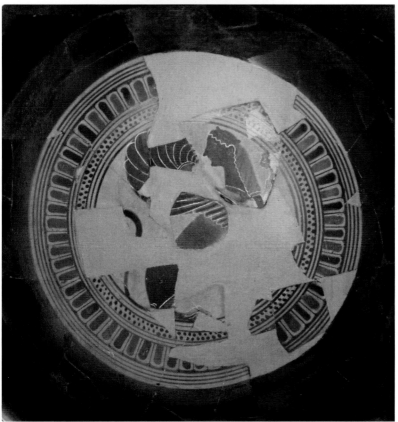

and other fine pottery finds suggests that the sixth-century B.C.E. occupants of this area used imported fineware regularly. There was less rebuilding and modification of this area of the citadel, so it is possible that sixth-century residents of the former palace and production area, which did see extensive later remodeling, may have also once favored imports.

53

Fig. 9. Fragments of lip cups found outside the northern citadel wall (see fig. 5), top: P 4975, P 4701; bottom: P 3944, mid-sixth century B.C.E. (photos by permission of the Gordion Excavations, University of Pennsylvania).

One final residual find that does come from the former Phrygian production area of the citadel provides a glimpse of what we may be missing.[47] The fragments in figure 10 are from a merrythought cup. The bowl of the cup is a continuous curve to a plain rim, and the interior features a series of added red lines overtop the black-gloss surface.[48] The imagery is narrative, but the scene and meaning of the inscriptions are not clear. It is possible that we have fragments from both sides. At the top right of figure 10 is Hermes and a bull's tail and back edge of its testicles. Hermes wears a petasos, and the edge of the top of his kerykeion is visible at the top break, although he is uncharacteristically beardless. The fragment at bottom left is Herakles wearing a lion-skin. The rim fragment in the upper left has an inscription, HEPA] ΚΛΕΣ, that identifies him, so these two pieces probably belong to the same side.[49] The female figure is probably a goddess. The partial vertical inscription to the right of her head is tempting for AΦ[POΔITE, but the hairstyle controverts this assumption. The ponytail or plait bound up in a sack at its end is a style reserved for parthenoi and youths. As Sian Lewis clearly states, "Deities like Hera and Aphrodite

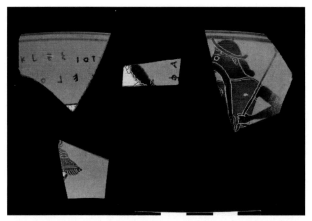

Fig. 10. Fragments of a merrythought cup from the citadel area (see fig. 1), P 3252 + P 2440 + P4210 + P 3633, mid-sixth century B.C.E. (photo by permission of the Gordion Excavations, University of Pennsylvania).

never wear it."[50] The vertical orientation of the inscription may also be a painter signature, ΕΓΡ]ΑΦ[ΣΕΝ although the painter name would have been on another line since the sherd comes from below the rim, which would not allow room for a name on the same vertical line.

The fragment at the top left also preserves the back of a white animal with its fur picked out with short black-glazed lines. In addition to the inscription identifying Herakles, two other fragmentary inscriptions appear above the animal's back, but are not clear. Immediately above the animal is a retrograde inscription,]ΕΛΟ[with a trace of a letter before the epsilon. A third inscription reads in smaller letters,]ΤΟΙ, with a trace of a letter before the tau. The meaning of these two inscriptions is uncertain.

Concluding Thoughts

The remaining Attic and Ionian cup fragments from poor contexts are comparable to the examples detailed here, and the overall consumption pattern of Attic cups permits some reflection. The residents of Gordion increased their use of Attic pottery during the second quarter of the sixth century B.C.E., which corresponded to the period of Lydian control of the site. Elsewhere I have discussed the trade routes for Attic pottery to Gordion, and I noted that in the sixth century B.C.E., the shapes, painters, and iconography that reached Gordion matched well the pattern of published pottery at Sardis.[51] As noted above, the only other merrythought cup in Anatolia comes from Sardis. The trade route used in the sixth century probably connected Gordion to Sardis using the pre-existing road that would become the Persian Royal Road (it existed

since Hittite times). In contrast, in the fifth century B.C.E. there is a considerable difference in pottery between the two sites, but a greater similarity in the character of Attic red-figure pottery found in Gordion and the Persian satrapal capital of Daskyleion. By the turn of the fifth century, trade may have switched to an overland route entering at Kyzikos, through Daskyleion, to Gordion via a river valley. Regardless of the specific trade route, the effort required to move delicate Athenian pottery to Gordion was extraordinary, and it gives us a reason to ask what was so special about Gordion and what motivated its residents' consumption of imported Attic pottery.[52]

At Gordion, the Lydians took over the waning but illustrious Phrygian Empire. The Lydians were wine drinkers, more so than the Phrygians, who preferred beer or a groggy mixture of beer, wine, and honey.[53] The Greek kylix did not serve Phrygian cultural needs, especially because the Phrygian beverage needed either a strainer or a straw to drink.[54] The Lydians, on the other hand, were known for their wine. Lydian regional pottery production favored the skyphos,[55] but evidence from the Persian destruction at Sardis confirms that Attic and Ionian kylikes were used in domestic areas of the Lydian capital, and cups are the dominant imported shape in the years before the Persian attack.[56]

The use of material culture, in this case access to imported pottery that supported a non-Phrygian dining style, may have helped the Lydians to establish their identity against the background of centuries of Phrygian power. The sudden appearance of Attic cups and the concentration of Attic cups in the Küçük Höyük fort strongly associate the use of cups with Lydians. As for the tumulus with Gordion cups, it is possible the deceased was, in fact, a Lydian; contemporary tombs in the region of Sardis occasionally contained Ionian, Attic, or Lakonian cups.[57] Additional study of the tumuli at Gordion may reveal further Lydian connections, especially in the magnificent grave goods of Tumulus A. The Attic cup shapes and images at Gordion have parallels throughout the Mediterranean, so targeted marketing seems unlikely in the mid-sixth century B.C.E. Even the dolphins and fish on the interior of the Kleitias and Ergotimos Gordion cup may seem out of place, but Livy (38.18) says that the Sangarios River, which flows by the site of Gordion, was not "remarkable so much for its size but because it furnishes the inhabitants with vast quantities of fish."

In sum, it may have been the Lydians who introduced the residents of Gordion to Athenian pottery. Whether the Lydians brought it with them from Sardis and the Lydian homeland or whether their presence at Gordion encouraged traders with Athenian pottery to make the journey farther east, is not certain. The overall small quantity of Athenian pottery during the Lydian period may argue for the former, but it is entirely possible that suppliers added some Attic pottery to provisions being sent overland to Gordion from Lydia. In the subsequent period of Persian control the quantity of Attic pottery at Gordion increased further. There is clearer evidence for true trade, and there is also good evidence of direct marketing of shapes and iconography.[58] Despite the meager number of primary archaeological find contexts at Gordion, the study of imported pottery from Gordion is satisfying because we know that it arrived there, and that alone is enough to allow us to ask some very interesting questions.

Notes

[1] Körte and Körte 1904, 139–45.

[2] Körte and Körte 1904, 140–43, nos. 1 (Berlin 4604), 2 (Berlin 4605), pl. 7–8. Beazley (1932) 185 defines the type and names it "Gordion Cup" on the basis of those found by the Körtes. The shape features a high, strongly offset rim with a straight or slightly convex lip. The body is shallow and thin walled and more rounded than broad. The foot is a tall, trumpet-shaped with a wide resting surface as in lip cups. The decoration can take two schemes, A and B, resembling lip cups and band cups respectively. Robertson 1951 divides the cups into three further groups, 143–49.

[3] SF 96-269, signed by Sondros as potter; DeVries 2005, 46–47, fig. 4.10, 11; Sams and Voigt 1998, 686, fig. 8; Brijder 2000, 556–57; Heesen 2011, no. 27, 32–35, pl. 9c.

[4] I am grateful to G. Kenneth Sams, Mary Voigt, and C. Brian Rose for permission to study the imported pottery at Gordion. Keith DeVries began this project before he passed away, but asked me to finish his work. A full discussion of all cup fragments, the majority of which do not have a secure findspot, will appear in a study of imported pottery in the Gordion final publications series.

[5] For recent research on the Phrygians at Gordion, see Rose 2012a.

[6] DeVries and Rose 2012. For Greek influence on the material culture of Gordion, see Mellink 1991, 650.

[7] It is interesting that a merrythought cup from the sanctuary of Aphaia on Aegina signed by Ergotimos as the potter (Berlin, Antikensammlung 3151; *ABV* 79; *Para* 30; Miller 1988, pl. 18.3, side A),

is one of the earliest depictions of Midas and Silenos in Attic pottery (Miller 1988, 80). Is it possible that the potter (and his painter collaborator) were inspired by the idea that some of their pots were destined for Gordion?

[8] Rose 2012b, 9–12, fig. 1.8.

[9] See Kohler 1980, 1995; Young 1981; and more recently on Tumulus MM, Liebhart 2012. Tumulus burials end in the sixth century B.C.E. and do not resume until the Hellenistic period.

[10] The exact date of Lydian takeover is not certain, and there is no archaeological evidence for a battle in the early sixth century B.C.E., but Lydian influence in the material culture of Gordion reflects a cultural relationship if not a political one, Rose 2012b, 16 with references.

[11] Rose 2012b, 16; Young 1958, 141; with a siege ramp: Mellink 1988, 288.

[12] Arrian, *Anabasis* 2.3.1

[13] Rose 2012b, 16.

[14] Lynch and Matter 2014.

[15] Under Rodney Young (1950–1973), Mary Voigt (1988–2002), and Brian Rose, (2013–) with continuous study seasons between campaigns.

[16] For the history of excavations, see Sams 2005.

[17] Pizzorno and Darbyshire 2012.

[18] See DeVries 2005, 37–40, fig. 4–3; Sams 1979, 47; mentioned: Voigt and DeVries 2011, 26–27.

[19] Hydria: Edwards 1959, 265, pl. 65, fig. 4 where it is described as an amphora with winged creatures. Mentioned: DeVries 1988, 51 n. 7; DeVries 2005, 47. Komast cup: unpublished.

[20] Edwards 1959, 265–66, pl. 65, fig. 10. The local wares are not datable, so the date of the destruction is given by the hydria, thus is a *terminus post quem*. The condition of the hydria indicates that it had been in use for some time, and it is likely that the destruction occurred sometime in the middle of the sixth century or later.

[21] Körte and Körte 1904, 139–40.

[22] *ABV* 78.13, *Add²* 22.

[23] *ABV* 79.1, *Add²* 22. Brijder 2000, 553.

[24] Heesen 2011, 34; Brijder 2000, 555–57.

[25] Lynch 2014.

[26] Körte and Körte 1904, 140–45.

[27] The Tumulus F assemblage is a small scale parallel to that in Tumulus MM, the largest of the tumuli and probably the resting place of Gordias, Midas's father; Young 1981, 79–190.

[28] DeVries 2005, 53.

[29] Rose 2012b, 16; DeVries 2011, 17–18; Mellink 1991, 653; 1959, 104; Young 1957, 324.

[30] Young 1958, 141.

[31] DeVries 2011, 18, n. 1.17 on the role of these fragments in the reevaluation of the Iron Age chronology at Gordion; DeVries

2005, 51 for similarity to the finds from the destruction of Sardis by the Persians.

[32] Mentioned: DeVries 2011, 18, n. 1.17

[33] DeVries 2005, 51, fig. 4–14; mentioned: DeVries 2011, 18, n. 1.17. Inscription not mentioned in either publication.

[34] New York, Metropolitan Museum 03.24.31, with sphinxes, *CVA* Metropolitan Museum 2, no. 16a, b, pl. 12, from Monteleone, found in the same tomb as the Etruscan chariot. London, British Museum B405, with panthers, *CVA* London, British Museum 2, pl. 14.1. The palmette on the London cup is similar to that on P 2304.

[35] See Heesen 2011, 246–48, fig. 127.

[36] Cf. Villard and Vallet 1955, type B3.

[37] DeVries 2005, 47–50; Sams and Voigt 1998, 684–87; Voigt et al. 1997, 20–21.

[38] Fragment YH 51501 from Operation 17, which is from the same krater as: P 4563a, b, P 5415. DeVries 2005, 47–48, fig. 4.12; DeVries 1997, 247, fig. 1; Sams 1979, 8, fig. 3; Voigt et al. 1997, 20, fig. 28. Mentioned: Sams and Voigt 1998, 687; Tiverios 1976, 85.

[39] SF 96–269, Sams and Voigt 1998, 686–87; Brijder 2000, no. G17, 556–57, fig. 114, where he dates it to ca. 560–550 B.C.E.

[40] Brijder 2000, 554–55.

[41] Heesen 2011, 11 n. 80, "565/60 BC: Berlin 4605…," 31, "Sondros, Sondros Painter, 560/540 BC." There is some debate about the chronology of Gordion Cups, Heesen 2011, 34–35.

[42] Heesen 2011, 31.

[43] There are at least three other fragments that preserve the tondo border with the sequence of: three lines, dot-band, three lines, alternating tongues, three lines, dot-band, and three lines.

[44] Ramage 1997, no. Att 3, 74, pl. 24, "Close to Lydos (?)."

[45] P 4701, fragment of the tondo of a Siana or Gordion cup with traces of an inscription, which is not common; P 3944, fragment with back of a rooster from a band cup; P 4975, fragment of tondo border of Siana or Gordion cup. All ca. 550 B.C.E., but by a decade either side.

[46] YH 60145, Siana cup; YH 56596, Siana cup foot; YH 24748.01, fragment of tondo border of Siana or Gordion cup. All ca. 550 B.C.E., but by a decade either side.

[47] Nonjoining fragments: P 3252, P 2440, P 4210, P 3633. All fragments found in the main excavation area of the citadel, in the vicinity of the Phrygian terrace buildings. P 2440 was found with P 2439, a rim fragment from an Ionian cup. All contexts are fills from classical or Hellenistic period construction. I thank Pieter Heesen for discussing this cup with me.

[48] Cf. Ramage 1983, a merrythought cup from Sardis, but by a different painter. The red bands are visible in figure 8. The handles to the Gordion cup have not been recognized among the excavated pottery, probably because their knobbed form is similar to Phrygian vessel features. This similarity may account for the attraction of the merrythought cup shape.

49 The four-bar sigma of the Herakles inscription is notable as the letter is relatively rare in vase-painting inscriptions at this date. A contemporary hand who uses it inconsistently is Sondros or his painter, who signs with a four-barred sigma on the Gordion cup discussed below (fig. 8) among others, Heesen 2011, 34. The ears of Hermes and especially the female figure are very similar to the ear of the sphinx in the Gordion Sondros cup (fig. 8). However, we know little about Sondros' figural style since most of his known fragments are signatures.

50 Lewis 2002, 28; discussion of the hairstyle, 27–28. The hairstyle is described as a classical innovation by Byvanck-Quarles van Ufford 1986 since it has a floruit in early classical red-figure; however, it also appears on the outlined female heads on Little Master cups (ca. 550–540 B.C.E.); e.g., by Sakonides, Heesen 2011, no. 177, pl. 52, among others illustrated there. A black-figure plaque from the Acropolis, ca. 560 B.C.E., depicts Aphrodite with her children Himeros and Eros—both boys—and both wear the same hairstyle; Graef and Langlotz 1909–25, no. 1.2526, pl. 104. Some of both the female and male Athenian youth in the geranos scene from the François Vase wear the same hairstyle, Shapiro, Iozzo, and Lezzi-Hafter 2013, pl. 10–12, 14–15; but so does Achilles in the scene with the funeral games of Patroklos, Shapiro, Iozzo, and Lezzi-Hafter 2013, pl. 21. The meaning of the hairstyle may not be strict.

51 Lynch and Matter 2014, 109.

52 It is true that Athenian pottery can be found throughout the eastern Mediterranean and at sites around the Black Sea; however, to find Athenian pottery so far inland is highly unusual.

53 McGovern 2000.

54 Figures on the frescoed walls of the "Painted House," which dates to the Persian period, show that something other than wine continued to be consumed at Gordion; Rose 2012b, 16, fig. 1.10; Mellink 1980. Phrygian ceramic tradition included a side-spouted, sieve mug to strain out the dregs, see Sams 1977.

55 Dusinberre 1999.

56 Ramage 1986, 1997, 70–71.

57 Ramage 1997, 121–27; Greenewalt 1997, 140. Most of the tumuli at Sardis had been looted before excavation.

58 Lynch and Matter 2014.

References

Beazley, J.D. 1932. "Little-Master Cups." *JHS* 52:167–204.

Byvanck-Quarles van Ufford, L. 1986. "Le coiffure des jeunes dames d'Athènes au second quart du 5ème siècle av. J.C." In *Enthousiasmos: Essays on Greek and Related Pottery Presented to J. M. Hemelrijk*, edited by H.A.G. Brijder, A.A. Drukker, C.W. Neeft, 135–40. Allard Pierson Series 6. Amsterdam: Allard Pierson Museum.

Brijder, H.A.G. 2000. *Siana Cups III: The Red-Black Painter, Griffin-Bird Painter, and Siana Cups Resembling Lip-Cups*. Allard Pierson Series 13. Amsterdam: Allard Pierson Museum.

DeVries, K. 1988. "Gordion and Phrygia in the Sixth Century B.C." *Source* 7.3:51–59.

———. 1997. "The Attic Pottery from Gordion." In *Athenian Potters and Painters, the Conference Proceedings*, edited by J.H. Oakley, W.D.E. Coulson, and O. Palagia, 447–55. Oxford: Oxbow Books.

———. 2005. "Greek Pottery and Gordion Chronology." In *The Archaeology of Midas and the Phrygians: Recent Work at Gordion*, edited by L. Kealhofer, 36–55. Philadelphia, PA: University of Pennsylvania Museum of Archaeology and Anthropology.

———. 2011. "The Creation of the old Chronology." In *The New Chronology of Iron Age Gordion*, edited by C.B. Rose and G. Darbyshire, 13–22. Gordion Special Studies 6. Philadelphia, PA: University of Pennsylvania Museum of Archaeology and Anthropology.

DeVries, K., and C. B. Rose. 2012. "The Throne of Midas? Delphi and the Power Politics of Phrygia, Lydia, and Greece." In *The Archaeology of Phrygian Gordion, Royal City of Midas*, edited by C.B. Rose, 189–200. Gordion Special Studies 7. Philadelphia, PA: University of Pennsylvania Museum of Archaeology and Anthropology.

Dusinberre, E. 1999. "Satrapal Sardis: Achaemenid Bowls in an Achaemenid Capital." *AJA* 103:73–102.

Edwards, G.R. 1959. "The Gordion Campaign of 1958: Preliminary Report." *AJA* 63:263–68.

Graef, B., and E. Langlotz. 1909–25. *Die antiken Vasen von der Akropolis zu Athen* I. Berlin: de Gruyter.

Greenewalt, C.H. 1997. "The Lakonian Pottery." In *The Corinthian, Attic, and Lakonian Pottery from Sardis*, J.S. Schaeffer, N.H. Ramage, C.H. Greenewalt, Jr., 131–40. Archaeological Exploration of Sardis 10. Cambridge, MA: Harvard University Press.

Heesen, P. 2011. *Athenian Little-Master Cups*. Amsterdam: Chairebooks.

Kohler, E.L. 1980. "Cremations of the Middle Phrygian Period from Gordion." In *From Athens to Gordion*, edited by K. DeVries, 65–89. Philadelphia, PA: University of Pennsylvania Museum of Archaeology and Anthropology.

———. 1995. *The Gordion Excavations (1950–1973) Final Reports Volume II: The Lesser Phrygian Tumuli, Part 1: The Inhumations*. Philadelphia, PA: University of Pennsylvania Museum of Archaeology and Anthropology.

Körte, G., and A. Körte. 1904. *Gordion: Ergebnisse der Ausgrabung im Jahre 1900. Jahrbuch des deutschen archäologischen Instituts*. Ergänzungsheft 5. Berlin: Reimer.

Lewis, S. 2002. *The Athenian Woman: An Iconographic Handbook.* London: Routledge.

Liebhart, R. 2012. "Phrygian Tomb Architecture: Some Observations on the 50th Anniversary of the Excavations of Tumulus MM." In *The Archaeology of Phrygian Gordion, Royal City of Midas,* edited by C.B. Rose, 128–47. Gordion Special Studies 7. Philadelphia, PA: University of Pennsylvania Museum of Archaeology and Anthropology.

Lynch, K.M. 2014. "Drinking Cups and the Symposium at Athens in the Archaic and Classical Periods." In *Cities Called Athens: Studies Honoring John McK. Camp II,* edited by K.F. Daly and L.A. Riccardi, 231–71. Lewisburg, PA: Bucknell University Press.

Lynch, K.M., and S.F. Matter. 2014. "Trade of Athenian Figured Pottery and the Effects of Connectivity." In *Athenian Potters and Painters, III,* edited by J. Oakley, 107–15. Oxford: Oxbow Books.

McGovern, P. 2000. "The Funerary Banquet of 'King Midas.'" *Expedition* 42:21–29.

Mellink, M.J. 1959. "The City of Midas." *Scientific American.* July, 1959:100–112.

———. 1980. "Archaic Wall Paintings from Gordion." In *From Athens to Gordion,* edited by K. DeVries, 91–98. Philadelphia, PA: University of Pennsylvania Museum of Archaeology and Anthropology.

———. 1988. "The Persian Empire: Anatolia." In *CAH* 4, 2nd ed., edited by J. Boardman, 211–33. London: Cambridge University Press.

———. 1991. "The Native Kingdoms of Anatolia." In *CAH* 3, 2nd ed., edited by J. Boardman, I.E.S. Edwards, E. Sollberger, and N.G.K. Hammond, 619–65. Cambridge: Cambridge University Press.

Miller, M.C. 1988. "Midas as the Great King in Attic Fifth-Century Vase Painting." *AK* 31:79–89.

Pizzorno, G.H., and G. Darbyshire. 2012. "Mapping Gordion." In *The Archaeology of Phrygian Gordion, Royal City of Midas,* edited by C.B. Rose, 23–38. Gordion Special Studies 7. Philadelphia, PA: University of Pennsylvania Museum of Archaeology and Anthropology.

Ramage, N.H. 1983. "A Merrythought Cup from Sardis." *AJA* 87:453–60.

———. 1986. "Two New Attic Cups and the Siege of Sardis." *AJA* 90:419–24.

———. 1997. "The Attic Pottery." In *The Corinthian, Attic, and Lakonian Pottery from Sardis,* J.S. Schaeffer, N.H. Ramage, C.H. Greenewalt, Jr., 63–130. Archaeological Exploration of Sardis 10. Cambridge, MA: Harvard University Press.

Robertson, M. 1951. "Gordion Cups from Naucratis." *JHS* 71:143–49.

Rose, C.B., ed. 2012a. *The Archaeology of Phrygian Gordion, Royal City of Midas*. Gordion Special Studies 7. Philadelphia, PA: University of Pennsylvania Museum of Archaeology and Anthropology.

———. 2012b. "Introduction: The Archaeology of Phrygian Gordion." In *The Archaeology of Phrygian Gordion, Royal City of Midas*, edited by C.B. Rose, 1–19. Gordion Special Studies 7. Philadelphia, PA: University of Pennsylvania Museum of Archaeology and Anthropology.

Sams, G.K. 1977. "Beer in the City of Midas." *Archaeology* 30:108–15.

———. 1979. "Imports at Gordion: Lydian and Persian Periods." *Expedition* 21.4:6–17.

———. 2005. "Gordion: Explorations over a Century." In *The Archaeology of Midas and the Phrygians: Recent Work at Gordion*, edited by L. Kealhofer, 10–21. Philadelphia, PA: University of Pennsylvania Museum of Archaeology and Anthropology.

Sams, G.K., and R.B. Burke. 2008. "Gordion 2006." *Kazı Sonuçları Toplantısı* 29.2:329–42

Sams, G.K., and M.M. Voigt. 1998. "Gordion 1996." *Kazı Sonuçları Toplantısı* 19.1:681–701.

Shapiro, H.A., M. Iozzo, and A. Lezzi-Hafter, eds. 2013. *The François Vase: New Perspectives*. Akanthus Proceedings 3. Kilchberg, Zurich: Akanthus.

Tiverios, M. 1976. Ὁ Λυδὸς καὶ τὸ ἔργο τοῦ. Συμβολὴ στὴν ἔρευνα τῆς ἀττικῆς μελανόμορφης ἀγγειογραφίας. Δημοσιεύματα τοῦ Ἀρχαιολογικοῦ Δελτίου 23. Athens.

Villard, F., and G. Vallet. 1955. "Megara Hyblaea V: Lampes du VIIᵉ siècle et chronologie des coupe Ioniennes." *MEFRA* 67:7–34.

Voigt, M.M., and K. DeVries. 2011. "Emerging Problems and Doubts." In *The New Chronology of Iron Age Gordion*, edited by C.B. Rose and G. Darbyshire, 23–48. Gordion Special Studies 6. Philadelphia, PA: University of Pennsylvania Museum of Archaeology and Anthropology.

Voigt, M.M., K. DeVries, R.C. Henrickson, M. Lawall, B. Marsh, A. Gürsan-Salzman, and T.C. Young. 1997. "Fieldwork at Gordion: 1993–1995." *Anatolica* 23:1–59.

Young, R.S. 1957. "Gordion 1956: Preliminary Report." *AJA* 61:319–31.

———. 1958. "The Gordion Campaign of 1957." *AJA* 62:139–54.

———. 1981. *The Gordion Excavations Final Reports*. Vol. 1: *Three Great Early Tumuli*. Philadelphia, PA: University of Pennsylvania Museum of Archaeology and Anthropology.

Eggs in a Drinking Cup: Unexpected Uses of a Greek Shape in Central Apulian Funerary Contexts

Bice Peruzzi

Abstract

This essay analyzes a large Attic red-figure skyphos discoverd in 1997 and attributed to the Penelope Painter in its context of consumption. I discuss the possible appeal of this vessel for the local population, the so-called Peucetians, and whether they were drawn to its iconography, "Greekness," or shape. I then explore how the pot was appropriated and used in concert with locally produced objects to stage identities in death. My goal is to demonstrate that the presence of Attic vessels in Peucetia was not the result of the "hellenization" of this area; rather, I propose that the inhabitants of this region actively chose specific Greek vases that could easily be assimilated into their funerary practices, and used them in very different ways from their Athenian counterparts.

In April 1977, a large Attic red figure skyphos attributed to the Penelope Painter came to light during the excavations of a rich tomb in the necropolis of Rutigliano-Purgatorio, a site 30 km south of the modern town of Bari (central Apulia, southern Italy; fig. 1). Inside it, the excavators found the remains of egg shells.

Archaeological literature has approached the study of Athenian pots abroad, such as this skyphos, primarily from a Greek perspective. As a consequence, Attic imports in Apulia have often been discussed without their find context or, when used as a means to reconstruct trade routes in the Adriatic, grouped in geographic regions that included many different ancient cultural entities.[1] This essay, instead, analyzes this particular Attic vase in its context of consumption. I discuss the possible appeal of this vessel for the local population, the so-called Peucetians, and whether they were drawn to its iconography, "Greekness," or shape. I then explore how this pot

Fig. 1. Map of Peucetia (after De Juliis 1995, Carta A).

was appropriated and used in concert with locally produced objects to stage identities in death. My goal is to demonstrate that the presence of Attic vessels in Peucetia was not the result of the "hellenization" of this area; rather, I propose that the inhabitants of this region actively chose specific Greek vases that could easily be assimilated into their funerary practices, and used them in very different ways from their Athenian counterparts.

Introduction to the Cultural Context

Apulia, the "heel" of the Italian peninsula, is a region that extends along the Adriatic coast from the Gargano mountains to the tip of the heel and inland to the Bradano river. This region was only marginally touched by Greek colonization; the only Greek city in Apulia was Taranto, which controlled a *chora* with a radius of about 15 km, while the rest of region was inhabited by non-Greek populations.[2] The analysis of pottery types and burial customs demonstrates that, at least from the eighth century B.C.E., the inhabitants can be divided into three archaeological cultures: Daunian in the north,

Peucetian in the center, and Messapian in the south; however, even recent attempts to reconcile ancient tribal designations with recognized archaeological and linguistic cultures have been only partially successful.

The Peucetians left no written accounts, and they are only rarely mentioned by ancient Greek and Roman authors.[3] Moreover, because of the continuity of life in this region, many settlements are still buried underneath modern towns. However, the grave goods from the hundreds of tombs that have been excavated in the last century in this region paint the image of a flourishing society with a stratified social hierarchy in commercial contact with Etruria, Greece, and other parts of southern Italy.[4]

From the middle of the sixth century B.C.E., the typical grave-good assemblage for both men and women in Peucetia focused around communal activities, in particular banqueting. The most important vase in the assemblage was a decorated mixing vessel, often a krater. Besides the mixing vessel, there were vases for serving and drinking liquids, a small vase for libations, and a number of pots and implements for food preparation and consumption (fig. 2). The number of vases per tomb varied between five and more than 100; however, even the richest assemblages can be broken down into iterations of this module with the addition of vases for storage and

Fig. 2. Grave-good assemblage from Bitonto tomb 6/2003, mid-sixth century B.C.E. (after Riccardi 2008, 23, fig. 26).

Fig. 3. Tomb 77/1977, end of fifth or beginning of fourth century B.C.E. (after Lo Porto 1978, tav. LXI, reproduced with permission of Ministero dei Beni e delle Attività culturali e del Turismo - Soprintendenza per i Beni Archeologici della Puglia- Archivio fotografico).

metal artifacts (weapons, jewelry, banqueting paraphernalia). Furthermore, although new shapes were introduced in the course of the fourth century, the general functional composition of the assemblages remained substantially the same until the middle of the third century B.C.E.[5]

The Archaeological Context

The Penelope Painter skyphos was found in a Peucetian male burial, dated at the end of the fifth or the beginning of the fourth century B.C.E. The tomb was of the so-called ripostiglio type (fig. 3). The human remains rested inside a large cyst tomb (1.40 x 0.85 x 0.85 m) that had been built and covered with calcareous slabs.[6] Rectangular indentations are visible on the longer sides of the tomb and small fragments of wood have been found by the excavators; it follows that originally, wooden planks rested on these indentations and could be used to support the cover slabs. The tomb also had a secondary, rectangular pit dug at the foot of the burial, the so-called ripostiglio; this smaller space was used to hold the ceramic grave goods.[7]

The assemblage included more than 90 vessels: a mix of local wares, Apulian and Lucanian red-figure pottery, and several other imports (fig. 4).[8] There were, in fact, four small Corinthian lekythoi, two Attic black-figure on white-ground

lekythoi with vegetal motifs, and a group of Attic red-figure vessels: a column krater with a scene of the return of Hephaistos; a neck amphora with Penthesilea and the Amazons—both attributed to the Polygnotos Group—a lekythos with a warrior departing; a rhyton shaped like a donkey's head; three askoi; three kantharoi of the class of Saint Valentin vases; and several cups. Together with the ceramic artifacts, the tomb also contained a bronze helmet, a bronze belt, greaves, and paraphernalia to cook and serve meat, such as a cauldron, a tripod, and a fork.[9]

Fig. 4. Grave-good assemblage from tomb 77/1977 (after Sena Chiesa and Arslan 2004, 129, reproduced with permission of Ministero dei Beni e delle Attività culturali e del Turismo - Soprintendenza per i Beni Archeologici della Puglia- Archivio fotografico).

The presence of artifacts of different technological traditions (local, Greek, and Italiote) in the assemblage speaks of the considerable thought that must have gone in the selections of the objects for this burial kit. Furthermore, it has to be noted that some of the vases included in this burial were substantially older than others.[10] While some of the black-gloss vessels can be dated to the first half of the fourth century B.C.E., the hydria by the Pisticci painter was probably produced in the last decades of the fifth century, and some of the Attic vases—including the Penelope Painter skyphos—were even older.[11] At a first glance, the presence of Greek and Greek-looking vases could be interpreted as a sign that the deceased took part in a communal drinking ritual that echoed the Greek symposium. However, the presence of local shapes,

Fig. 5. Attic Skyphos, third quarter of fifth century B.C.E. Obverse. Taranto, TA 165084 (reproduced with permission of Ministero dei Beni e delle Attività culturali e del Turismo - Soprintendenza per i Beni Archeologici della Puglia- Archivio fotografico).

the unexpected use of the Penelope Painter skyphos as a storage vessel, and the inclusion in the assemblage of tools to prepare and consume food indicate that the Peucetian banquet must have had different characteristics, and probably different functions from the Athenian symposium.[12] Moreover, despite the higher level of expenditure, this grave assemblage fit the general characteristics of its contemporaries, as its vases facilitated the same behaviors (i.e., mixing, offering, serving, cooking, eating, and storage).[13] It follows that the introduction of Greek-looking vases (imported from Athens, or produced in Apulia and Lucania) did not change the basic core of the assemblage and what it represented culturally. Rather, the Peucetians chose specific shapes from the pottery repertoire that could be better assimilated into their existing categories, and fit the requirements for the funeral.[14]

The Skyphos

I will now turn to the skyphos by the Penelope Painter (fig. 5). This vase, now in the Taranto Museum, has received only limited scholarly attention and it is still mainly known from preliminary excavation reports.[15] It is ca. 20 cm tall, with a diameter of ca. 23 cm at the mouth and 15 cm at the foot, which puts it among the small group of large skyphoi produced by the Penelope Painter (all above 16 cm in height), like the name vase in Chiusi with Odysseus and Eurykleia on one side, and Penelope on the other.[16] The vase is in a very good state of preservation, although the wear on the black slip

Fig. 6. Vegetal motif from figure 5. Taranto, TA 165084 (reproduced with permission of Ministero dei Beni e delle Attività culturali e del Turismo - Soprintendenza per i Beni Archeologici della Puglia- Archivio fotografico).

around the rim, on the handles, and on the inside indicates that it had been used before it was put in the tomb.

The skyphos is decorated on both sides with scenes of libation performed by women. The two scenes are framed by composite vegetal motifs underneath the handles: palmettes, spirals, and leaves in an arrangement very similar to others by the same painter, for example the skyphos in Berlin with the satyr pushing a nymph on a swing (fig. 6).[17]

On the obverse, there is a woman on the left, in profile, standing near a heavily decorated stool. She is depicted wearing a crown on her long, curly hair; she is clothed in a chiton and a himation with a black band along its border. In her hands are a phiale and a thin scepter that ends in a three-leaf finial. The woman on the right is depicted, instead, with a frontal body and her head in profile. Her hair is bound with a white band wrapped around her forehead and behind her ears, and she is wearing a peplos. In her right hand she is holding a trefoil oinochoe, and with her left, she is lifting her skirt, so her feet and ankles are visible. Very faint traces of white paint are still visible, depicting the stream of liquid pouring out from oinochoe into the phiale and from the phiale onto a small fire on the ground. Next to the heads of both women is the inscription ΚΑΛΗ.

The two women are not identified. However, the iconography of the woman on the left, with crown and scepter, and the general composition of the scene, with the two women

71

Fig. 7. Interior of figure 5. TA
165084 (reproduced with per-
mission of Ministero dei Beni
e delle Attività culturali e del
Turismo - Soprintendenza per i
Beni Archeologici della Puglia-
Archivio fotografico).

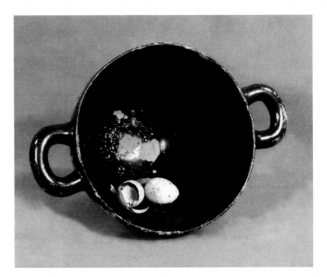

facing each other performing a libation, echoes closely some
contemporary representations of Demeter and Kore.[18]

What makes this vase exceptional is the fact that inside it
the excavators found the remains of egg shells (fig. 7). A dis-
cussion of the meaning of egg offerings in tombs, which have
been often interpreted as a symbol of rebirth and tied with
Orphism, far exceeds the scope of this paper.[19] However, it
is safe to say that eggs were an established part of the funer-
ary ritual in Peucetia, as illustrated by depictions on many
red-figure vases, egg clay models, and even the presence of
eggs' shells in another tomb in Rutigliano-Purgatorio.[20] Thus,
I will concentrate on another question: what prompted the
unusual choice of using a skyphos—traditionally considered
a drinking vessel—for storage?

Hypothesis A: Iconography

One possibility is that its iconography was the major
draw. As I have argued elsewhere, Peucetians could choose
imports with specific, even rare, iconographies when they
could be integrated successfully in the message of the as-
semblage, either because they could be thematically linked
to the other vessels, or because their subjects were culturally
appropriate.[21] In this view, the scene of libation—especially
if performed by Demeter and Kore—could have been the
factor that made this particular vase appropriate as a con-
tainer for funerary offerings.

Yet, food offerings in central Apulian burials have main-

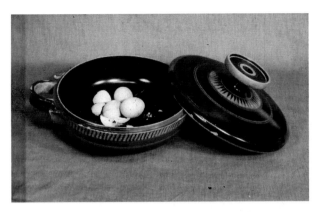

Fig. 8. Black-figure Lekanis from tomb 17/1976, late fifth or early fourth century B.C.E. (after Lo Porto 1977, pl. CX. 2, reproduced with permission of Ministero dei Beni e delle Attività culturali e del Turismo - Soprintendenza per i Beni Archeologici della Puglia- Archivio fotografico).

ly been found in pots without any figured decoration. For example, from another tomb in Rutigliano-Purgatorio comes a roughly contemporary, black-figure Attic lekanis that also had been used as a container of eggs. This vessel has only a band with a pattern of vertical zigzags on its body, and a motif of triangles radiating from the knob on its lid (fig. 8).[22]

More examples come from tombs in Canosa, a site just over the northern border of Peucetia. The first one is a locally produced stamnos decorated with bands that contained olives pits and grape seeds.[23] The other pot is even more interesting for the purpose of this paper, because it shows that skyphoi used as storage containers were uncommon but not unique. From tomb 8/08 in via Piano S. Giovanni comes a black-gloss South Italian skyphos containing the mineralized remains of rowan fruits (*sorbus domestica*).[24] The sample size available is undoubtedly small; however, if one considers that less than 30% of the roughly 300 scenes represented on Attic imports found in Peucetia illustrated narratives, it seems that the Peucetians were primarily consumers of shapes.[25] Decoration, even when present and suitable as in the case of the Penelope Painter skyphos, might not have been the most important criterion for the selection of a vase.

Hypothesis B: "Greekness"

Another possibility is that the main appeal of this vase was its Athenian origin, and that its owners wanted to flaunt their Greek connections without really understanding how it was supposed to function. For many decades "hellenization" has been the dominant paradigm to explain cultural exchange be-

Bice Peruzzi

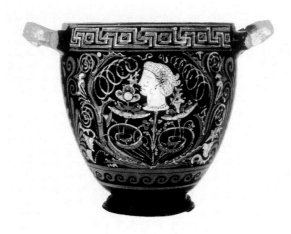

1 (164536)

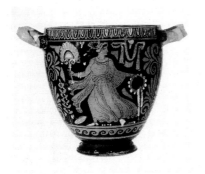

2 (164536)

3 (164536)

ITALIA 3411 CERAMICA APULA

Fig. 9. Apulian Skyphoid pyxis from Matera. Matera, Museo Nazionale di Matera "Domenico Ridola," 164536 (after CVA Matera, pl. 54, photo courtesy L'Erma di Bretschneider).

74

tween Greeks and non-Greeks. To quote Boardman, in the contact with the colonists—bringers of civilization–"the natives weighted their new prosperity, brought by the Greeks, against the sites and land they had lost to them, and were generally satisfied."[26] All things Greek were regarded as generally superior and, thus, eminently desirable for the locals. The acculturation process was seen as a one-way street, and "different forms of borrowing were equated with different depths of cultural assimilation."[27]

Yet, the mechanisms of cultural exchange rarely followed such a straightforward process. The non-Greek populations could assimilate selected customs or artifacts, while maintaining their own beliefs and practices.[28] Moreover, as Michael Dietler has noted, the imported Greek objects were intentionally manipulated by different social groups who gave them new meanings to fit their own local agendas.[29]

Hypothesis C: Shape

Excluding the idea that its iconography or its Greek origin were the primary appeals of this vase, it follows that this vessel was selected because of its shape; therefore, one must contemplate the possibility that a skyphos could be used for more than drinking wine in Peucetia. The sheer size of the Penelope Painter skyphos, which sets it apart from the other pots of the same shape in the Rutigliano-Purgatorio tomb, seems to also point toward this conclusion. When full, this vase could have contained more than five liters of wine, which making it very difficult to handle.[30]

One indication that the inhabitants of this region could have used shapes differently from the Athenians comes from the presence of a locally produced kalathos in the same assemblage as the Penelope Painter skyphos. In Athens, the kalathos is exclusively connected with the female sphere. It is the clay counterpart of the wicker basket used to hold the wool that the women spin, and it is known from ceramic examples and many representations on black- and red-figure vases. As mentioned above, the tomb in Rutigliano-Purgatorio contained weapons, and it has been identified as male by the excavators.[31]

It is possible to understand this apparent dichotomy of a "woman's vase" in what is an ostensibly a male tomb by eliminating the Greek connotations. A kalathos is after all a storage vessel, and it can be used to contain a number of different

things, for example fruit offerings—as illustrated by a clay model of a full-sized, undecorated kalathos brimming with fruit found in a fourth-century tomb from Conversano, a site just 20 km south of Rutigliano.[32]

Another hint that skyphoi could be used in this region in different ways comes from the existence of the so-called skyphoid pyxis, a shape which Beazley defined of "some importance in Italiote vase-painting."[33] This shape is more common in Campanian and Sicilian ceramic productions; however, it is attested also in Apulian red-figure pottery with examples found in Ruvo, Lecce, Egnatia, and Matera.[34] In these pots, the bowl takes the form of a skyphos, and it is only distinguishable from an actual drinking vessel by the internal inset lip used to set the lid and, sometimes, by the articulated handles (fig. 9). Yet, the presence of the lid marks this shape as something that was used for storage.

As skyphoid pyxides do not exist in either Attic or Corinthian pottery, it follows that this is a shape created to satisfy the southern Italian market. Moreover, its widespread geographical diffusion shows that it was not an experiment of a single potter—à la Nikosthenes—but an established part of the repertoire. Considering the similarities between the bowl of a skyphoid pyxis and a skyphos, it is not such a huge leap to imagine that a skyphos could double as a storage vessel, maybe with another vase used "inappropriately" as a lid, as in the case of one of the small local stamnoi in this very same assemblage.

Conclusions

The Penelope Painter skyphos prompts us to reexamine some of our assumptions about the function of Greek vases in non-Greek contexts. Traditionally, archaeological literature has approached the study of Attic pots abroad through the lenses of Athenian behavior. As the adoption of elements from the Greek drinking set is still often interpreted as a sign of the "hellenization" of a population, scholars sometimes assume that the role and function of Greek vases everywhere mirrored that of their counterparts in Athens. Yet, as this skyphos from the necropolis of Rutigliano-Purgatorio indicates, different cultural entities could appropriate Greek shapes and use them according to their local practices.

If this skyphos had been found in an Athenian house, one could think that it belonged to a male individual of a specific

social class who used it to drink [quite a lot!] of wine at symposia.[35] None of these things apply when one acknowledges the Peucetian funerary context. In Peucetia, communal dining was not restricted to men, this skyphos might never have contained wine, and banquets must have served different objectives, for example, asserting status through the provision of both wine and food.[36]

So, while Greek vases were certainly appealing to the Peucetians, it is probable that "Greekness" was only one aspect of the carefully crafted image that the inhabitants of Rutigliano-Purgatorio were trying to project. After all, Greek-looking pots never completely replaced locally produced ones. Once appropriated by the consumers, the imports became part of a broader narrative made of local needs, logic, and strategies. Therefore, one has to abandon a few traditional preconceptions about Attic shapes abroad and think about how these pots functioned in these new contexts; only this way, is it possible to shed light on the identity of the consumers, and ultimately allow the material culture to give voice to these populations.

Notes

[1] E.g., see Giudice 2007 for a discussion of Attic pots and trade routes.

[2] Carpenter 2009, 27–28.

[3] Strabo is the only source who defines the territory of the Peucetians (Strabo 6.3.8); there is no mention of a triumph over the Peucetians in the *Fasti triumphales*, and Pliny the Elder does not list the Peucetians in his list of the populations of Regio II.

[4] E.g., see Montanaro 2007 for an overview of the rich necropoleis of Ruvo.

[5] Peruzzi 2014, 37–39.

[6] The tomb contained a skeleton and the remains a previous deposition. It was a common Peucetian custom to reuse tombs, even just after a few years from the original interment. Sena Chiesa and Arslan 2004, 129.

[7] Lo Porto 1978, 503, pl. LXI.

[8] A.D. Trendall (1983, 6, no. 24c) attributed the hydria with the scene of pursuit to the Developed style of the Pisticci painter.

[9] Sena Chiesa and Arslan 2004, 129.

[10] The inclusion in graves of objects with different chronologies is a common practice in Peucetia. In the fifth and early fourth centuries B.C.E. assemblages seem to have been made largely of preowned objects and some of them might have been family heirlooms.

[11] Among the more recent artifacts are the black-gloss guttus

(close to Morel 8165a1 and datable by comparison to the first half of the fourth century B.C.E.), the black-gloss trefoil oinochoe with the ovoid body (close to Morel 5623b1, datable between the 450–350 B.C.E.), and two of the miniature type 8 oinochoai (close to Morel 5333e1 and dated generically to the fourth century.

[12] On the Athenian symposion see most recently Lynch 2011. For an overview of the role of funerary banquets in different societies, see, e.g., Dietler and Hayden 2001, 65–114.

[13] The vases in the assemblage can be divided in the six categories. Mixing: Attic red-figure column krater. Libation: four banded one-handled bowls. Drinking: three Attic red-figure cups; Attic red-figure rhyton; two Apulian red-figure skyphoi; Apulian red-figure cup skypos; two matt-painted kantharoid vases; three St. Valentin kantharoi; black-gloss skyphos; black cup skyphos; six black cups. Serving: Attic red-figure amphora; Attic red-figure trefoil oinochoe; two Apulian red-figure hydriai; two Apulian red-figure pelikai; Apulian red-figure miniature hydria; three Apulian red-figure oinochoai; three miniature black-gloss shape 8 oinochoai; two shape 8 oinochoai; two trefoil onochoai; guttus. Food preparation: two chytrai; coarseware mortarium; two black-gloss salt-cellars. Food consumption: two overpainted stem plates; five black-gloss stemplates; two matt-painted stemplates. Storage: four Corinthian lekythoi; two Attic black-figure lekythoi; Attic red-figure lekythos; Attic red-figure skyphos; three Attic red-figure askoi; five matt-painted stamnoi; four matt-painted lekanides; matt-painted kalathos.

[14] Thomas Carpenter has convincingly argued that the there was a distinct preference for Attic red-figure column kraters, in Peucetia; one of the reasons for the popularity of the Attic column krater was the fact that it resembled the local mixing vessel that had been produced at least from the late seventh century B.C.E. Carpenter 2003, 1–24.

[15] Lo Porto 1978, 703–4. I am very thankful to the *Soprintendenza per i Beni Archeologici della Puglia* for allowing me the use of the images.

[16] Chiusi: Chiusi Museo Archeologico 62705: ARV² 1300.2. There is a vast bibliography on this vase. For a recent overview of the bibliography see Stansbury-O'Donnell 2014, 378.

[17] *ARV²* 1301.7; CVA Berlin Antikensammlung- Pergamonmuseum 1 [East Germany 3], pl. 35 [146]:1–4; LIMC VIII, pl. 770 s.v. Silenoi.

[18] E.g., stamnos by the Painter of the Yale Oinochoe: *ARV²* 501.1; CVA Oxford 1 [Great Britain 3] pl. 27 [119]: 1–2.

[19] E.g., on the role of eggs in Orphism, see Edmonds 2013, 164–68.

[20] Clay eggs were found in Conversano tomb 2 in via Iapigia, Depalo 1987; eggshell were found in Tomb 17/1976 in Rutigliano, Lo Porto 1977, 739, pl. CVIX.

[21] Peruzzi 2013.

22 From Tomb 17/1976; see Lo Porto 1977, 736; pl. CX.2

23 From the hypogeum in Via Fornari in Canosa; Corrente 2014, 184.

24 Tomb 8/08 from via piano San Giovanni; Corrente 2014, 175.

25 The vast majority, instead, had standard, stock scenes, most commonly Dionysiac; Lucchese 2010, 299–306.

26 Boardman 1980, 198.

27 Dietler 2010, 46.

28 Papadopoulos 2002, 7.

29 Dietler 2010, 55. *Contra*, see Yntema 2014, 219.

30 Mark Stansbury-O'Donnell in a recent paper on the Penelope Painter has argued similarly. Stansbury-O'Donnell 2014, 383.

31 An extensive analysis of the anthropological remains was conducted after the discovery of the necropolis of Rutigliano-Purgatorio; see Scattarella and De Lucia 1982, 137–47. Unfortunately, the most complete publication does not reference specific tomb numbers, so I am not able to check this information directly. However, in over 350 tombs analyzed for my Ph.D. dissertation, weapons consistently appear in adult male tombs.

32 Tomb 2 of via Iapigia, excavated in 1979; Depalo 1987.

33 Beazley 1943, 104.

34 Beazley 1943, 104, note. 10; Trendall 1980, 89; *RVAp* 11/15a; CVA Matera, pl. 54.

35 However, some scholars have argued that even in Athens skyphoi could be used outside of a traditional male symposia, and were associated with women's drinking; e.g., see Venit 1998, 124.

36 Mark Stansbury-O'Donnell has similarly questioned whether the larger skyphoi in the Penelope Painter's production were produced specifically for offerings, in particular the name vase, which was found in a sanctuary; Stansbury-O'Donnell 2014, 384; see also Iozzo 2012, 72.

References

Beazley, J.D. 1943. "Groups of Red Figure." *JHS* 63:66–111.

Boardman, J. 1980. *The Greeks Overseas*. London: Thames & Hudson.

Carpenter, T.H. 2003. "The Native Market for Red-figure Vases in Apulia." *MAAR* 48:1–24.

———. 2009. "Prolegomenon to the Study of Apulian Red-Figure Pottery." *AJA* 113:27–38.

Corrente, M. 2014. "Red-Figure Vases in Fourth Century B.C.E. Canosa: Images, Assemblages, and the Creation of a Social Hierarchy." In *The Italic People of Apulia: New Evidence from Pottery for Workshops, Markets, and Customs*, edited by T.H. Carpenter, K.M. Lynch, and E.G.D. Robinson, 168–85. Cambridge: Cambridge University Press.

Depalo, M.R. 1987. "Conversano: Rinvenimenti Archeologici in via Japigia." In *Storia e Cultura in terra di Bari* 2:81–109.

Dietler, M. 2010. *Archaeologies of Colonialism: Consumption, Entanglement, and Violence n Ancient Mediterranean France*. Berkeley: University of California Press.

Dietler, M., and B. Hayden, eds. 2001. *Feasts: Archaeological and Ethnographic Perspectives on Food, Politics, and Power*. Washington DC: Smithsonian Institute Press.

Edmonds, R.G. 2013. *Redefining Ancient Orphism: A Study in Greek Religion*. Cambridge: Cambridge University Press.

Giudice, G. 2007. *Il Tornio, la nave e le terre lontane: Ceramografici attici in Magna Grecia nella seconda metà del V sec. a. C.* Rome: "L'Erma" di Bretschneider.

Iozzo, M. 2012. "Chiusi, Telemaco e il Pittore di Penelope." In *Vasenbilder im Kulturtransfer. Zirkulation und Rezeption griechischer Keramik in Mittelmeerraum*, edited by S. Schmidt and A. Stähli, 69–83. Munich: Beck.

Lo Porto, F.G. 1977. "Recenti scoperte archeologiche in Puglia." In *Locri Epizefirii: atti del sedicesimo. Convegno di studi sulla Magna Grecia, Taranto, 3–8 ottobre 1976*, 725–45. Naples: Arte tipografica.

———. 1978. "La documentazione archeologica in Puglia." In *Magna Grecia bizantina e tradizione Classica: atti del diciasettesimo Convegno di studi sulla Magna Grecia, Taranto, 9–14 ottobre 1977*, 495–504. Naples: Arte tipografica.

Lucchese, C. 2010. "L'importazione della Ceramica Attica." In *La Puglia Centrale dall'Età del Bronzo all'Alto Medioevo. Archeologia e Storia. Atti del convegno di studi*, ed. L. Todisco, 299–306. Rome: "L'Erma" di Bretschneider.

Lynch, K.M. 2011. *The Symposium in Context: Pottery from a Late Archaic House near the Athenian Agora*. Princeton: American School of Classical Studies at Athens.

Montanaro, A.C. 2007. *Ruvo di Puglia e il suo territorio: le necropoli: i corredi funerari tra la documentazione del XIX secolo e gli scavi moderni*. Rome: "L'Erma" di Bretschneider.

Papadopoulos, J.K. 2002. "Archeology and Colonialism." in *The Archaeology of Colonialism*, edited by C.L. Lyons and J.K. Papadopoulos, 1–26. Los Angeles: Getty Research Institute.

Peruzzi, B. 2013. "The Role of Attic Imports in Apulian Grave Assemblages." Paper read at the 114th Annual Meeting of the Archaeological Institute of America, 3–6 January, Seattle.

———. 2014. "The (D)evolution of Grave Good Assemblages in Peucetia in the 3rd Century," in *Beyond Vagnari, New Themes in the Study of Roman South Italy*, edited by A. Small, 33–39. Bari: Edipuglia.

Scattarella, V., and A. De Lucia. 1982. "Esame Antropologico dei Resti Scheletrici della Necropoli Classica di Purgatorio Presso Rutigliano (Bari)." *Taras* 2:137–47.

Sena Chiesa, G., and E.A. Arslan, eds. 2004. *Miti greci: archeologia e pittura dalla Magna Grecia al collezionismo.* Milan: Electra.

Stansbury-O'Donnell, M.D. 2014. "Composition and Narrative on Skyphoi of the Penelope Painter." In *Approaching the Ancient Artifact. Representation, Narrative, and Function. A Festschrift in Honor of H. Alan Shapiro,* edited by A. Avramidou and D. Demetriou, 373–83. Berlin: de Gruyter.

Trendall, A. 1980. "A Sicilian Skyphoid Pyxis in Lugano." *Quaderni ticinesi di numismatica e antichità classiche* IX: 89–113.

———. 1983. *The Red-Figured Vases of Lucania, Campania and Sicily,* Third Supplement. BICS, Bulletin Supplement, 41. London: Institute of Classical Studies.

Venit, M.S. 1998. "Women in Their Cups." *CW* 92:117–30.

Yntema, D. 2014. *The Archaeology of South East Italy in the First Millennium B.C.* Amsterdam: Amsterdam University Press.

Too Young to Fight (or Drink): A Warrior Krater in a Child Burial at Ancient Sindos

Vivi Saripanidi

Abstract

The subject of this paper is an Attic black-figure column krater by the Painter of Louvre F6. The vessel is dated to ca. 540 B.C.E. and is decorated with a scene of a departing warrior on the front and a group of animals on the back. This is one of the four imported and locally made vessels that were found in Grave 66 of the archaic to classical cemetery of ancient Sindos, which is located in northern Greece a few kilometers to the northwest of Thessaloniki. The excavation of this cemetery in the early 1980s brought to light 123 mostly lavishly furnished burials that belonged to men, women, and children. Although the ethnic identity of this population has been debated, the mortuary practices attested at the site are indistinguishable from those recorded at Macedonian cemeteries, such as the one at Vergina. Grave 66, a rather richly equipped pit grave that also yielded several golden and iron artifacts, had received a young boy, less than 10 years old, who died ca. 530 B.C.E. Taking into account the patterns of the mortuary consumption of vases attested at the cemetery, I demonstrate that the krater mainly functioned as a sympotic vessel. More precisely, as such it alluded to the high social rank ascribed to the dead boy and perhaps also to his cultural identity. However, since the boy was buried with the attributes of a warrior (a sword and two spears), I also consider whether the subject of its figural decoration may also have affected the selection of this vase as a gift for this particular burial. In this frame, I examine the presence and reception of Attic pottery, and especially of vases by the same painter, in the broader region of modern central Macedonia during the third quarter of the sixth century B.C.E.

POTTERY FROM SOUTHERN GREECE REACHED THE NORTHERN part of the Aegean at least from the beginning of the Late Bronze Age, that is, long before the establishment of the first Greek settlements in the region.[1] By the Archaic period, Macedonia and Thrace offered a fast-growing market for the products of southern and eastern Greek pottery workshops, which were incorporated into the material culture not only of

Greek settlers, but also of indigenous populations. According to literary sources, the latter consisted of various ethnic groups that included Paeonians, Thracians, and, at the latest from the mid-seventh century B.C.E., the inhabitants of the Macedonian kingdom.[2] Although the corpus of archaic Greek vases found in the north is constantly increasing, the modes of their consumption by local communities, Greek and non-Greek, have been little investigated to date.[3] In this paper I will focus on an Attic black-figure krater from a burial at ancient Sindos (for all sites see fig. 1).[4] Ancient Sindos, albeit textually attested, has been difficult to associate with any particular ethnic group. Contextualizing successively the krater, the burial, and the larger necropolis, I will explore the ways that the shape and decoration of the vase may have operated in the frame of the local mortuary rituals.

The krater was unearthed at the South Cemetery of Sindos, which was in use from ca. 560 B.C.E. until the end of the fifth century.[5] M. Tiverios has attributed the vase to a companion of Lydos, the Painter of Louvre F6, and has dated it to the last years of the painter's career, ca. 540 B.C.E.[6] Its front side is decorated with a scene of a departing warrior, who is being seen off by five mantled youths (fig. 2); its reverse shows a swan squeezed between two panthers (fig. 3). The frequent repetition of the warrior departure theme by this and other painters during the second half of the sixth century has been understood as symptomatic of the broadening of the Athenian hoplite force under Peisistratus.[7] It has been further maintained that such scenes would have visualized the ideal of citizenship by conflating Athenian hoplites with epic heroes. While this interpretation may apply well to vases that remained within Attic territory, it appears that this was rarely the case. Among the 238 examples of this theme with known provenance, which are recorded at the online database of the *Beazley Archive*, only 11% comes from Attica (fig. 4); the vast majority (67%) were found in Italy, especially at Etruscan sites.[8]

The *Beazley Archive* lists nine examples from Macedonia, one of them being the krater from Sindos.[9] This vase was found in Grave 66 with the remains of a boy, who died sometime between 540 and 530 B.C.E. at the age of about five.[10] The boy was buried with the attributes of a warrior: an iron sword with golden fittings (fig. 5) and two spears with iron heads. The sword had been deposited together with its sheath,

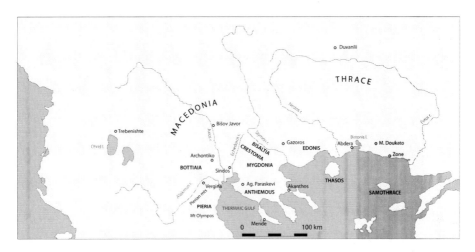

which was decorated with golden foils. Additional golden sheets covered the boy's mouth (fig. 6), diadem, and shoes. Aside from a Corinthian exaleiptron, the remaining grave goods formed a feasting set that complemented the krater: a miniature Boeotian kotyle (fig. 7), a local jug (fig. 8), an iron knife,[11] and a miniature table with a chair made of iron.

Grave 66 contained one of the many versions of the feasting set that appears in all archaic graves from this site that escaped looting.[12] At Sindos, the more modest version of feasting equipment consists of a single, local, or imported, drinking cup.[13] The more grandiose version, which occurs at graves that could be described as "princely," may include up to 22 pouring, mixing, and drinking vases, which are either clay imports or, for the greater part, made of bronze. Grave 25, for instance, from ca. 540, yielded four imported clay drinking cups, 14 bronze phialai, two imported clay jugs and one made of bronze, as well as a bronze cauldron.[14] These vessels were accompanied by a miniature table and a chair (fig. 9), a bundle of miniature iron spits with a pair of firedogs (fig. 10), three iron knives, and an iron flesh-hook. The feasting sets from the rest of the graves represent, with regard to form and size, all possible variations between the more modest and the more luxurious versions. Within this continuum, there are two prevalent tendencies that are often copresent in the same burial: the first is to form the basic trio of drinking, pouring, and mixing vase; and the second, to include some metal artefacts. Interestingly, the quantity and types of feasting accessories correlate neither with the age nor with the gender of the deceased.[15]

Fig. 1. Map of the northern Aegean with the sites mentioned in the text (N. Bloch and the author).

Fig. 2. *Krater by the Painter of
Louvre F6, from Grave 66 at
Sindos, ca. 540 B.C.E.; ht. 26.9
cm. Side A (Vokotopoulou et
al. 1985, cat. no. 372 © Hellenic
Ministry of Culture – Archaeo-
logical Receipts Fund).*

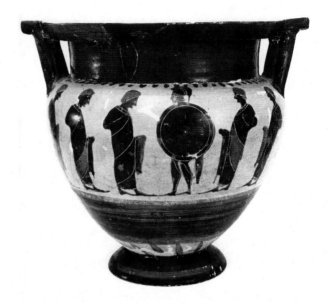

Fig. 3. *Side B of figure 2
(adapted from Vokotopoulou
1996, cat. no. 8327 © Kapon
Editions).*

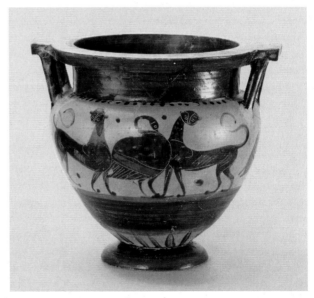

In archaic Sindos, age does not seem to have functioned as a major factor in the construction of mortuary differentiation. The only age group that was clearly distinguished was that of infants less than six months old. Although their burials were made among those of adults and followed the same principles of orientation, they were the only burials to be left completely

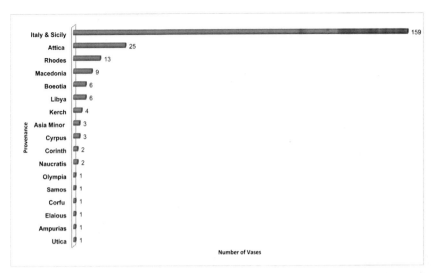

Fig. 4. Graph showing the provenances of Attic vases that date from 550–500 B.C.E. and are decorated with warrior departure scenes (data drawn on BAPD).

unfurnished.[16] Older infants are not represented, but children, the youngest of which is that of Grave 66, received the same treatment as adults in terms of grave types, form of disposal of the body,[17] orientation, and grave gifts. As a matter of fact, none of the aspects of the local mortuary rituals that are archaeologically visible seems to have involved practices or material forms reserved for children. It must be stressed that miniature objects, such as the kotyle from Grave 66, were by no means exclusive to child burials. Since they were also not exclusive to more modestly equipped graves, they must have functioned as artifacts with reinforced connotative meaning, chosen because of their association with specific spheres of action.[18]

Furthermore, child burials appear to have been gendered in the same ways as those of adults. At this cemetery, female individuals were inhumed with their head facing east, whereas male bodies were placed in the opposite direction. Gender distinctions were further articulated through particular types of offerings: weapons were male-specific; distaffs, jewelry, and dress fasteners (with the exception of finger rings and double pins) accompanied only women.[19] However, such gender distinctions do not seem to have had a hierarchical dimension. Rather than age or gender, the main distinction structuring inequalities between burials appears to have been related to social status, real or ascribed. This factor played out not only in terms of the quantity and quality of offerings, but also in the form of the grave.[20] Nevertheless, if the Sindos burials

Fig. 5. Iron sword with golden fittings from Grave 66 at Sindos; length 55.5 cm (Vokotopoulou et al. 1985, cat. no. 370 © Hellenic Ministry of Culture – Archaeological Receipts Fund).

embody vertical differentiations that cut across gender and age, at the same time they resist a binary classification into a "rich" and a "poor" category. As already implied by the pattern of the funerary consumption of feasting equipment, burials at this site attest to all possible gradations within a continuum. Moreover, even though some types of offerings had a more exclusive character than others, none was reserved for burials either at the upper or at the lower end of the scale.

Given that the presence of feasting sets in female burials is hard to reconcile with the norms of the male-dominated Greek *symposion*, scholars have sought to interpret it in various ways. K. Despoini, who identified the inhabitants of Sindos with Greek colonists, understood it as a manifestation of religious beliefs in an afterlife.[21] Yet, others suggested that this practice, along with the pairing of miniature tables with chairs (instead of couches) and the excessive wealth of several graves, must be indicative of the "non-Greekness" of the local population.[22] In most modern accounts of the region, Sindos figures, indeed, as a Thracian or mixed "Graeco-barbarian" settlement.[23] Unlike such accounts, which rely primarily on indirect literary evidence, in a forthcoming paper I have examined this site in the light of the finds from a series of archaic cemeteries excavated in modern northern Greece, Bulgaria, and FYROM.[24] I will summarize here some of the conclusions of this paper and particularly those that pertain to the use of feasting accessories at these sites.

At the archaic cemeteries of northern Greek colonies, such as the ones at Clazomenian Abdera and the Andrian Akanthos, graves are very often unfurnished; when they are not, they point to a level of mortuary expenditure that is hardly comparable to that attested at Sindos.[25] Metal artefacts are uncommon and almost exclusively made of bronze and iron. Moreover, grave inventories suggest no allusions to the spheres of warfare and feasting. Even if the assemblages of broken pottery often found between burials were to be the remains of funerary feasts, vases deposited inside graves do not necessarily include drinking cups and they certainly never include mixing vessels. Rather infrequently a grave may contain a jug; but jugs rarely come together with drinking vessels.

With regard to archaic Thracian cemeteries, such as those excavated at Mikro Doukato and Gazoros, the situation is somewhat different.[26] Thracian graves are more regularly furnished and may contain bronze jewelry and dress accessories or, from

Fig. 6. Golden mouthpiece from Grave 66 at Sindos, ca. 540–530 B.C.E.; length 12.2 cm (adapted from Vokotopoulou et al. 1985, cat. no. 362 © Hellenic Ministry of Culture – Archaeological Receipts Fund).

Fig. 7. Miniature Boeotian kotyle from Grave 66 at Sindos, ca. 540–530 B.C.E.; ht. 3.7 cm (Vokotopoulou et al. 1985, cat. no. 359 © Hellenic Ministry of Culture – Archaeological Receipts Fund).

the late sixth century B.C.E., some artefacts made of precious metals. They usually also yield vases, which may include Greek imports and may sometimes take the form of a cup or a jug, but never that of a mixing vessel. In addition, drinking cups, whose presence is far from standard, are very rarely combined with pouring vessels. Luxurious metal feasting sets, such as the ones from Duvanlii, do not appear at Thracian sites until the mid-fifth century and the foundation of the Odrysian kingdom.[27] Apart from feasting accessories, the wealthiest Odrysian graves are furnished with artifacts made of precious metals, imported goods, and weapons. Nevertheless, the types, provenance, and patterns of deposition of their finds overlap only in part with those of the finds from Sindos. In all, graves at Sindos and the Odrysian kingdom do not witness the same funerary "idiom." Equally distinct "idioms" were articulated through the lavishly equipped graves that have come to light in modern FYROM, such as the ones at Trebenishte, the earliest among which date from the end of the sixth century.[28] While the populations that lived in the region of lake Ohrid have been tentatively identified as Illyrians or Pelagonians,[29] the rich burials found in the Gevgelija Valley, for example, at Bišov Javor, have been associated with Paeonians.[30]

By far the closest parallels to the Sindos burials are found in the Macedonian kingdom, especially at Vergina and Archon-

Fig. 8. Local jug with cut-away neck from Grave 66 at Sindos, ca. 540–530 B.C.E.; ht. 15 cm (adapted from Vokotopoulou et al. 1985, cat. no. 361 © Hellenic Ministry of Culture – Archaeological Receipts Fund).

tiko.[31] Burials at these sites, as a rule single inhumations in pit graves, were outfitted with goods from the same regional, southern and eastern Greek workshops that provided Sindos. Most importantly, the funerary consumption of these goods seems to have followed the exact same patterns as those described with regard to Sindos. Interestingly, the suite of artifacts and practices shared by Vergina, Archontiko, and Sindos does not occur at Macedonian sites until ca. 570. At Vergina and Archontiko, archaic burials performed before and after that time form two distinctive groups that are marked by some striking differences. Just like their successors, graves of the early group betray gender and vertical differentiations, the construction of which involved the manipulation of weapons, jewelry, and garment accessories; nevertheless, their weapons were exclusively offensive and their metal ornaments made mainly of bronze.[32] Furthermore, before 570 imported goods of any sort had a negligible presence and vases were assigned no diacritical function. Most graves contained a drinking cup, alone or with a jug, but all vases were locally produced and

Fig. 9. Miniature iron table and chair from Grave 25 at Sindos, ca. 540 B.C.E.; chair ht. 11 cm, table ht. 10 cm (adapted from Vokotopoulou et al. 1985, cat. nos. 276–277 © Hellenic Ministry of Culture – Archaeological Receipts Fund).

Fig. 10. Miniature iron spits and firedogs from Grave 25 at Sindos, ca. 540 B.C.E.; spits length 26.5 cm, firedogs ht. 7.5 cm (Vokotopoulou et al. 1985, cat. nos. 278–279 © Hellenic Ministry of Culture – Archaeological Receipts Fund).

often handmade. Thus, from the second quarter of the sixth century B.C.E., burials at Vergina and Archontiko testify to a rather radical, even if partial, transformation of the material expressions of local funerary rituals. Significantly, within the same decade the Macedonian mortuary practices, in their new form, also appeared outside the core area of the kingdom at a number of sites to the east of the river Axios, such as Sindos.

From that time on, graves at Vergina, Archontiko, and Sindos received the same type of feasting equipment. The new feasting set incorporated clay vases from eastern and especially southern Greece. At the same time, local drinking forms were upgraded, as they were now exclusively wheelmade. Even if the quantity and sometimes also the quality of imported pottery tend to increase along with grave wealth, it is not imports that prevail at richer burials but metal vessels. The vast majority of these were locally produced after southern Greek models.[33] The repertoire of feasting accessories was further enhanced with iron tripods, miniature furniture and spits with firedogs, and flesh-hooks that, together with the sets of spits and knives, must have signified meat consumption. In

addition, some graves at Archontiko yielded bronze graters.[34] The funerary use of such items is of particular interest, since along with that of cauldrons, tripods, flesh-hooks, and spits, it evokes earlier practices from southern Greece that were no longer at work there in the Archaic period.[35] More precisely, such artifacts figure among the most common furnishings of southern Greek "heroic" burials of the Early Iron Age.[36] In fact, the similarities with such burials do not end here; aside from the inurned male cremations with ritually "killed" weapons at the so-called Royal Cluster Γ at Vergina,[37] I will briefly mention here the use of "exotica," antiques and ornamental golden sheets.[38]

The phenomenon of "heroic" burials has been associated with the process of formation of a cultural memory of the Greek past, which seems to have begun already in the immediate postpalatial period.[39] Within the frame of this process, "heroic" burials appear to have functioned as a strategy employed by various elite groups with the aim of legitimating their claims to power, by embodying their own connection to the past into ritual practice. To this purpose, the devising of "heroic" burials involved the selective appropriation of archaizing practices and material forms drawing, on the one hand, upon actual relics of the past, and, on the other hand, upon oral, poetic traditions. To be sure, by the Archaic period, excessive mortuary display was no longer practiced in southern Greece;[40] however, the idea of "heroic" burials persisted[41] and some of their earlier material components continued to be offered at sanctuaries.[42] Poetic traditions and ritual practices, which both fed off and reinforced the "memory" of a Greek heroic past, must have reached the north before the end of the Early Iron Age, along with Greek settlers especially from Euboea.[43] The processes through which they infiltrated the Macedonian kingdom remain uncertain, as does the precise time when this happened.[44] Regardless, by the sixth century B.C.E., Macedonians were familiar both with "heroic" burial practices and with the narratives on which these were predicated. In this respect, it is very telling that some of the most emblematic artefacts they offered to their dead carried scenes from myth and even from the Homeric epics.[45] At this point, three main questions arise: a) in what ways could the Macedonians have related themselves to a Greek heroic past? b) why would they have decided to incorporate symbolic references to this past into their funer-

ary rites? and c) why would they have begun to do so at this particular moment?

According to literary sources, the Macedonian dynasty claimed descent from Temenos, the Herakleid king of Argos.[46] It is true that this myth is only recorded for the first time by Herodotus (8.136–139) with regard to the early fifth century; however, a recent analysis of the Herodotean passage has shown that its source must have lain in a long existing folklore oral tradition.[47] If such a tradition had been established by the second quarter of the sixth century, then the "heroic" elements introduced at that time in funerary rites could have aimed to promulgate the genealogical claims of the Macedonian ruler. Still, as stated earlier in this paper, neither "heroic" elements nor any other practice or type of grave good were reserved for more elaborate burials. Apparently the symbolic meanings embedded in grave goods were open to appropriation by all members of the burying group, which undoubtedly extended beyond the ruling elites of the kingdom.[48] In other words, while the new Macedonian mortuary practices offered a venue for the articulation of vertical social differentiations, at the same time they appear to have fostered some sort of bond of affiliation that transcended status, gender, and largely age. The nature of this bond is well illustrated by the new set of feasting equipment.

The configuration of this set involved the "mixing of genealogies and origins of things" that, as C. Antonaccio has nicely demonstrated, "makes the discourse of things inherently ethnic."[49] The new Macedonian funerary feasting set combined local forms, which were emphatically upgraded, together with selectively appropriated forms and artifacts that signalled links not only with archaic Greece, but also with the age of Greek heroes. Thus, if this set objectified the partial cultural difference between sixth-century Macedonians and contemporary Greeks of the east and the south, it must have also embodied the belief of a common descent shared with these peoples. Accordingly, rather than proclaiming a specifically heroic Argive origin, which was restricted to the royal house,[50] "heroic" elements in graves, in interaction with archaic local and imported forms, must have served the symbolic representation of the way that Macedonians of that time perceived their own Greekness.[51] The question that remains to be answered pertains to the reason why the introduction of this feasting set, which formed part

of a broader funerary change, would have taken place in that particular period.

The key to the answer seems to lie in the roughly simultaneous appearance of the same funerary practices at a group of sites to the east of Axios, including Sindos. Located on the strip of land around the head of the Thermaic gulf and down to the Anthemous Valley, these sites are not believed to have become part of the Macedonian kingdom until the late sixth or the early fifth century.[52] Nevertheless, it is hard to accept that different populations, with different cultural traditions and conflicting interests, would have shared the same funerary ideology; indeed, the comparative study of cemeteries of Greek, Thracian, and possible Illyrian and Paeonian settlements in the north has revealed conspicuous differences. It is equally hard to accept that different funerary ideologies would have found identical material manifestations. Therefore, the only reasonable explanation for the close similarities on the two sides of Axios is that Macedonians themselves had crossed this river at an earlier date, most probably shortly before 570 B.C.E.[53] If this were the case, then the shift noted in funerary practices on both sides of the river at that time would have been elicited precisely by the annexation of the aforementioned region. Entailing a series of transformations in the economic, social, and political structures of the kingdom, a territorial expansion would have created, among other things, the imperative for the forging of a new ideology that would legitimate royal authority. Given the power of ritual as hegemonic apparatus, the promotion of such an ideology through mortuary reform would be hardly surprising.[54] It must not be coincidental that the reform introduced around 570 B.C.E. placed a particular emphasis on identity bonds between the Macedonian people. At the same time, the new practices advertised the military power of the kingdom and its newly accumulated wealth, along with the control it held over long-distance trade and natural resources (especially metal ores). There is little doubt that such statements would have also addressed the close or more distant neighbors of the kingdom, its potential enemies and allies.

In the light of the above, the krater from Grave 66 at Sindos should be understood as part of an eclectic feasting set, which signified, on the one hand, the status ascribed to the dead boy and, on the other hand, his cultural and ethnic identity. The material remains of this and other Macedonian burials sug-

gest that, unlike what is true for example of archaic Athens,[55] in this region funerary rites were little informed by concepts of childhood. Of course, our knowledge of such concepts or the processes of child socialization in the archaic Macedonian kingdom is very limited. Nonetheless, it appears that while very young infants received no offerings at all, a child at the age of five was considered old enough to be buried as an adult member of the community. In the case of Grave 66, the boy was ritually transformed into a Macedonian warrior.[56] The decoration of the krater with a warrior departure scene could have affected the selection of this vase for the rite of the boy's own departure. Still, it must be stressed that, at least at Archontiko, which has yielded a larger quantity of decorated pottery, sympotic shapes with male-gendered scenes also appear in female burials.[57] The priority accorded to shape over decoration is further suggested by the frequent presence, in Macedonian graves, of column kraters from the workshop of Lydos that depict only animals.[58] The large numbers of kraters from that particular workshop that have come to light at Macedonian sites may actually suggest directional trade practices. Such practices would have been initiated after the expansion of the kingdom, in part to meet the ensuing new needs of the local mortuary rites.

Notes

This research is supported by a postdoctoral fellowship by the Fonds de la Recherche Scientifique – FNRS. For a more thorough presentation of its first results, as well as for extensive bibliography, the reader is referred to Saripanidi forthcoming. I would like to thank M. Stansbury-O'Donnell, T. Carpenter, and E. Langridge-Noti for inviting me to participate both in the 116th Annual Meeting of the Archaeological Institute of America and this volume. I am particularly indebted to M. Stansbury-O'Donnell for his insightful comments and considerable improvement of the manuscript. For their helpful suggestions I would also like to thank C. Neeft and the two anonymous reviewers. Finally, I wish to thank N. Bloch and A. Stoll for their precious help in preparing the map and the photographs presented in this article.

[1] Tiverios 2008, esp. 1–17; Papadopoulos 2011, esp. 122–24.

[2] Hammond 1972, 276, 407–41. This and most other scholars date the foundation of this kingdom within the first half of the seventh century; see, e.g., Borza 1992, 58–76, 84; Mallios 2011, 115–22. Recently Pabst (2009, 31–45) proposed a much earlier date, at the beginning of the tenth century.

[3] For an overview of Attic decorated pottery found in Macedonia, see Tiverios 2012.

[4] Gimatzidis 2010, esp. 50–54, with bibliography.

[5] Vokotopoulou et al. 1985. For the complete publication of the site, see Despoini forthcoming a and b; Despoini et al. forthcoming.

[6] Vokotopoulou et al. 1985, cat. no. 372. On the painter, see Beazley, *ABV*, 123–29, 685, 714; *Paralipomena*, 50–53, 518; *Beazley Addenda*, 34.

[7] Spieß 1992, 141–59. On the frequent repetition of this theme particularly by the Painter of Louvre F6, see Connor 1981.

[8] These estimates do not take into acount vases with scenes that are not identifiable with certainty.

[9] *BAPD*, no. 15185.

[10] Vokotopoulou et al. 1985, cat. nos. 359–72; Despoini (forthcoming a). J. Musgrave, who examined the skeletal remains from this site, did not determine the biological sex of children. However, since adult burials attest a correspondence between gendered grave goods and the sex of the deceased, the excavator identified the sex of children on the basis of their gendered goods.

[11] Knives are, of course, connected with various spheres of action (e.g., warfare, agriculture). In the case of Sindos, the pattern of their deposition strongly suggests that knives functioned primarily as feasting utensils in their signification; see Saripanidi forthcoming.

[12] Out of the 52 archaic graves, only half were found undisturbed. Among these, only Grave 101B did not yield any feasting accessories; but this grave belonged to a neonate and was completely unfurnished; see n. 16.

[13] This version was found only at five of the 25 undisturbed burials.

[14] On this grave, see Vokotopoulou et al. 1985, cat. nos. 181–199, 243–281; Despoini forthcoming a.

[15] The only exception is the multiprong hook, which occurs only at male burials; see Despoini forthcoming b.

[16] At this site, which received only part of the population of Sindos, only 15% of the archaic burials belonged to children. Very young infants, in particular, are even more underrepresented; see Despoini forthcoming a. On the existing evidence, there appears to be a difference from Greek practices, in that the latter a) did not exclude very young infants from receiving offerings and, b) they often involved the use of separate burial sites for children; see Dasen 2010, 22–24. This was the case, for instance, with the Clazomenian colony at Abdera; see Skarlatidou 2010.

[17] At Sindos, inhumation was almost universally practiced; see Despoini forthcoming a.

[18] Pilz 2011.

[19] Despoini forthcoming a and b.

[20] In general, cist graves were more lavishly equipped than sarcophagi and these were wealthier than pit graves.

[21] Despoini 2009, 30–43, 44–47; 2011a, 340–41.

[22] Tomlinson 1993.

[23] See, e.g., Bouzek and Ondřejová 1988, 85; Hatzopoulos 1996, 107 n. 4, 173; Theodossiev 2000, 191–92.

[24] Saripanidi forthcoming.

[25] Clazomenian Abdera: Kallintzi 2004, 271–74, 276–79; Skarlatidou 2010. Akanthos: Kaltsas 1998.

[26] Mikro Doukato: Triantaphyllos 1983; Gazoros: Poulios 1995.

[27] Archibald 1998, 158–66, 168–69, 171–74, 177–209, 240–51; see also Bouzek and Ondřejová 1988.

[28] Stibbe 2003, with bibliography.

[29] Bouzek and Ondřejová 1988, 84; Theodossiev 2000, 177–85.

[30] Husenovski and Slamkov 2005, 23–24.

[31] Vergina: Kottaridi 2001, 2009, 2012. Archontiko: Chrysostomou and Chrysostomou 2009, 478–87; 2012, with bibliography.

[32] Vergina: Bräuning and Kilian-Dirlmeier 2013. Archontiko: Chrysostomou and Chrysostomou 2009, 477, 479.

[33] Despoini et al. forthcoming. On the presence of a few metal feasting accessories of Achaemenid inspiration, see Saripanidi forthcoming.

[34] Chrysostomou and Chrysostomou 2009, 481.

[35] On the presence of such artefacts in the Homeric poems and the archaeological record of Late Bronze and Early Iron Age Greece, see Sherratt 2004, with bibliography.

[36] See mainly Morris 1999; Antonaccio 2006, 388–94.

[37] Kottaridi 2001, 359–61.

[38] For a thorough discussion of archaic Macedonian burials with relation to the phenomena of "heroic" and "princely" graves, see Saripanidi forthcoming.

[39] Maran 2011; Antonaccio 2006.

[40] Though exceptionally wealthy "heroic" burials continued to appear in Cyprus; see, e.g., Rupp 1988

[41] For later "heroic" burials that, in much more modest forms and not without breaks, continued down to the Hellenistic period, see, e.g., Guggisberg 2008.

[42] Such artifacts are also found at Greek sanctuaries in the northern Aegean. For iron spits from the sanctuaries of Poseidon and Apollo at Mende and Zone, respectively, see Moschonissioti 2012, 387; Archibald 2013, 178.

[43] On Euboean presence in the north, see more recently Tiverios 2008, esp. 1–17; 2013; Papadopoulos 2011.

[44] On these issues, see Saripanidi forthcoming.

[45] Kottaridi 2012, 425 no. 1, 430 no. 14 (golden diadem and garment ornaments); Chrysostomou and Chrysostomou 2012, 499, 516, fig. 6; Despoini 2011b (bronze shield bands).

[46] Mallios 2011, 179–277.

[47] Mallios 2011, 181–87, 197, 205–10, 212–14.

[48] At Archontiko, for instance, so far there have been found 474 graves from the Archaic period; see Chrysostomou and Chrysostomou 2012, 491; see also Archibald 2013, 316; contra Despoini 2009, 51–53.

[49] Antonaccio 2009.

[50] On the genealogical myths of the Macedonian people, which date already from the Archaic period and connect their eponymous ancestor, Makedon, with Hellen, see Mallios 2011, 97–175.

[51] On the long-held debates over the Greekness (or non) of Macedonians, which have been largely based on essentialist and ahistorical concepts of ethnicity, see Mallios 2011, 109–22, with bibliography. On the contextual contingency of ethnic identity manifestations, see Jones 2007, esp. 48–53.

[52] Borza 1992, 84–89, 100; Hatzopoulos 1996, 171–72; Despoini 2009, 38 with. 138, 44 with n. 196, for extensive bibliography.

[53] An earlier date was also suggested by Andronikos (1987–1990, 32–33) and Tiverios (1991, 242–43), though the latter scholar proposed a date around 700 B.C.E.

[54] Dietler 1999, 135–37.

[55] Houby-Nielsen 2000.

[56] On the transformative effects of funerary rites on social identities, see Fowler 2013.

[57] See, e.g., Chrysostomou and Chrysostomou 2002, 468–69 (Grave 234), 475 fig. 6.

[58] The cemetery at Agia Paraskevi, for instance, has yielded over 20 examples; see *CVA* Thessaloniki 1, 13–25, pls. 1–30, where some of these vases are considered to be local products. For the refutation of this view, see Tiverios 2012, 47.

References

Andronikos, M. 1987–1990. "Πρῶτες σκέψεις για τα τελευταία ευρήματα της Βεργίνας." Θρακική Επετηρίδα 7:25–34.

Antonaccio, C. 2006. "Religion, *Basileis* and Heroes." In *Ancient Greece: From the Mycenaean Palaces to the Age of Homer*, edited by S. Deger-Jalkotzy and I. S. Lemos, 381–95. Edinburgh Leventis Studies 3. Edinburgh: Edinburgh University Press.

———. 2009. "(Re)defining Ethnicity: Culture, Material Culture, and Identity." In *Material Culture and Social Identities in the Ancient World*, edited by S. Hales and T. Hodos, 32–53. Cambridge and New York: Cambridge University Press.

Archibald, Z. 1998. *The Odrysian Kingdom of Thrace: Orpheus Unmasked*. Oxford: Clarendon.

———. 2013. *Ancient Economies of the Northern Aegean: Fifth to First Centuries BC*. Oxford: Oxford University Press.

Borza, E. 1992. *In the Shadow of Olympus: The Emergence of Macedon*. 2nd ed. Princeton: Princeton University Press.

Bouzek, J., and I. Ondřejová. 1988. "Sindos-Trebenishte-Duvanli. Interrelations between Thrace, Macedonia, and Greece in the 6th and 5th Centuries BC." *MeditArch* 1:84–94.

Bräuning, A., and I. Kilian-Dirlmeier. 2013. *Die eisenzeitlichen Grabhügel von Vergina: Die Ausgrabungen von Photis Petsas 1960–1961*. Monographien des Römisch-Germanischen Zentralmuseums 119. Mainz: Verlag des Römisch-Germanischen Zentralmuseums.

Chrysostomou, A., and P. Chrysostomou. 2002. "Ανασκαφή στη δυτική νεκρόπολη του Αρχοντικού Πέλλας κατά το 2002." Το Αρχαιολογικό Έργο στη Μακεδονία και στη Θράκη 16:465–78.

———. 2009. "Τα νεκροταφεία του αρχαίου οικισμού στο Αρχοντικό Πέλλας." In Το Αρχαιολογικό Έργο στη Μακεδονία και στη Θράκη: 20 χρόνια, επετειακός τόμος, edited by P. Adam-Veleni and K. Tzanavari, 477–90. Thessaloniki: Greek Ministry of Culture and Tourism and Aristotle University of Thessaloniki.

———. 2012. "The 'Gold-Wearing' Archaic Macedonians from the Western Cemetery of Archontiko, Pella." In *Threpteria: Studies on Ancient Macedonia*, edited by M. Tiverios, P. Nigdelis and P. Adam-Veleni, 490–517. Thessaloniki: Aristotle University of Thessaloniki.

Connor, P.J. 1981. "Replicas in Greek Vase-Painting: The Work of the Painter of Louvre F6." *BABesch* 56:37–44.

Dasen, V. 2010. "Archéologie funéraire et histoire de l'enfance dans l'antiquité: nouveaux enjeux, nouvelles perspectives." In *L'Enfant et la mort dans l'Antiquité*. Vol. 1, *Nouvelles recherches dans les nécropoles grecques. Le signalement des tombes d'enfants: Actes de la table ronde internationale organisée à Athènes, École française d'Athènes, 29–30 mai 2008*, edited by A.-M. Guimier-Sorbets and Y. Morizot, 19–44. Travaux de la Maison René-Ginouvès 12. Paris: de Boccard.

Despoini, A. 2009. "Gold Funerary Masks." *AntK* 52:20–65.

———. 2011a. "Κτερίσματα και νεκρικές δοξασίες. Οι μαρτυρίες των τάφων της Σίνδου." In Νάματα: Τιμητικός τόμος για τον καθηγητή Δημήτριο Παντερμαλή, edited by S. Pingiatoglou and T. Stefanidou-Tiveriou, 335–43. Thessaloniki: University Studio Press.

———. 2011b. "Μύθοι ηρώων σε όχανα ασπίδων της Σίνδου." In Έπαινος *Luigi Beschi*, edited by A. Delivorrias, G. Despinis and A. Zarkadas, 95–106. Μουσείο Μπενάκη, Παράρτημα 7. Athens: Benaki Museum.

———. Forthcoming a. Σίνδος, Το Νεκροταφείο: Ανασκαφικές Έρευνες 1980–1982. Vol. 1, Οι τάφοι, τα ταφικά έθιμα, το σκελετικό υλικό. Athens: The Archaeological Society at Athens.

———. Forthcoming b. Σίνδος, Το Νεκροταφείο: Ανασκαφικές Έρευνες 1980–1982. Vol. 3, Μάσκες και χρυσά ελάσματα, κοσμήματα, μικροαντικείμενα, είδη οπλισμού. Athens: The Archaeological Society at Athens.

Despoini, A., A. Liampi, V. Misailidou-Despotidou, V. Saripanidi,

and M. Tiverios. Forthcoming. Σίνδος, Το Νεκροταφείο: Ανασκαφικές Έρευνες 1980–1982. Vol. 2, Πήλινα, γυάλινα και φαγεντιανά αγγεία, πήλινοι λύχνοι, μεταλλικά αγγεία, πήλινα ειδώλια και πλαστικά αγγεία, νομίσματα. Athens: The Archaeological Society at Athens.

Dietler, M. 1999. "Rituals of Commensality and the Politics of State Formation in the 'Princely' Societies of Early Iron Age Europe." In *Les Princes de la Protohistoire et l'émergence de l'état: Actes de la table ronde internationale organisée par le Centre Jean Bérard et l'École Française de Rome, Naples, 27–29 octobre 1994,* edited by P. Ruby, 135–52. Collection du Centre Jean Bérard 17, Collection de l'École Française de Rome 252. Naples and Rome: Centre Jean Bérard and École Française de Rome.

Fowler, C. 2013. "Identities in Transformation: Identities, Funerary Rites, and the Mortuary Process." In *The Oxford Handbook of the Archaeology of Death and Burial,* edited by S. Tarlow and L. Nilsson Stutz, 511–26. Oxford: Oxford University Press.

Gimatzidis, S. 2010. *Die Stadt Sindos: Eine Siedlung von der späten Bronze- bis zur klassischen Zeit am Thermaischen Golf in Makedonien.* Prähistorische Archäologie in Südosteuropa 26. Rahden: Leidorf.

Guggisberg, M. 2008. "Gräber von Bürgern und Heroen: 'Homerische' Bestattungen im klassischen Athen." In *Körperinszenierung, Objektsammlung, Monumentalisierung: Totenritual und Grabkult in frühen Gesellschaften. Archäologische Quellen in kulturwissenschaftlicher Perspektive,* edited by C. Kümmel, B. Schweizer, and U. Veit, 287–317. Tübinger archäologische Taschenbücher 6. Münster: Waxmann.

Hammond, N.G.L. 1972. *A History of Macedonia.* Vol. 1. Oxford: Clarendon.

Hatzopoulos, M.B. 1996. *Macedonian Institutions under the Kings.* Vol. 1: *A Historical and Epigraphic Study.* Μελετήματα 22. Athens and Paris: Centre for Greek and Roman Antiquity.

Houby-Nielsen, S. 2000. "Child Burials in Ancient Athens." In *Children and Material Culture,* edited J. Sofaer Derevenski, 151–66. London: Routledge.

Husenovski, B., and E. Slamkov. 2005. *Guide to the Permanent Archaeological Exhibition 'Vardarski Rid and the Adjacent Sites.'* Gevgelija: Museum of Gevgelija.

Jones, S. 2007. "Discourses of Identity in the Interpretation of the Past." In *The Archaeology of Identities: A Reader,* edited by T. Insoll, 44–58. New York: Routledge.

Kallintzi, K. 2004. "Abdera: Organization and Utilization of the Area *Extra Muros.*" In *Klazomenai, Teos and Abdera. Metropoleis and Colony: Proceedings of the International Sym-*

posium Held at the Archaeological Museum of Abdera, 20–21 October 2001, edited by A. Moustaka, E. Skarlatidou, M.-C. Tzannes, and Y.E. Ersoy, 271–89. Thessaloniki: 19th Ephorate of Prehistoric and Classical Antiquities.

Kaltsas, N.E. 1998. Άκανθος. Vol. 1: Η ανασκαφή στο νεκροταφείο κατά το 1979. Δημοσιεύματα του Αρχαιολογικού Δελτίου 65. Athens: Hellenic Ministry of Culture.

Kottaridi, A. 2001. "Το έθιμο της καύσης και οι Μακεδόνες. Σκέψεις με αφορμή τα ευρήματα της νεκρόπολης των Αιγών." In Καύσεις στην Εποχή του Χαλκού και την πρώιμη Εποχή του Σιδήρου, edited by N.C. Stampolidis, 359–71. Athens: University of Crete and 22nd Ephorate of Prehistoric and Classical Antiquities.

———. 2009. "Η νεκρόπολη των Αιγών στα αρχαϊκά χρόνια και οι βασιλικές ταφικές συστάδες." In Το Αρχαιολογικό Έργο στη Μακεδονία και στη Θράκη: 20 χρόνια, επετειακός τόμος, edited by P. Adam-Veleni and K. Tzanavari, 143–53. Thessaloniki: Greek Ministry of Culture and Tourism and Aristotle University of Thessaloniki.

———. 2012. "The Lady of Aigai." In *'Princesses' of the Mediterranean in the Dawn of History*, edited by N.C. Stampolidis and M. Giannopoulou, 412–33. Athens: Museum of Cycladic Art.

Mallios, G. 2011. "Μύθος και Ιστορία: Η περίπτωση της αρχαίας Μακεδονίας." Ph.D. diss., Aristotle University of Thessaloniki.

Maran, J. 2011. "Coming to Terms with the Past: Ideology and Power in Late Helladic IIIC." In *Ancient Greece: From the Mycenaean Palaces to the Age of Homer*, edited by S. Deger-Jalkotzy and I.S. Lemos, 123–50. Edinburgh Leventis Studies 3. Edinburgh: Edinburgh University Press.

Morris, I. 1999. "Iron Age Greece and the Meanings of 'Princely Tombs.'" In *Les Princes de la Protohistoire et l'émergence de l'état: Actes de la table ronde internationale organisée par le Centre Jean Bérard et l'École Française de Rome, Naples, 27–29 octobre 1994*, edited by P. Ruby, 57–80. Collection du Centre Jean Bérard 17, Collection de l'École Française de Rome 252. Naples and Rome: Centre Jean Bérard and École Française de Rome.

Moschonissioti, S. 2012. "Αρχαϊκή κεραμική από το ιερό του Ποσειδώνα στο Ποσείδι της Χαλκιδικής." In *Archaic Pottery of the Northern Aegean and Its Periphery (700–480 BC): Proceedings of the Archaeological Meeting, Thessaloniki, 19–22 May 2011*, edited by M. Tiverios, V. Misailidou-Despotidou, E. Manakidou, and A. Arvanitaki, 385–98. Δημοσιεύματα Αρχαιολογικού Ινστιτούτου

Μακεδονικών και Θρακικών Σπουδών 11. Thessaloniki: Archaeological Institute of Macedonian and Thracians Studies and Aristotle University of Thessaloniki.

Pabst, S. 2009. "Bevölkerungsbewegungen auf der Balkanhalbinsel am Beginn der Früheisenzeit und die Frage der Ethnogenese der Makedonen," *JdI* 124:1–74.

Papadopoulos, J.K. 2011. "'Phantom Euboians'—A Decade On." In *Euboea and Athens: Proceedings of a Colloquium in Memory of Malcolm B. Wallace, Athens, 26–27 June 2009*, edited by D.W. Rupp and J.E. Tomlinson, 113–33. Publications of the Canadian Institute in Greece 6. Athens: The Canadian Institute in Greece.

Pilz, O. 2011. "The Use of Small Things and the Semiotics of Greek Miniature Objects." *Pallas: Révue d'Études Antiques* 86:15–30.

Poulios, V. 1995. "Σωστική ανασκαφή στο νεκροταφείο της αρχαίας Γαζώρου." Το Αρχαιολογικό Έργο στη Μακεδονία και στη Θράκη 9:411–22.

Rupp, W.D. 1988. "The 'Royal Tombs' at Salamis (Cyprus): Ideological Messages of Power and Authority." *JMA* 1:111–39.

Saripanidi, V. Forthcoming. "Constructing Continuities with a Heroic Past: Death, Feasting and Political Ideology in the Archaic Macedonian Kingdom." In *Beyond the Polis: Collective Rituals and the Construction of Social Identity in Early Iron Age and Archaic Greece*, edited by A. Tsingarida and I. Lemos. Kernos Suppl. Brussels: Université libre de Bruxelles.

Sherratt, S. 2004. "Feasting in Homeric Epic." *Hesperia* 73:301–37.

Skarlatidou, E.K. 2010. Το αρχαϊκό νεκροταφείο των Αβδήρων: Συμβολή στην έρευνα της αποικίας των Κλαζομενίων στα Άβδηρα. Δημοσιεύματα Αρχαιολογικού Ινστιτούτου Μακεδονικών και Θρακικών Σπουδών 9. Thessaloniki: Archaeological Institute of Macedonian and Thracian Studies.

Spieß, A.B. 1992. *Der Kriegerabschied auf attischen Vasen der archaischen Zeit*. Europäische Hochschulschriften 39. Frankfurt: Lang.

Stibbe, C.M. 2003. *Trebenishte: The Fortunes of an Unusual Excavation*. StArch 121. Rome: "L'Erma" di Bretschneider.

Theodossiev, N. 2000. "The Dead with Golden Faces II. Other Evidence and Connections." *OJA* 19:175–210.

Tiverios, M. 1991. "Αρχαιολογικές έρευνες στη Διπλή Τράπεζα της Αγχιάλου (Σίνδος) κατά το 1991." Το Αρχαιολογικό Έργο στη Μακεδονία και στη Θράκη 5:235–46.

———. 2008. "Greek Colonisation of the Northern Aegean." In *Greek Colonisation: An Account of Greek Colonies and Other Settlements Overseas*. Vol. 2, edited by G.R. Tsetskhladze, 1–154. Mnemosyne Suppl. 193.2. Leiden: Brill.

———. 2012. "Αττικά αγγεία πολυτελείας στη Μακεδονία."

In *Archaic Pottery of the Northern Aegean and Its Periphery (700–480 BC): Proceedings of the Archaeological Meeting, Thessaloniki, 19–22 May 2011*, edited by M. Tiverios, V. Misailidou-Despotidou, E. Manakidou, and A. Arvanitaki, 39–52. Δημοσιεύματα Αρχαιολογικού Ινστιτούτου Μακεδονικών και Θρακικών Σπουδών 11. Thessaloniki: Archaeological Institute of Macedonian and Thracians Studies and Aristotle University of Thessaloniki.

———. 2013. "The Presence of Euboeans in the North Helladic Region and the Myths of Heracles." In *Studies in Ancient Art and Civilization*, vol. 17, edited by J. Bodzek, 97–110. Krakow: Jagiellonian University.

Tomlinson, R. 1993. "Furniture in the Macedonian Tombs." In *Ancient Macedonia. Vol. 5.3: Papers Read at the Fifth International Symposium, Thessaloniki, 10–15 October 1989*: 1495–99. Institute for Balkan Studies 240. Thessaloniki: Institute for Balkan Studies.

Triantaphyllos, D. 1983. "Αρχαϊκό νεκροταφείο στη δυτική Θράκη." In *Atti del convegno internazionale 'Grecia, Italia e Sicilia nell'VIII e VII sec. A.C.', Atene, 15–20 ottobre 1979*. Vol. 3. *ASAtene* 61:179–207.

Vokotopoulou, I. 1996. *Guide to the Archaeological Museum of Thessalonike*. Athens: Kapon.

Vokotopoulou, I., A. Despoini, V. Misailidou, and M. Tiverios. 1985. Σίνδος: Κατάλογος της έκθεσης στο Αρχαιολογικό Μουσείο Θεσσαλονίκης. Athens: Archaeological Receipts Fund.

Trademarks and the Dynamic Image: A Step to Visualizing Patterns in Imagery Movement from Athens to Etruria

Tara M. Trahey

Abstract

The figured vase trade between ancient Athens and the Etruscan city of Vulci during the sixth century B.C.E. involved a complex arrangement of local and external networks that transmitted both physical material and cultural ideologies. This paper aims to visualize these relationships through a case study stemming from provenance research on twin Attic black-figure vases showing a "woman riding a bull." I explore why ancient Athenian vase painters made particular choices in subject matter. I use iconography, rather than traditional economic data, to construct our understanding of the ancient historical economic network between Athens and Vulci. Iconographic decision making within Attic workshops depended upon influences from both Athens and Vulci. I use the web-based visualization platforms, Palladio and RAW, and an expanded data set of 86 vases with like iconography to create a set of network visualizations that explore how and why particular choices in subject matter were made. Connectivity is visualized between attributed hand, destination, and trademarks. From the visualizations, I argue that the identity of the woman on the bull is purposefully ambiguous and I demonstrate the cultural and economic reasons why such ambiguity was advantageous for the ancient pottery industry. Ultimately, the case study of the "woman riding a bull" presents an organization and visualization of a complex set of interactions, local and external. Through the use of network visualizations, the traditional established considerations for discussing iconography may be reevaluated in the context of visualizing the dynamic trade network of the sixth century B.C.E.

A STUDY OF AN UNEXCEPTIONAL DEPICTION OF A WOMAN riding on the back of a bull that appears on nearly 90 Attic black-figure vases demonstrates ways that new technologies allow us to reconsider the interactions between participants in the distribution networks of Attic figure-decorated pottery:

producers, traders and consumers. A recognition of these interactions, in turn, allows us to see how images can reflect the impact that each of the participants can have on the others.

We may begin by considering the connection between a vase at Duke University (fig. 1) and its "twin" at the University of California, Berkeley (fig. 2).[1] The style and iconography of the two vases is almost identical, though the subject matter has been identified differently in both cases. Both vases depict a woman riding a bull sidesaddle on each side. The scenes differ only in the placement of the woman's hand, either over the horn or raised. The woman has been variously identified in modern scholarship as either Europa or a maenad, though surrounded by grape vines in both cases. The placement of the woman's hand over the horn of the bull led to scholars' identification of her as Europa, abducted by Zeus.[2] However, the display of the grapes and vines, indicative of Dionysos, established her identity for other scholars as a maenad.[3]

The uncertain identification of the subject is further emphasized through another stylistically similar composition of a woman with wings riding a bull, also surrounded by grape vines (fig. 3).[4] Motivated by the ambiguity of the images, I located vases with this composition of a female figure riding a bull among grape vines, producing a data set of 86 vases of various shapes, all produced in Athens between 550–475 B.C.E.[5] As will be discussed later in detail, the majority of the vases depicting this image, when the findspot was known, were found in Etruria, with the highest concentration in the ancient city of Vulci. However, only one example among the 86 vases, a neck amphora in Würzburg, bears an inscription within the scene itself, identifying the woman as Europa (fig. 4).[6] If only one vase out of the entire data set was labeled, what could be said for the intended "meaning" of the others?[7] Since the labeled image is without vines, unlike the Duke and Berkeley amphorae, does the identification as Europa apply to them?

Fig. 3. Attic Neck Amphora attributed to Group of Copenhagen 114, ca. 500 B.C.E.; 44.13 cm. Los Angeles County Museum of Art, William Randolph Hearst Collection, 50.8.22 (photo museum).

Traditional studies of vase iconography have argued in favor of the particular and unchanging identification of a scene and its characters, by privileging an Athenian viewpoint and situating the interpretation of the image within a single culture.[8] The exploration that follows in this paper will not provide a list of speculations regarding how we *should* identify the woman, as either Europa or a maenad. Rather, it will examine the points of interaction within the export channel between Athens and Vulci that would have informed the image's creation, reception, and perceived meaning. By examining the image of the woman riding a bull alongside the corresponding trademark data for the vases, I will show that the study of vase iconography calls for a more nuanced understanding of the creation and reception of particular imagery. By using digital tools to visualize the relationships within the export market of figured pottery, I will demonstrate the possibilities

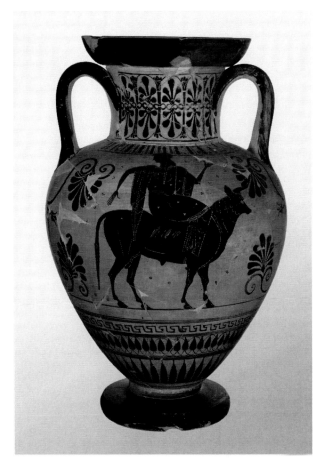

Fig. 4. Attic Neck Amphora, ca. 525–500 B.C.E.; 46 cm. Würzburg, Martin von Wagner Museum der Universität Würzburg, L193 (© Martin von Wagner Museum der Universität Würzburg, photo P. Neckermann, respectively E. Oehrlein).

of contextualizing iconography through modern technology, as a means of developing the postcolonial narrative of the Attic pottery trade. I will argue that, as a product of the conversation between Athens and Vulci in the sixth century B.C.E., this image of the woman on the bull might have been created as purposefully ambiguous, rather than situated with a single fixed meaning or interpretation.

Some recent analyses of figured pottery, particularly of pottery involved in an export market, consider the possibility of an image being intentionally created with, or acquiring, a "fluid" meaning—in other words, a meaning that might fluctuate through time and space, depending upon both its creators and consumers. In her 2013 article featuring three case studies of Attic pots related to the Eucharides Painter, Elizabeth Langridge-Noti describes the images on three col-

umn-kraters from Spina as "deliberately vague."[9] Investigating the depictions of courtship and pursuit scenes, she suggests that the producer of the scenes likely had some knowledge of his market, and thus created scenes that might have been understood differently in an Etruscan, rather than Greek, mythological context. Her argument that a pot, and thus its iconography, is ascribed a fluctuating meaning that reinforces identities within receptive communities, has served as a model for my examination of the iconography of the woman on a bull, as it suggests that the ancient interpretation of imagery on Attic vases was not constrained by or restricted to Athenian ideologies.[10]

My approach, like that of Langridge-Noti, is part of a larger "postcolonial" methodology that reassesses modern scholarship's understanding of the relationship between the Greeks and the Etruscans.[11] In recent scholarship, arguments have been put forward to challenge Greek maritime hegemony, to reexamine the defined sense of "Greekness," and to deconstruct the overall concept of Hellenization.[12] This newly developed examination of the ancient Mediterranean largely parallels the more refined considerations of cultural systems elsewhere, such as Thomas's study of European trading contacts in the South Pacific and Comaroff's study of British missionaries in South Africa; both deemphasize emulation in favor of interaction and conjunction.[13]

In the case study of an ambiguous woman riding a bull, the woman's identity might be interpreted within a "Middle-Ground," a term first coined by Richard White to describe seventeenth and eighteenth century colonization in the Great Lakes.[14] Middle Ground theory sought to understand and explain how "individuals of different cultural backgrounds reached accommodation and constructed a common, mutually comprehensible world."[15] Using Middle Ground theory to assess the image depicting a woman riding a bull, I argue that the identity of the woman would not have been "Athenian" or "Etruscan," but would have been appropriate in *both* contexts, changing meaning as it crossed cultural boundaries. The fairly recent recognition of Etruscan (rather than only Greek) influence in the trade between Athens and Etruria is due in large part to the greater foregrounding of the evidence of Etruscan traders' involvement and presence in the Hellenic world.[16] However, this case study, which analyzes the image depicting a woman riding a bull, considers the trade-

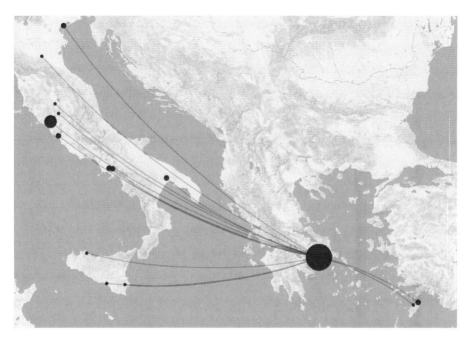

mark data in conjunction with a specific subject. Through the creation of diagrams to visualize the relationships between a particular image and its related trademarks, this study adds an unconventional and heretofore unexamined layer to the existing postcolonial narrative by illuminating the important, yet overlooked association between trademark and image production.

The visualization in figure 5 is created with Palladio, a web-based software developed by Stanford University to visualize multidimensional data; it maps all known findspots, representing 31 out of the 86 vases, depicting the image of a woman riding a bull.[17] Based on the surviving evidence, the map indicates that the vases with this image were mainly distributed within and around the Etruscan region, with the largest concentration in Vulci.[18] Because such evidence showed that the image of a woman riding a bull was involved primarily in an export market, I chose to interpret the image within a context of trade between Athens and Etruria.

Because of the lack of traditional economic data associated with the vase trade in the sixth century B.C.E., I maintain that it is necessary to consider the available iconographic evidence when exploring the market environment. By considering the roles of the producer and consumer equally, I find that an

Fig. 5. Map of 31 vases, with known provenance, depicting a woman riding a bull (map generated via Palladio, a project of Humanities + Design, a research lab at the Center for Spatial and Textual Analysis, Stanford University. Data © OpenStreetMap contributors. Licensed under the Open Data Commons Open Database License. Design © Mapbox. Licensed according to the Mapbox Terms of Service).

111

image with a fluid iconographical meaning might have been economically efficient for a local and export market system that traversed cultural boundaries. Additionally, by considering the relationships between producers and *traders*, which will be explored later in detail, I argue that this image of a woman riding a bull was settled within a system of thoughtful consumption and production.

Though economic studies have long favored consumption of staple goods rather than the trade of manufactured commodities such as vases, it can be argued that regardless of how one values pottery, ceramics are a primary form of material exchange.[19] To quote Zosia Archibald, "if ceramics are symptoms of exchange, then ceramic evidence charts aspects of human motivation, economic capacity, industrial organisation and transport, as well as reflecting the taste for particular products and commodities."[20] There is limited traditional economic data to support conjecture about the sixth century B.C.E. vase trade, largely because Greek cities only began to coin money in the mid-sixth century, providing a reference point for prices and trade.[21] Alan Johnston notes that it is not until 500–490 B.C.E. when fractions of obols are mentioned in a price inscription on the underfoot of a vase.[22] However, evidence from shipwrecks and legal documents does support the notion that ancient traders were aware of profitable strategies in export and were flexible in their trade to suit the changing needs of the market.[23] In her recent article entitled "Athenian Eye Cups in Context," Sheramy Bundrick presents the contents of the Pointe Lequin 1A shipwreck as evidence for such market awareness. Because the vessel contained such a large number of Type A eye cups, Bundrick argues the trader would not have invested in such a large inventory of a single type without an awareness of the particular demand for it.[24]

In the sixth century B.C.E., the relationship between Athens and Etruria strengthened as an accumulation of traders and migrant craftsmen, whose pattern of commercial exchange was likely first in metals, took the place of the aristocratic cultural sovereignty and gift exchange that had dominated in the earlier eighth century.[25] This growing trade fostered small mixed communities to form as points of contact at the Greek and Etruscan-inhabited ports of Gravisca and Pyrgi.[26] The economic success of pottery imports within the region is reflected in the increase of these imports by about 400% in the third quarter of the sixth century, and

again by the same factor in the last quarter.[27] The trade between Athens and Vulci in particular occurred during this very concentrated period of the sixth century B.C.E., [28] and collapsed around 474 B.C.E. when Greek activity in Etruscan ports declined as a result of the Battle of Cumae.[29] Indeed, 52% of Attic black-figure pottery found within Etruria and dated between 530 and 500 B.C.E. comes from Vulci alone.[30]

As such, the vase trade between the cities of Vulci and Athens is not one that should be generalized. Though particular and narrow examples of targeted markets for pottery export and import have been identified and studied, such as the representation of perizomata on Attic vases in Etruria, the vase imports at Vulci have largely been conceptualized in a Greek fashion as being received very willingly by a "voracious" Etruscan population.[31] This perspective largely disregards the potential for a particularized Athenian knowledge or awareness of consumer desire or profitable strategies in trade, and reinforces an Atheno-centric interpretation by regarding the "other populations either as passive spectators (or victims) of the events that unfolded or as imitators who changed, uniformly and rapidly, to make themselves more like the Greeks."[32] Rather than understanding this channel of image flow as being directed only from the centers of Greek production, we should perceive the relationships within the channel between Athens and Vulci as symbiotic exchanges of knowledge.[33]

As previously mentioned, the recognition of Etruscan influence on the trade between Athens and Etruria is due largely to the evidence for the presence of Etruscan traders in the Hellenic world. However, there has not thus far been a case study that explores how this Etruscan presence, as evidenced by underfoot trademarks, relates to the creation or circulation of a particular image. Though Alan Johnston's scholarship on vase trademarks has already noted the relationship between trademarks and attributed painters, the relationship between images and trademarks has not been considered closely. As mercantile signifiers, these particular trademarks allow us to identify the participants in an export channel. The significance of Vulci and trademarks in particular is something that cannot be neglected, as of all vases trademarked with mercantile significance, far more come from Vulci than from any other site.[34] The trademarks marked on the bottom of the vases depicting a woman riding a bull reflect that traders and

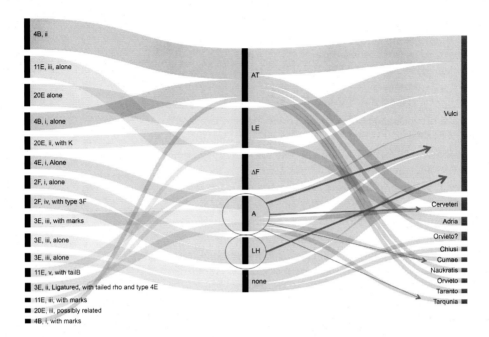

Fig. 6. Diagram of provenance and trademarks associated with seven vases depicting the woman riding a bull. Left column: trademarks as given by Alan Johnston (1979); middle column: individual trademarks of seven vases; right column: provenance (diagram generated via RAW, designed and developed by Giorgio Caviglia, Michele Mauri, Matteo Azzi and Giorgio Uboldi at the DensityDesign Research Lab at the Politecnico di Milano. http://raw.densitydesign.org).

merchants, both Greek and Etruscan, were actively involved in the export of these particular vases.

In the dataset of 86 vases, there were 13 neck amphorae depicting a woman riding a bull that were most stylistically similar to one another, including the vases from Duke and Berkeley. Of this group of 13, seven vases had under-foot trademarks.[35] Though under-foot incisions have been interpreted as indicating owner's marks or pricing marks, the particular types of markings on these vases were noted by Johnston as being predominately of commercial and mercantile significance.[36] Using RAW, an open-source web application that allows spreadsheet data to be presented as vector graphics, I created a series of diagrams that signify the different relationships between attribution, trademark, and provenance.[37] Using Johnston's 1979 catalogue to identify all trademarks that existed in the data set of vases depicting a woman riding a bull, I used RAW's open-source software to parse and arrange the various pieces of information given by Johnston, such as provenance, vase type, and painter (figs. 6–7). Visualizing the information in this way allows one to more easily perceive patterns that were too difficult to discern within the catalogue's presentation, such as where the marks were going, what painters they were associated with, and the

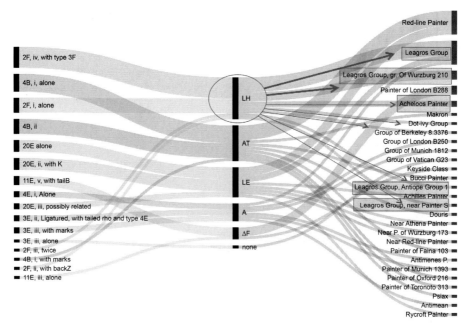

types of scripts being used in the markings. Most importantly, through these markings I wanted to know the places and people involved in the production and distribution of the woman-on-bull iconography.

To summarize, the visualizations showed that most of the trademarks connected to the group of vases depicting the woman riding a bull were more generally connected to vases painted by the the Leagros group and the closely related Red Line Painter.[38] This is also the workshop to which the majority of these woman-on-bull neck amphorae have been attributed by Beazley and others, confirming a likely affiliation between image, trademark/trader, and workshop.

I would like to focus on only two specific examples that I have used as a test case to represent my general methodology and findings. For the purposes of systematic data collection, each trademark found on the group of seven vases depicting the woman riding a bull has been given a keyboard symbol, which can be seen down the middle column of figure 6.[39] Looking at group "A," the RAW visualization indicates that mark was found in Vulci, Cerveteri, Tarquinia, and Cumae (see red arrows).[40] The node bar on the right indicates that the number of vases with mark A is greatest in Vulci, though from the mark's presence in the nearby locations, we might infer that the trader related to this mark likely traveled through the nearby Etrus-

Fig. 7. Diagram of workshops and selected trademarks related to the seven vases depicting the woman riding a bull. Left column: type, as given by Alan Johnston (1979); middle column: trademarks; right column: workshop attributions, according to Alan Johnston (1979) (diagram generated via RAW, designed and developed by Giorgio Caviglia, Michele Mauri, Matteo Azzi and Giorgio Uboldi at the DensityDesign Research Lab at the Politecnico di Milano. http://raw.density-design.org).

Fig. 8. Digital drawing of
trademarks found on Munich,
Antikensammlung (drawing
by Tara Trahey, after Johnston
(1979, 125), 22. Fig. 7i 4E, 7).

can cites of Cerveteri and Tarquinia, and the southernmost site of Cumae, near Naples. In comparison, the visualization shows that the trademark "LH"[41] was found almost exclusively at the site of Vulci, when the findspot was known.

Figure 7 illustrates how the trademarks found on the vases depicting a woman on a bull are generally related to particular painters and workshops rather than to provenances. The visualization indicates that the mark LH, which, as mentioned previously, was found only in Vulci, was related to a range of workshops and painters (see blue arrows). The size of the nodes and branching indicate that this mark was predominately connected to the large Leagros Group, or smaller painters related to the group such as the Group of Würzburg 210, the Acheloös Painter, and the Antiope Group.[42] This information indicates that the individuals, likely traders, making the marks probably had consistent relationships with the Leagros workshop and casual relationship with the other painters. Both pottery workshops and traders would have benefited by building longstanding relationships with particular individuals with whom they could trust their livelihood.[43]

But what do these markings and trader-workshop relationships mean for this particular woman-on-bull composition? Such markings indicate that this image was a part of a rather systematic trade network between Athens and Vulci. There

are two particular markings on the grouping of seven vases that support this argument and demonstrate an Etruscan involvement in the trade: a tailed rho-epsilon marking and a figure-eight marking, often very roughly incised. The tailed rho-epsilon marking is, as catalogued by Johnston, a subgroup of a tailless rho-epsilon marking related to Painter N.[44] According to Johnston, Painter N, of the Nikosthenic amphorae, did specific orders for the market in Cerveteri, Etruria.[45] The figure eight is a mark that was introduced into the Etruscan script in the sixth century B.C.E. (fig. 8).[46] It is seen here on the foot of a vase adjacent to another tailed-rho epsilon marking which does *not* belong to an Etruscan script.[47] It is unclear from what Greek region or settlement this tailed-rho marking may have originated, perhaps Ionia.[48] In any case, the combination of markings indicates that Etruscan individuals were part of the trade of these vases in some systematic capacity.[49] To further support the involvement of Etruscans, Johnston notes that there are several *dipinti* (painted rather than inscribed markings) on Attic vases that are in Etruscan script.[50] It is contested as to whether these *dipinti* marks were applied before or after the vases were fired. Though it cannot be said with certainty, Johnston has postulated that if the markings were made before firing, Etruscan traders might have been present at these Athenian production sites.[51]

The trade of vases from Athens allowed for a particular interaction among various ethnic peoples. According to Johnston, "the proportions of non-Athenians shipping Attic vases in the later sixth century was probably high."[52] Though it cannot be said with certainty, perhaps the Leagros Group and its associates—primary producers of the woman-on-bull iconography—developed longstanding relationships with particular Etruscan traders. Or, if not Etruscan, these traders would be individuals that had some significant knowledge about Etruscan cities since their marks ended up there. As such, it does not seem appropriate to assume Etruscans were passive receivers of Athenian leftovers. In this context, the woman-on-bull iconography should be interpreted through the lens of a thoughtful, if not systematic, trade between Athens and the Etruscan city of Vulci. Thus, the image might not have been identified as "Athenian" or "Etruscan," but rather it might have had a fluid and changing significance, depending upon its cultural reception in either place—informed by its producers, traders, and consumers alike.

Notes

[1] Nasher Museum 2006.1.38: BAPD 302959; *ABV* 395.5. Berkeley, Phoebe Hearst Museum 8-3852; BAPD 302197; *ABV* 375.202.

[2] See Technau 1937 for an early discussion of the identification of women riding bulls; for the identification of the woman as Europa see Langlotz 1932, no. 193, pl. 58; for the identification of the woman as Europa more generally and based upon hand placement and other characteristics, see Peeters 2009. Note that the identification of the woman as Europa is present within entries in the Beazley Archive as well: for example, see infra n. 6 for the identification of the woman as "Europa or maenad on bull."

[3] For the identification of the woman as a maenad see Smith 1936, 30; *LIMC* III, 460, s.v. Dionysos 427, *LIMC* VIII, 789, s.v. mainades 84. Note that many vases from my case study have been identified variously in the BAPD: for examples of vases identified as depicting a "maenad (?)" see BAPD 5266 (Gela N151), BAPD 5665 (Geneva I731.1891); for examples of vases identified as depicting "Europa or maenad on bull" see BAPD 14293 (Rhodes 10662); BAPD 14251 (Syracuse 8763).

Though their seemingly identical iconography initially connected the two vases, their association was solidified by discovery of a discrepancy in their modern provenances that placed the vase at Berkeley, rather than the vase at Duke, in Lucien Bonaparte's collection at Vulci. For the graffito that matches the vase at Berkeley, rather than the vase at the Nasher, see entry 315 in Bonaparte 1829.

[4] Los Angeles County Museum of Art 50.8.22. *ABV* 395.4; BAPD 302958.

[5] Though this particular article limits the iconography explicitly to women riding a bull, I originally considered 15 outlier vases in addition to the 86 mentioned above. These 15 vases, though they do not depict a woman riding a bull, are all arguably very close variations of the subject: for example, two vases depict a woman riding a mule in an almost identical composition to the original woman riding a bull (BAPD 352249 and 303061), three vases depict a woman similarly accompanying a bull, though not riding the animal (BAPD 21266, 9024511, and 330011), and two vases depict a male, identified as Dionysos, riding a bull in an almost identical composition to the original woman riding a bull (BAPD 5464 and 51014).

[6] Würzburg, Martin von Wagner Museum L193. BAPD 44251.

[7] See Langridge-Noti 2013, 67 for a further explanation on the matters of titling and labeling; for the relationship between image and text generally see Snodgrass 2006.

[8] See Sparkes 1996, 1–3 for a general discussion of the problematic quantification, classification, and systematization of Greek pottery. His second chapter (34–63) focuses specifically on the development of the interest in the study of vases; see Neils 1997 for

a traditional iconographic examination that seeks a single identifi-
cation for each figure; see Osborne 2001 for an example of a case
study that implements iconographic categorization and emphasizes
a static nature of iconography; see Woodford 2003, 215 for an ex-
amination of traditional iconographic interpretation, more generally,
and a discussion on finding the "key" to an image.

⁹ Langridge-Noti 2013, 67.

¹⁰ See Arafat and Morgan 1994, 108, citing Appadurai 1986.

¹¹ For a general discussion on postcolonial approaches see Izzet
2007, 213; for the transformation of object-meaning depending
on context, see Appadurai 1986, Gosden and Marshall 1999; for a
discussion on colonizer and colonial consumer see Hannerz 1992;
Willis 1990.

¹² Izzet 2007, 214; for arguments that refute Greek maritime
hegemony see Cristofani 1983 and Martelli 1987, 263–64; for the
dismissal of homogeneity in the Greek world see Hall 1997 and the
essays in Dougherty and Kurke 2003.

¹³ Izzet 2007, 214; Thomas 1991; Comaroff 1996.

¹⁴ White 1991.

¹⁵ Malkin 2002, 152. See Langridge-Noti 2013 for the applica-
tion of Middle Ground theory to specific case studies related to the
Eucharides Painter. In particular, she argues that the choices on the
receiving end (rather than on the Athenian end) may transform the
original uses and meanings of an object or scene.

¹⁶ Izzet 2007, 217.

¹⁷ In addition to the 31 vases mentioned above, there are four
neck amphorae that have not been included on the map because
their provenance is too uncertain; however, their trademarks and/
or stylistic relationship with the vases from Etruria lead me to be-
lieve that they are also originally from the Etruscan region (BAPD
9029446, 302958, 10875, 1573). Palladio is made possible by sup-
port from the Office of Digital Humanities within the National
Endowment for the Humanities, the Vice Provost for Online Edu-
cation at Stanford, the Wallenberg Foundation, the Stanford Uni-
versity Libraries, and the Dean of Research at Stanford. http://pal-
ladio.designhumanities.org.

¹⁸ Nine of the aforementioned 31 vases with known provenance
were found at the site of Vulci, as demonstrated by the larger sized
node in the central Italian region. Additionally, seven of the 15 out-
lier vases that have not been included in this particular article, but
are arguably still related to the subject (supra n. 5), were found at
the site of Vulci and 1 was found at the Etruscan site of Tarquinia.
The large sized node over Athens indicates that all of the vases were
presumably shipped from Athens in antiquity.

¹⁹ Archibald 2013, 133.

²⁰ Archibald 2013, 133.

²¹ Williams 2013, 54; for more on coinage in ancient Greece
see Kim 2001, 7–21, Kroll 2008, 12–37, Kroll and Wagner 1984,
325–40.

[22] Johnston 1991, 224–25.

[23] For a discussion on shipwrecks and bottomry loans for information on trade in pottery see Langridge-Noti 2013, 63 and Bundrick 2015, 304.

[24] Bundrick 2015, 304 notes that a merchant vessel of the late sixth century B.C.E., of either Greek or Etruscan origin, sank on the way to Massalia along the French coast. The cargo was comprised of a great number of Athenian finewares, and in particular a large number of Athenian Type A eye cups.

[25] Williams 2013, 52.

[26] Malkin 2002, 170.

[27] Williams 2013, 52.

[28] Osborne 2001, 277.

[29] Haynes 2000, 173.

[30] Arafat and Morgan 1994, 119.

[31] See Shapiro 2000 and Williams 2013, 47 for specific instances of a targeted market, such as the depiction of *perizomata* (loincloths) on sixth-century B.C.E. stamnoi, a shape closely associated with Etruria. Athletes wearing white loincloths were a fashion in Etruria rather than in Greece. Additionally, this group of vase painters depicted women reclining in the symposium alongside men, in an Etruscan, rather than Greek, manner. See Osborne 2001 for a more traditional argument about Etruscan consumption of Greek iconography. Osborne offers a counter-position to the more recent arguments, particularly with regard to recognizing the artist's intensions. His argument is two-fold: "First, although Etruscan demand affected the shapes of pots made in Athens ... it did not affect the general run of imagery painted in Athens. Second, the imagery on imported Athenian pots was nevertheless what the Etruscans demanded....The Etruscans emerge as both voracious and discriminating consumers of Athenian pottery" (290). In his study, Osborne has created two tables of data, which show the distribution of mythical and nonmythical scenes on Athenian and Etruscan pottery. Arguably, these tables are the closest one gets to the idea of using visualizations to identify patterns in iconography. However, while Osborne's argument does recognize a reception and selection of the iconography by the Etruscans as uniquely their own in some cases, it still assumes that the Athenians were producing a "lexicon of scenes" with only Greek intentions (277).

[32] Walsh 2013, 90.

[33] Sian Lewis (2002, 11) became one of the first in the conversation to challenge the Atheno-centric understanding of representation in her iconographic handbook on Athenian women, by arguing that iconography cannot be understood as a "symbolic system complete within itself."

[34] Johnston 1979, 12 and 54, app. 1. See Johnston 1974, 139 for an earlier conclusion in which he states, "the great majority of decorated vases with marks, where their provenance is known, were

found in Etruria and Campania, and indeed of marked Attic vases with known provenance more have been found at Vulci than at all other sites put together."

[35] The seven vases with underfoot trademarks that are used in the trademark analysis are as follows: Berkeley, Phoebe Hearst Museum 8-3852; BAPD 302197; *ABV* 375.202. Oxford, Ashmolean Museum 1960.540; BAPD 1573. Los Angeles (CA), County Museum 50.8.22; BAPD 302958; *ABV* 395.4. Paris, Musee du Louvre F255; BAPD 10875. Leiden, Rijksmuseum van Oudheden PC35; BAPD 616. Toronto, Royal Ontario Museum 306; BAPD 302175; *ABV* 373.180.Tarquinia, Museo Nazionale Tarquiniense 635; BAPD 902944.

[36] Johnston 1979, 48.

[37] RAW has been designed and developed by Giorgio Caviglia, Michele Mauri, Matteo Azzi, and Giorgio Uboldi at the Density-Design Research Lab at the Politecnico di Milano. http://raw.densitydesign.org/.

[38] See Johnston 1985, 250 for discussion on another possible Etruscan marking connected to the Leagros group, where the only known provenance is Vulci.

[39] For the purposes of this analysis, Johnston's "types" have been broken down into individual markings, because some individual trademarks occur in various combinations. The middle column depicts a selection of individual trademarks related to the seven vases depicting the woman riding a bull. The left column allows the viewer to trace the individual trademark back to its type(s) as given by Johnston 1979. The right column depicts the provenances associated with the selected individual trademarks.

[40] The individual marking "A" is found in three types within Johnston's catalogue (1979): 3E, iii (125, 208), 4E, i (126, 210), and 3E, ii (125, 208).

[41] See Johnston 1979, 151–53 for type 2F and comments on 221–23. Thirty-two out of the 35 vases with provenance were found in Vulci.

[42] *ABV* chapter 23.

[43] Morley 2007, 86; See Xen. *Mem.* 2.6, [Dem.] 34.40., Hes. *WD* 320–25 for ancient opinions on the professions of merchant and trader, and more generally on the concern for making money.

[44] See Johnston 1979, 125 for subgroup ii of type 3E.

[45] Johnston 1979, 208 notes that "one might think that the Nikosthenics were snapped up by the dealers for Cerveteri, close by what must have been a major port for the intake of Etruscan goods, Pyrgi. This does not however explain the fact that many masterpieces of vase-painting, some of which must have surely been recognized by the Etruscans as such, were found at other Etruscan sites. There is a strong suggestion that Nikosthenes was working for specific order from Cerveteri, otherwise his work would have reached a number of other Etruscan cemeteries."

[46] Johnston 1979, 210.

[47] Johnston 1979, 209 refers to the tailed-rho epsilon and its accompanying markings and notes that "the main accompanying mark, subgroup ii (see type 4E) and the accompanying signs on 26, 27, 29, and 32 are also Etruscan, with some reservations about 29.... As type 3E is so often accompanied by an Etruscan graffito, I am tempted to think the association more than casual or accidental." For another related example see de La Genière 1999, 419, who suggests that Johnston's type 8E might be the mark of an Etruscan middleman who channeled material from several Greek merchants to Vulci.

[48] Johnston 1979, 209

[49] See Johnston 1985, 250 for a discussion on the regular pairing of a Greek (rho and epsilon) and Etruscan marking on five neck-amphorae of the late sixth century.

[50] Johnston 1979, 5.

[51] Johnston 1979, 5; 1985, 250.

[52] Johnston 1979, 52 notes that "Ionians evolved a certain sophistication in their marketing technique and the appearance of 'proto-acrophonic' numerals in association with possibly Aeginetan graffiti (type 1D) suggests a similarly brisk trade."

References

Appadurai, A. 1986. "Introduction: Commodities and the Politics of Value." In *The Social Life of Things*, edited by A. Appadurai, 3–63. Cambridge: Cambridge University Press.

Arafat, K., and Morgan, C. 1994. "Athens, Etruria, and the Heuneburg; Mutual Misconceptions in the Study of Greek-Barbarian Relations." In *Classical Greece: Ancient Histories and Modern Archeologies*, edited by Ian Morris, 108–34. Cambridge: Cambridge University Press.

Archibald, Z. 2013. "Joining up the Dots: Making Economic Sense of Pottery Distributions in the Aegean and Beyond." In *Pottery Markets in the Ancient Greek World (8th–1st Centuries B.C.). Proceedings of the International Symposium Held at the Université libre de Bruxelles, 19–21 June 2008*, edited by A. Tsingarida and D. Viviers, 133–58. Brussels: CReA-Patrimoine.

Bonaparte, L. 1829. *Catalogo di scelte antichità etrusche trovate negli scavi del principe di Canino*. Viterbo: dalla tipografia dei Fratelli Monarchi.

Bundrick, S.D. 2015. "Athenian Eye Cups in Context." *AJA* 119:295–341.

Comaroff, J. 1996. "The Empire's Old Clothes: Fashioning the Colonial Subject." In *Cross-Cultural Consumption: Global Markets, Local Realities*, edited by D. Howes, 19–38. New York: Routledge.

Cristofani, M. 1983. *Gli Etruschi del mare*. 2nd ed. Milan: Longanesi.

de La Genière, J. 1999. "Quelques reflexions sur les clients de la céramique attique." *Céramique et peinture grecques: Modes d'emploi*, edited by M.-C. Villanueva Puig et al., 411–24. Paris: Documentation Française.

Dougherty, C., and L. Kurke, eds. 2003. *Cultures within Ancient Greek Culture: Contact, Conflict, and Collaboration*. Cambridge: Cambridge University Press.

Gosden, C., and Y. Marshall. 1999. "The Cultural Biography of Objects." *WorldArch* 31:169–78.

Hall, J.M. 1997. *Ethnic Identity in Ancient Greece*. Cambridge: Cambridge University Press.

Hannerz, U. 1992. *Cultural Complexity: Studies in the Social Organisation of Meaning*. New York: Columbia University Press.

Haynes, S. 2000. *Etruscan Civilization: A Cultural History*. Los Angeles: Getty Publications.

Izzet, V. 2007. *The Archaeology of Etruscan Society*. Cambridge: Cambridge University Press.

Johnston, A.W. 1974. "Trademarks on Greece Vases." *G&R* 21:138–52.

———. 1979. *Trademarks on Greek Vases*. Warminster, Wiltshire, England: Aris & Philips.

———. 1985. "Etruscans in the Greek Vase Trade?" In *Il Commercio Etrusco Arcaico*, 249–55, edited by M. Cristofani. Rome: Consiglio nazionale delle ricerche.

———. 1991. "Greek Vases in the Marketplace." In *Looking at Greek Vases*, edited by T. Rasmussen and N. Spivey, 203–31. Cambridge: Cambridge University Press.

Kim, H.S. 2001. "Archaic Coinage as Evidence of the Use of Money." In *Money and Its Uses in the Ancient Greek World*, edited by A. Meadows and K. Shipton, 7–21. Oxford: Oxford University Press.

Kroll, J.H. 2008. "Monetary Used of Weighed Bullion in Archaic Greece," in *The Monetary Systems of the Greeks and Romans*, edited by W.V. Harris. Oxford: Oxford University Press.

Kroll, J.H., and N.M. Wagner. 1984. "Dating the Earliest Coins of Athens, Corinth and Aegina." *AJA* 88:325–40.

Langlotz, E. 1932. *Griechische Vasen in Würzburg*. Munich: Obernetter.

Langridge-Noti, E. 2013. "Consuming Iconographies." In *Pottery Markets in the Ancient Greek World (8th–1st Centuries B.C.). Proceedings of the International Symposium Held at the Université libre de Bruxelles, 19–21 June 2008*, edited by A. Tsingarida and D. Viviers, 61–73. Brussels: CReA-Patrimoine.

Lewis, S. 2002. *The Athenian Woman: An Iconographic Handbook*. London: Routledge.

Malkin, I. 2002. "A Colonial Middle Ground: Greek, Etruscan and Local Elites in the Bay of Naples." In *The Archaeology of Colonialism*, edited by C.L. Lyons and J.K. Papadopoulos, 151–81. Los Angeles: Getty Research Institute.

Martelli, M., ed. 1987. *La ceramic degli Eturschi: La pittura vascolare.* Novara: Istituto Geografico de Agostini.

Morley, N. 2007. *Trade in Classical Antiquity.* Cambridge: Cambridge University Press.

Neils, J. 1997. "'Lost' and Found: Adam Buck's Wedding of Dionysos." *Athenian Potters and Painters,* edited by J.H. Oakley, W.D.E. Coulson, and O. Palagia, 231–40. Oxford: Oxbow Books.

Osborne, R. 2001. "Why Did Athenian Pots Appeal to the Etruscans?" *WorldArch* 33:277–95.

Peeters, M. 2009. "L'évolution du mythe d'Europe dans l'iconographie grecque et romaine des VIIe–VIe s. avant aux Ve–VIe s. de notre ère: de la «déesse au taureau» au rapt et du rapt au consentement." *Dialogues d'histoire ancienne* 351, no. 1:61–82.

Shapiro, H.A. 2000. "Modest Athletes and Liberated Women: Etruscans on Attic Black-figure Vases." In *Not the Classical Ideal: Athens and the Construction of the Other in Greek Art,* edited by B. Cohen, 315–37. Leiden: Brill.

Smith, H.R.W. 1936. *CVA, United States 5, Berkeley, University of California, 1.* Cambridge, MA: Harvard University Press.

Snodgrass, A. 2006. "The Uses of Writing on Early Greek Painted Pottery." In A. Snodgrass, *Archaeology and the Emergence of Greece,* 407–21. Ithaca: Cornell University Press.

Sparkes, B. 1996. *The Red and the Black: Studies in Greek Pottery.* London: Routledge.

Technau, W. 1937. "Die Göttin auf dem Stier." *JdI* 52:76–103.

Thomas, N. 1991. *Entangled Objects: Exchange, Material Culture and Colonialism in the South Pacific.* Cambridge, MA: Harvard University Press.

Walsh, J.St.P. 2013. *Consumerism in the Ancient World: Imports and Identity Construction.* London: Routledge.

White, R. 1991. *The Middle Ground: Indians, Empires, and Republics in the Great Lakes Region, 1650–1815.* Cambridge: Cambridge University Press.

Williams, D. 2013. "Greek Potters and Painters: Marketing and Movings." In *Pottery Markets in the Ancient Greek World (8th–1st Centuries B.C.). Proceedings of the International Symposium Held at the Université libre de Bruxelles, 19–21 June 2008,* edited by A. Tsingarida and D. Viviers, 39–61. Brussels: CReA-Patrimoine.

Willis, P. 1990. *Common Culture: Symbolic Work at Play in the Everyday Cultures of the Young.* Milton Keynes, Philadelphia: Open University Press.

Woodford, S. 2003. *Images of Myth in Classical Antiquity.* Cambridge: Cambridge University Press.

Image and Story in
Late Geometric Attica:
Interpreting a Giant Pitcher
from Marathon

Vicky Vlachou

Abstract

A giant pitcher (h. 78 cm) was found in 1995 during rescue excavations at the southern entrance of the Marathonian plain. The vessel seems to have been placed with the burial of a young female, along with two small stranded bowls and two simple bronze finger rings. The burial can be dated to the Late Geometric period and forms part of a larger burial ground of the Geometric and Archaic periods that has been investigated in the same area to the west of Brexiza. The figured decoration, which includes two continuous friezes with numerous male and female dancers and six panels depicting human figures, animals, real and mythical creatures, covers the whole surface of the vessel leaving no vacant space. The imagery of the pitcher suggests a festive gathering, despite its placement with a burial. The choice of certain iconographical themes have no precedents in Geometric iconography, while the large number of the dancers depicted finds no parallels in Greek art. The style demonstrates strong connections with the concurrent Athenian workshops, although a local production is suggested by its technical characteristics. I argue that a specific class of pottery, the large pitchers that are found only in Athens and Attica, is inextricably associated with Attic funerary behavior, most probably for young females. Such vessels seem to represent special commissions presumably related to the class and gender of the deceased. The Marathon pitcher, however, is the only vessel painted with such dense and original figured decoration, which, taken as a whole, seems to illustrate the intended effort of the painter to depict a certain story.

THE INTRODUCTION OF FIGURED DECORATED POTTERY TO Athens around the beginning of the eighth century B.C.E. marks a fascinating instance of the complex connections between people and the pottery they owned and used. Geometric figured vessels have been largely investigated for the cultural significance they were accorded and the degree of

social exclusivity they manifested.[1] By the third quarter of the eighth century B.C.E. pictorial representations displayed a wide range of themes that have been discussed in terms of mythic and epic narratives, and equally for the encoded social values they expressed.[2] Images of athletic and musical contests, hunts, processions and dances presumably at public festivals became popular in Attic iconography, as in most regional styles, coinciding with an apparent escalation in the popular taste for smaller, finely decorated pots.

The iconography of the male-female pair is a fresh introduction to the Late Geometric repertory, presented on gold bands, stone seals, and ceramic vessels in Attica, Corinthia, the Cyclades (Naxos), Ithaka, Crete and further afield in Cyprus and Etruria.[3] The claiming of a maiden by a man, manifested through the *cheir' epi karpo* gesture, prevails in the visual rendering of the male-female pair, even with a certain degree of variability as to the composition (abduction from the dance, by centaur or ship) and the spatial setting (at the shore, at the dance floor). A constant reference to the iconography of dance is made explicit by the addition of wreaths, branches, and even the belted skirts that the maidens occasionally wear. As an illustration of the stories of pairs in myth and contemporary poetry, the figures have been variously identified as Theseus and Ariadne, Jason and Medea, Menelaos/Paris and Helen, Hektor and Andromache, and Odysseus and Circe. Be they emblematic prototypes of mythic action and epic narrative, or artistic renditions of the transformations of social life, this new interest in representing the male-female pair has been discussed recently by Susan Langdon and convincingly associated with significant changes that occurred at the social and ideological level during the second half of the eighth century B.C.E.[4]

An exceptional opportunity for exploring these social dynamics and symbolic meanings inherent in early pictorial representations is provided by a recent find from Marathon (Attica), a giant pitcher, h. 78 cm, with extraordinary and unique figured decoration (fig. 1a–c). The pitcher was found, broken, inside a grave (grave 15) near the southern limit of the small burial ground along Marathonos Avenue, in the narrow pass east of Mount Agrieliki, at the entrance to the plain.[5] The giant vessel was placed at the left of the inhumation of a young female, who was identified by osteological analysis. Two skyphoi with low pedestals and two bronze finger rings were found by her left arm. From the pottery, the burial may be dated to ca. 720–700 B.C.E.

No *comparandum* fully matches either the richness of the pot's figured scenes organized in two continuous friezes and six consecutive panels, or their iconography. Among the pictorial themes illustrated on the pitcher, some of which are new entries into Late Geometric (LG) iconography, the male-female pair seems to hold a central place. In contrast to the prevailing abduction scenes, the moment of the union between the male and female seems intentionally emphasized on the pitcher, providing an early iconographic treatment of the theme of sacred marriage (*hieros gamos*). The theme seems to comport with a conspicuous use of the giant pitcher, possibly as an early *loutrophoros*, a water container for the ritual bathing in both marriage and funerals. By its large size, the high quality of potting and complexity of decoration, this unique vase should be considered as a special commission of individuals of apparently high social status, presumably members of the local elite, for a specific event—possibly a marriage. Its placement inside the tomb, either in a symbolic manner for a maiden who died unmarried, or as a highly valued possession that accompanied its owner to the grave even though not necessarily ordered for the tomb, registers a new tension in the use of figured pottery in the funerary record in the late eighth century B.C.E. as argued below.

A Dance Floor for Youths and Maidens

The pitcher's imagery strongly evokes a public gathering, certainly a festive occasion, judging by the two large dances, in which no fewer than 83 male and female participants are involved. One processional dance is displayed in the broad zone immediately below the exterior of the vase's lip: it comprises 40 male and female figures, holding hands and branches (fig. 2). The composition of the dance with its alternating male and female celebrants is among the earliest of this type in Attic iconography,[6] anticipating similar representations of mixed dances in the somewhat later works by the Analatos Painter, although with far fewer people depicted there.[7] Large mixed choruses are commonly associated with the wedding ritual in literary sources;[8] a similar allusion may be equally intended on the Marathon pitcher if we consider the object held by the male leader of the dance. This object does not resemble any known depiction of a musical instrument, but seems more akin to a closed vessel.

People bearing vessels are extremely rare in Late Geometric and Early Archaic iconography. A single example may be seen

Vicky Vlachou

Fig. 1a–b. Late Geometric IIb
giant pitcher from Marathon
(Attica), 720–700 B.C.E. Mara-
thon, Archaeological Museum
K2209 (photo: author. Used
by permission of Ephorate of
Antiquities of Eastern Attica.
© Hellenic Ministry of Culture,
Education and Religious Affairs
/ Archaeological Receipts
Fund).

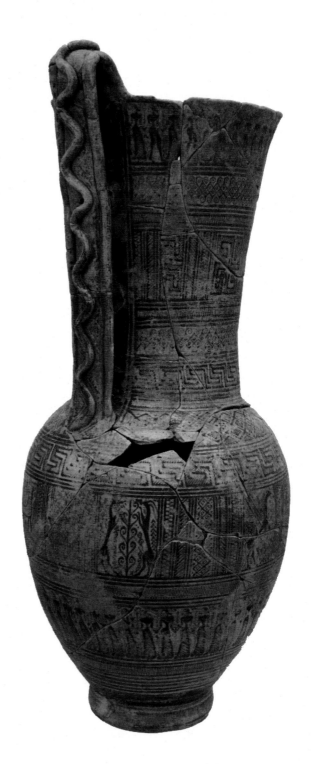

Fig. 1c. Late Geometric IIb
Giant Pitcher from Marathon
(Attica), 720–700 B.C.E. Mara-
thon, Archaeological Museum
K2209 (photo: author. Used
by permission of Ephorate of
Antiquities of Eastern Attica.
© Hellenic Ministry of Culture,
Education and Religious Affairs
/ Archaeological Receipts
Fund).

Fig. 2. Detail of figure 1c, top frieze.

Fig. 3. Detail of figure 1c, bottom frieze.

on a contemporary amphora from the Athenian Agora:[9] on the neck panel three males carry gifts for the deceased represented in the *prothesis* scene on the other side of the neck. The last figure holds what looks like a closed vessel, presumably a water container for the ritual bathing of the deceased? In Proto-attic iconography, people with vessels are occasionally present in wedding processions, bringing water for the bridal bath.[10] The *loutrophoria* (λουτροφορία) becomes popular only in the course of the fifth century B.C.E.[11] Although the theme is not attested in Late Geometric iconography, certain hydriae and amphorae decorated with choruses of youths and maidens or processions of mourners have been seen as the forerunners of archaic *loutrophoroi*, as to their use and function in the funerary context.[12]

Moving to the lower body of the vessel, 43 dancing maidens are linked in a circular dance. Female dancers are a frequent pictorial theme in Late Geometric iconography, regularly shown, although not exclusively, on the newly adopted hydria.[13] What is new about the Marathon pitcher is the addition of a stylized tree motif, the center around which the action takes place (fig. 3). This circular performance of the maidens around the tree is further accentuated by two of the female figures flanking it with their hands held upright. Stylized trees reminiscent of the Phoenician-flower type of the tree of life motif are occasionally held by sphinxes or even flanked by lions and centaurs in Attic iconography of the late eighth century B.C.E.,[14] while goats flanking the tree motif are also shown on one of the six square panels decorating the Marathon pitcher (see discussion below). Circular dances in front of trees constitute a frequent pictorial theme in Cypriote art, shown both on the Cypro-Archaic pottery and metal bowls.[15] A sacred grove (*alsos*), serving as the setting for the dancers has been convincingly argued for those cases. In an Aegean context, the addition of the tree motif emphasizes the outdoor setting for the dance, presumably performed in an open ritual space. In the figured repertory of LG IIb Attica, stylized tree motifs are occasionally shown with pairs

of female dancers holding hands and branches, although in separate square panels and not combined in a single image.[16] On the Marathon pitcher the tree motif holds an important symbolic role that is further manifested by its repetition elsewhere on the vessel, serving as a sort of "iconographical key" for unlocking the imagery as a whole.

Fig. 4. Line drawing of central frieze, figure 1 (drawing author).

The Tree of Life and the Male-Female Pair

The second similarly stylized tree motif is placed in one of the six figural panels depicting a male-female pair (fig. 4). The two figures face each other: in one hand they hold branches, while from their other joined hands sprouts a large branch resembling the tree motif. This apparent emblematic representation of male-female union is emphasized further by the addition of a wreath that encircles the joined hands of the figures, as if binding them together. The presence of both the wreath and the tree motif underscores the moment of the union between male and female: an image that serves as an early visual contextualization of the symbolism in the ritual of the *hieros gamos* (*Theogamia*).[17] The emphasis is on the maturation of youths and maidens, on fertility and the eternal circle of life. A slightly later (around 700 B.C.E.) Argive seal from Megara[18] (fig. 5a) offers an iconographical counterpart for the Marathonian pair: it anticipates the symbolic representation of the heterosexual pair in the seventh century B.C.E. context of *hieros gamos* on votives and pottery from Crete, the Samian and Argive *Heraion* and the sanctuary of Artemis *Orthia*.[19]

The third tree of life motif is shown in the square panel just below the base of the handle (figs. 1a and 4). The theme of rampant goats flanking a central tree motif has an equally long tradition in the Near East, being introduced into the Attic LG Ia repertoire probably under Cypro-Phoenician influence.[20] It is clear that the scene functions as a counterpart to the symmetrically arranged male-female pair by drawing analogies to land fertility and the regeneration of life. In this context, the iconography of the male-female pair on the

133

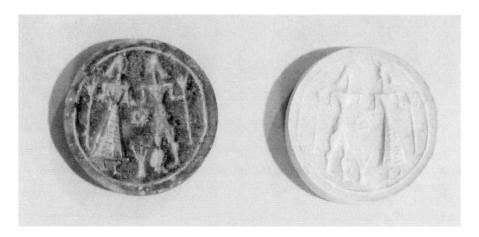

Fig. 5. Stone Seal from Megara, ca. 700 B.C.E. Athens, National Archaeological Museum 11750. A: Male-female pair. B: Rider (photo: author. © Hellenic Ministry of Culture, Education and Religious Affairs / Archaeological Receipts Fund).

Marathon pitcher diverges from the LG IIb treatment of the theme. Still, an emphasis on erotic implications of the male-female pair is also absent. A comparable treatment of the theme within the framework of the sacred marriage beyond the Aegean is found in a highly stylized scene on a small Cypriot krater.[21] Each figure is shown holding a wreath and a trap pattern, a reference to dance and hunt respectively, while high trees frame the scene on both sides of the krater. On a later ovoid pithos from Knossos, both figures are placed on bases, possibly an attempt by the painter to emphasize the divine character of the figures.[22]

Hunt, Horse, and Fantastic Creatures

The images of a hunt and of a winged horse should be counted as visual innovations by this imaginative painter. The composition of the hunting scene, with three youths shown at the moment of capture of a ferocious feline (apparently using what seems like a rope or noose), is highly experimental with neither antecedents nor descendants in Attica or elsewhere. The large feline occupies most of the space, looking directly out at the viewer, while the three males are shown in the background, each holding in both hands the presumed rope, judging by the odd-looking knot at the feline's neck. The frontal portrayal of the head of the animal recalls certain Corinthian examples.[23] The large size of the animal in comparison to the human figures and the posture of its body with one paw raised as if ready to attack is perhaps intended to highlight the masterful skills of the hunters and their domination over the wild and uncivilized beast. The image thus forms a proper

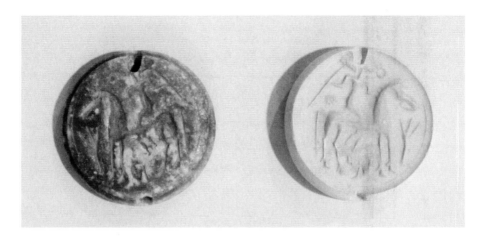

accessory to the male-female pair, in that it celebrates balance and stability over the ferocious and uncivilized nature of the animal.

The winged horse is another new iconographical theme that will be developed further in the Attic, Cycladic, and mainly the Corinthian repertoire in association with the myth of Pegasus.[24] The depiction on the Marathon pitcher is the earliest to my knowledge among the Attic examples and the only one with the horse depicted in full flight.[25] Winged goats enter the Attic repertoire around the same time,[26] yet the semantic value of the appearance of the winged horse, at least for the Marathon pitcher, seems to go beyond the mere preference for such creatures in the late eighth century B.C.E.

Alongside the winged horse, a horse-rider and a centaur give a particular equine emphasis to the vase, providing an aristocratic context for the marriage theme. The peaceful centaur with branches in both hands becomes a popular theme in LG IIb Attic iconography: he is seen in later mythological narratives and receives an important role in abduction scenes and the iconography of marriage.[27] The peaceful horse-rider,[28] shown to the left of the pair, also holds branches in his upraised arms. Both figures make a strong iconographical reference to the chorus members depicted in a similar posture, carrying branches. In this sense, the figure in each framing panel accentuates the festive character of the composition.

Pictorial Evidence for Marriage Celebrations

The core meaning inherent in the images is arguably to do with a celebration of the male-female union. The three-

fold repetition of both the tree motif and the theme of the horse, as well as the reiteration of the theme of youths and maidens performing dances, all seem to function as a sort of "iconographical key" emphasizing what is important, and so forcing the viewer to consider the consecutive themes as parts of an entity. The images presented on the pitcher seem to fall into two broad categories: those common enough to assist the viewer in identifying the meaning, namely, the female and mixed dances, the centaurs and the horse riders, and also newly introduced themes, for which further information and possibly the knowledge of a certain story would be necessary for them to be understood.[29]

One such new pictorial theme was the winged horse. This mythical creature is usually identified as Pegasus, offspring of the mythic union of Poseidon with the Gorgon Medusa according to Hesiod's *Theogony* (270–286). The basic storylines of the myth of Pegasus could have been known from existing narratives, as is implied by the appearance of the theme in the Attic visual repertory at the very end of the eighth and the early seventh centuries B.C.E. The attempt of the painter to show the creature in full flight, even if quite clumsily executed, seems to align with the Hesiodic narrative, where after its birth from Medusa's severed head, Pegasus flew away from earth and into the house of Zeus. As the divine offspring of a union between a god and a mortal maiden, the winged horse serves the core meaning of the pitcher's imagery in providing a counterpoint to the legitimate union as celebrated on the event of a marriage.

The reference to *hieros gamos* (*Theogamia*) functions as a paradigm in Hesiod's *Theogony* (590–612), endorsing the social aspects of human marriage, and thus forming a legitimizing model for the institution. The moment presented on the Marathon pitcher is precisely that of the male-female union, a basic aspect in the life circle for the individuals, the *oikos* and the community. The imagery on the pitcher seems better related to a bride, placing an importance on her marriage as a crucial factor for ensuring social organization and stability—something different and beyond abduction scenes and heroic episodes.

In this setting, the unique character of the hunt and the particularities of the scene presenting the exact moment of the capture of the feline with only a rope, could have equally referred to a particular story. In the context of the pitcher's

imagery, the hunt exemplifies the boldness and bravery of the hunters in taming the wild nature of the animal, and points to the maturation of the noble youths.

A new emphasis is placed by the Late Geometric period on the iconography of the male-female pair within the concept of marriage. Variability in the visual rendering of the theme may reflect the intentional portrayal of different moments—forceful claim and abduction on the one hand, and on the other the concept of a stable and shared life that the ritual of sacred marriage symbolized, or even marriage as an agreement between two families.[30] Nonetheless, the use of certain repeated iconographical elements seem to have created a visual communication channel between those objects and the viewers. In the selective use and combination of certain images, it is thus possible to trace an encoded symbolism of social behavior that progressively took shape by the late eighth century B.C.E.

For example, a peaceful rider occupies the rear side of the Argive seal from Megara (Athens NM 11750) discussed above (fig. 5b) and is combined with the male-female pair on the front side. Although the choice of both images is rare, their combination on the same object could have been intended as a visual shortcut to a longer story. On another pitcher, Athens NM 29838[31] (figs. 6 and 7), female ring dancers shown in a wide zone around the lip are combined with four square panels around the body depicting single horses (twice), a centaur carrying branches and a single female with branches and a wreath. On a hydria published by Kenneth Sheedy, now in Cambridge (CAM 345),[32] females dancing to the accompaniment of a male musician are placed around the neck and combined with heraldic lions flanking a stylized tree of life motif that is shown lower on the body. During the same period, specific classes of material culture became associated with maidens in the funerary record, revealing the gendered beliefs of Athenian society.[33]

It is thus arguable that during the Late Geometric II period a new association may be traced between people and the pottery used in funerary rituals. Whether the festive iconography with references to nuptial celebrations actually means that these objects were purposely made for such an occasion is difficult to verify. However the Marathon pitcher may be grouped with a small number of equally giant Attic pitchers that seem to have served as ritual utensils during the funerals, in addition to their highly exclusive character as funerary gifts.[34]

Fig. 6. Late Geometric IIb Pitcher, ca. 720–700 B.C.E. Athens, National Archaeological Museum 29838 (photo author. © Hellenic Ministry of Culture, Education and Religious Affairs / Archaeological Receipts Fund).

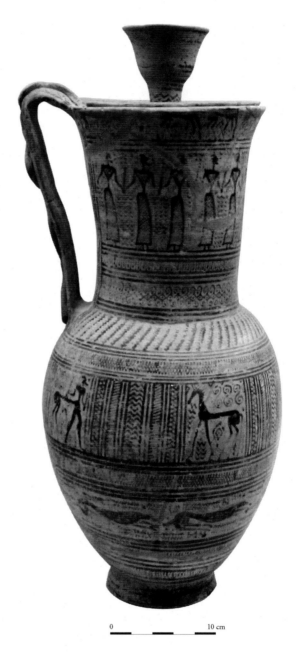

Giant Pitchers and Early *loutrophoroi*

The pitcher, a pouring vessel with one vertical handle, was introduced into the Athenian repertoire before the middle of the eighth century B.C.E.[35] and went out of use by the end of

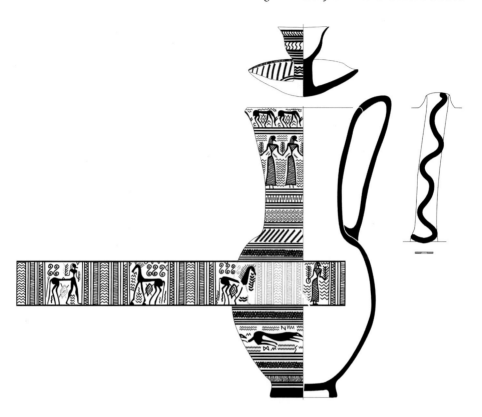

Fig. 7. Line drawing of figure 6 (drawing author).

the century. *Prochous* (Πρόχους), as a water container made of metal, is frequently mentioned in the epics, often used with a *chernips* (χέρνιψ) for washing the hands before meals, sacrifices or religious services.[36] The wide mouth of the vessel facilitated the rapid flow of water for washing, but it would be unsuited for serving. The shape was placed with LG II burials in Athens and Attica, irrespective of the gender of the deceased. The pitcher from Marathon may be added to a small group of no more than 25 examples that stand out by their size, reaching almost a meter in height; they are inextricably associated with burials and placed without exception inside the grave.[37]

These giant pitchers have been found in the Athenian burial grounds at the Kerameikos, the Dipylon (Eriai Gates), the Melitides Gates, to the south of the Acropolis, as well as elsewhere in Attica at Anavyssos, Spata, Trachones and Marathon, areas with strong Athenian affinities. A few more vases are located today in museums and collections, but with no further information as to their archaeological context. Apart

from the burial from Marathon, where osteological analysis showed that the vessel accompanied a young female, no such association is available for the rest of the vases when found with burials. Certain excavators infer that young females or *korai* were interred with large pitchers as some of the other grave offerings, especially those from the Dipylon and the Spata graves, would seem more appropriate for young females.

The enlargement of the pitcher shape and its selective deposition in a small number of graves in Athens and Attica indicates a special symbolism at work: one that may be compared to the later conspicuous use and function of the Archaic *loutrophoros*, the vessel containing the water for ritual bathing in both funerary and nuptial rituals. The short-lived phenomenon of the LG giant pitcher could be considered from a similar viewpoint. Even though the shape seems associated exclusively with funerary contexts, its iconography is both funerary and nuptial.[38] Whether these vessels were symbolically destined for young females who died unmarried, in accordance with the later use of the *loutrophoros* is more difficult to assess. Giant pitchers seem to have accompanied, although not exclusively, certain richly furnished burials, while a number of graves that were quite richly furnished lacked such an offering.[39] Furthermore, certain specimens had their bottoms pierced, evidence of a ritual use of those vessels during the funerals.[40] We may thus argue for a high degree of exclusivity accompanying the use of those vessels, possibly reserved for families that enjoyed a high social status and also held an important place in the ritual life of early Athens and Attica.

Conclusion

The giant pitcher from Marathon is unique in the richness and complexity of the pictorial representations, leading me to suggest it is the result of the consumer's choice, one possibly related to the original context for which this vessel was destined, perhaps a wedding of an important young member of the Marathonian community. Furthermore, the significance of this imaginative potter/painter's work rests on his ability to promote a formal framework of ritual expression with reference to marriage, by integrating original scenes with stock motifs drawn from his contemporary pictorial repertory with references to myth and poetry. Even as a nuptial vessel, as seems

manifest both from its shape and iconography, the giant pitcher remains an unusual phenomenon of particular value for the Late Geometric society of Marathon. As well as the biographical aspects of this vase and its possible gendered use and symbolism, its choice registers and mirrors the social concerns and tensions at the turn of the early seventh century B.C.E.

Notes

This study was part of my postdoctoral research fellowship (ESF, 2012–2015), which was carried out jointly at the University of Athens and the CReA-Patrimoine – Université libre des Bruxelles, whose unstinting support I gratefully acknowledge. I would like to thank especially Alexandros Mazarakis Ainian for the permission to study the pitcher and the rest of the Geometric material from the burial ground along Marathonos Avenue. I am grateful to Nota Kourou for discussing with me a number of issues related to the pitcher and the rest of the Geometric material from Marathon. My sincerest thanks are to Tom Carpenter, Susan Langdon, Liz Langridge-Noti, Mark Stansbury-O'Donnell, and Athéna Tsingarida for accepting my paper for the pottery session organized at the 116th Annual Meeting of the Archaeological Institute of America at New Orleans in January 2015 and for including the article in the present volume. I am particularly grateful to Liz Langridge-Noti for her valuable help and insightful comments during the final editing of the article. My thanks are also to my anonymous reviewers for their thoughtful comments.

[1] Ahlberg-Cornell 1971; Boardman 1988; Coldstream 1991; Coulié 2013, 61–104; Vlachou 2015.

[2] Carter 1972; Boardman 1983; Ahlberg-Cornell 1992; Stansbury-O'Donnell 1995; Snodgrass 1998; Langdon 2008; Giuliani 2013; Mikrakis 2015.

[3] Langdon 1998; 2008, 276–91. Naxos: Simantoni-Bournia 1998, fig. 1. Ithaka: Morgan 2006, 225–26. Crete: Lebessi 2009. Cyprus: Vlachou 2012, 352. Etruria: Leach 1987, 77, cat. no. 198, 124–26, 192–93, figs. 52–5; Langdon 1993, 170–73 no. 63 and col. pl. 8.

[4] Langdon 1998, 2006; 2008, 197–233. For a similar approach, Morgan 2006, 224–25; 2010, 78–81.

[5] Marathon Museum inv. no. (K 2207). For the excavation of the small burial ground, see Mazarakis Ainian 2011. For more burials from the same burial ground, see Eustratiou 1985, 72–73. For a detailed treatment of pottery and burials from Marathon, see Vlachou 2011; Vlachou forthcoming c.

[6] Dances are integrated into the repertory of the Burly Workshop (LG Ib/LG IIa), identified by Davison (1961, 83–86) and refined by Rombos (1988, 352–57, 497–502, cat. nos. 298–309, with bibliography). The oinochoe now Tübingen 2657 (Rombos 1988,

497, cat. no. 298, pl. 71a) is among the earliest depicting two groups of youths and maidens flanking a central musician. See also, Buboltz 2002, 63–65. For similar arrangement of the male and female participants, see amphora in Copenhagen (LG IIb), Johansen 1945, 16, figs. 5–6. For the *loutrophoros*-hydria by the Analatos Painter in Athens, NM 313 (ca. 700 BC), see Denoyelle 1996, pls. 14.2–3 and 15.2–3; Coulié 2013, 195–97, fig. 189.

[7] Hydria: Ruhr-Universität Bochum (inv. S 1067); see Kunisch 1996, 25–29. Loutrophoros amphora: Paris Musée du Louvre CA 295; see Denoyelle 1996, pls. 15.1 and 16.1–2; Coulié 2013, 201, fig. 194. Fragmentary hydria from the Athenian Agora: see Brann 1962, pl. 22.384. For an early Euboean specimen from Pithekoussai interpreted as the "Crane Dance," see Coldstream 1968b.

[8] *Il.* 18.491–497, 590–605; Hes. *Shield* 272–279; Pl. *Laws* 771e–772. For a discussion, see Calame 2001, 25–33, 36–37; Swift 2006.

[9] From the remains of pyre XII: Young 1939, 55–57, figs. 37–38; Davison 1961, fig. 36; Ahlberg-Cornell 1971, 28, no. 39, fig. 39; Rombos 1988, 444–45, cat. no. 167.

[10] The earliest pictorial representation of the *loutrophoria* is considered to be that on the fragmentary Protoattic *loutrophoros*-hydria dedicated at the Sanctuary of the Nymph on the south slope of the Athenian Acropolis (Akropolis Mus. 1957-Aa-189). See Oakley and Sinos 1993, 5, 15; Sabetai 1993, 136; Winkler 1999, 20–21, no. 17, pl. 1; A.C. Smith 2012, 83–94, esp. 90, pl. 35.3.

[11] For the clay *loutrophoros*, the container of water for ritual bathing, both during wedding and funerary rituals, and equally the youth carrying the vessel that contained the bathwater see Mösch 1988; Sabetai 1993, 129–74, 2009; Oakley and Sinos 1993, 6–7, 15–16, 32; Bergemann 1996, 166–74; Mösch-Klingele 1999; Hildebrandt 2011; A.C. Smith 2012, 88, 90–91.

[12] For the origins of the clay *loutrophoros* already in the LG period, see Walter-Karydi 1963, 90–92; Boardman 1988, 175–78; Sabetai 1993, 132–36; Vlachou forthcoming a and c.

[13] Tölle 1964; Bronson 1964; Rombos 1988, 330–51; Langdon 2008, 143–82; Haug 2012, 119–63. Add a recent find from Kifissia (tomb 126), Skilardi 2011, 700 fig. 15 and 701 fig 20.

[14] For the Phoenician flower-tree, see Shefton 1989; Rehm 1997, 130–31, S9, fig. 16; Aruz, Graff, and Rakic 2014, fig. 3.38. For a similar tree motif in LG Attic iconography, see Brann 1962, pl. 44; amphora (early work by the Analatos Painter): Shapiro, Iozzo, and Lezzi-Hafter 1995, 50–52 no. 10; for lions and fantastic creatures flanking a tree of life, see Sheedy 1992, 20; *CVA* France 25, Paris Musée du Louvre 16, pls. 42–43. For single trees in narrow panels, see *CVA* Germany 44, Tübingen 2, 33–34, pls. 21.3–5, 22; Mack 1974, pl. 5A.

[15] Borell 1978, 44–47, 67–70; Kourou 1985, 415–17; Sheedy 1992, 15–20.

[16] Attica: Pedestalled high-rimmed skyphos, Institut für Klassische Archäologie, Eberard-Karls-Universität Tübingen, 1086; see *CVA* Germany 44, Tübingen 2, 33–34, pls. 21.3–5, 22; Tölle 1964, pls. 20–21; Langdon 2008, 155, fig. 3.15. Flat bottomed pyxis; see Mack 1974, pl. 5A. A volute tree, resembling the Phoenician flower-tree type, is equally well represented. Both have been assigned to the Workshop of Athens 894, with which the painter of the Marathon pitcher shares a common style; see Vlachou forthcoming a. Boeotia: Boeotian bronze fibula, now in Paris, showing two females with long dresses holding a branch; a wreath is placed below their joined hands; see Perrot and Chipiez 1898, 253, fig. 125 and 255, figs. 130–131; Hampe 1936, 25, fig. 6. Argos: Seal from the Argive Heraion with female dancers holding hands and branches placed in the free space, Athens NM 14066; Waldstein et al. 1905, pl. 138.21; Langdon 2008, 157, fig. 3.15. Ithaka (Aetos): two long-robed figures identified by Morgan (2006, 255–56) as male aristocrats.

[17] Cremer 1982; Avagiannou 1991; *LIMC* VII Suppl. Hieros Gamos; A.C. Smith 2012, 86.

[18] Athens, NM 11750; see Boardman 1963, 130, G14, pl. XVI (around 700 B.C.E.).

[19] Marangou 1969, 17, no. 3, fig. 7; Cremer 1982, 284–86; Hall 2002; Langdon 2008, 190–95; Lebessi 2009.

[20] Kepinski 1982; W.S. Smith 1958, 137, pl. 99A; Catling 1964, 196, pl. 29c–e. For the tree motif in Greek art, see Kourou 2001. For the tree motif in the LG iconography of Attica, Euboea and related regions, see Coldstream 1994; Kourou 1998.

[21] Nicosia, Cyprus Museum inv. B 1988. Karageorghis 1973; Karageorghis and Des Gagniers 1974, 1:80–82 and 2:493, XXVI; Boardman 1976, 153–54, pl. 23.3–5; Vlachou 2012, 353, 358 no. 9, fig. 11.

[22] Payne 1927–28, 286–88; Coldstream 2001, 31 and fig. 1.4c. For the use of a wheeled base for the depiction of a nature goddess on a PGB Knossian pithos, see Coldstream 1984.

[23] Among the earliest is an aryballos from the Argive Heraion; Payne 1933, pl. 9.2. For few Attic LG II specimens, see Borell 1978, 61, pl. 9 and 9, no. 73.

[24] For a recent treatment of the myth of Bellerophon and its symbolism in early Corinthian history, see Ziskowski 2014.

[25] For the theme of the winged horse in the early seventh century B.C.E., see Attica: Langlotz 1932, pl. 7.79 (the Vulture Painter); Petrocheilos 1996, 50–51, pl. 6.2–3; Charalambidou 2011, 849, fig. 6. Eretria: Huber 2003, pl. 76. Perachora: Payne and Dunbabin 1962, 53, no. 390, pl. 20. Delos: Poulsen and Dugas 1911, 383, fig. 47.

[26] Tankard: *CVA* France 25, Paris, Musée du Louvre 16, pl. 39.3–4 (CA 1780); Rombos 1988, 462 no. 209. Skyphos from Anavyssos (Athens, NM 14441): Borell 1978, 10 no. 30, pl. 21; Rombos 1988, 461 no. 203 and pl. 46a.

[27] For LG iconography, see Rombos 1998, 232–34. For the association with abduction and marriage, see Langdon 2006, 211, 214–15; 2008, 95–110.

[28] Rombos 1998, 161–84. The posture of the figure with both arms upraised and his long legs almost reaching the ground differs from that of LG horse riders, and may be intended as showing a figure riding a mule or an ass. The posture of the rider could equally denote sidesaddle riding, although no indication of a saddle exists. For sidesaddle riders, see Voyatzis 1992; Morgan 2006.

[29] Giuliani 2013, 51, defines as a narrative image one that presupposes knowledge of a particular story or context of action in order to be understood. However, the iconography of the Marathon pitcher cannot be claimed as narrative as, with the exception of the dancers, the figures do not interact to build a united story. Hurwit 2011, 14, argues on the distinction of "weak" and "strong" images on the basis of their "power to evoke the specifics of either real life or myth rather than universals." It seems that certain images on the Marathon pitcher, namely, the hunt scene and the flying winged horse, could be approached in a similar way.

[30] A unique scene shows what has been interpreted as the moment of agreement between two aristocratic families on a clay stand now in Munich (Staatliche Antikensammlungen inv. 8936): Fittschen 1969, 196, no. 936; Ahlberg-Cornell 1992, 61–62, figs. 91–93; Murray 1993, 214; Snodgrass 1998, 79, figs. 27–29; Langdon 2006, 213–21; 2008, 234–44. Note also the addition of a male hunter with his prey in the scene.

[31] Tölle 1964, pl. 10; Vlachou forthcoming a.

[32] Tölle 1964, 21, no. 49, pl. 18; Sheedy 1992.

[33] Whitley 1996; Langdon 2005; Vlachou forthcoming a and b.

[34] Vlachou forthcoming a and c.

[35] Coldstream 1968a, 34; Cook 1997, 22. Davison 1961, 10, fig. A.5 and 12, refers to the wide-mouthed pitcher of the LG II period as "pitcher-olpe," distinguishing it from the "mug-olpe" or tankard of a much smaller size.

[36] *Il.* 24.304; *Od.* 1.136, 4.52, 15.135; Hesiod, *Theog.* 785. It is rarely used for serving wine, *Od.* 18.397.

[37] Vlachou forthcoming a and c.

[38] Compare the pitcher in Athens, NM 16022 (Coldstream 1968a, pl. 12d; Vlachou forthcoming a) decorated with female mourners around the neck.

[39] E.g., the burial XVII from the Agora Tholos burial plot: Young 1939, 76–87. Burial VADK1 from Kerameikos: Von Freytag 1974.

[40] Vlachou forthcoming a.

References

Ahlberg-Cornell, G. 1971. *Prothesis and Ekphora in Greek Geometric Art*. SIMA 32. Jonsered: Åströms.

———. 1992. *Myth and Epos in Early Greek Art: Representation and Interpretation.* SIMA 100. Jonsered: Åströms.

Aruz, J., S.B. Graff, and Y. Rakic, eds. 2014. *Assyria to Iberia: At the Dawn of the Classical Age.* New York: The Metropolitan Museum of Art.

Avagianou, A. 1991. *Sacred Marriage in the Rituals of Greek Religion.* European University Studies XV. Bern: Lang.

Bergemann, J. 1996. "Die sogenannte Lutrophoros: Grabmal für unverheiratete Tote?" *AM* 111:149–90.

Boardman, J. 1963. *Island Gems. A study of Greek Seals in the Geometric and Early Archaic Periods.* London: The Society for the Promotion of Hellenic Studies, Suppl. Paper 10.

———. 1976. "Iconographica Cypria." *RDAC*:152– 54.

———. 1983. "Symbol and Story in Geometric Art." In *Ancient Greek Art and Iconography*, edited by W.G. Moon, 15–36. Madison: University of Wisconsin Press.

———. 1988. "Sex Differentiation in Grave Vases." In *La parola, l'immagine, la tomba. Atti del Colloquio Internazionale di Capri, Napoli*, edited by B. d'Agostino, 171–8. *AION* 10. Naples: Instituto Universitario Orientale.

Borell, B. 1978. *Attisch Geometrische Schalen, eine Spätgeometrische Keramikgattung und ihre Beziehungen zum Orient, Keramikforschungen II.* Mainz: von Zabern.

Brann, E.T.H. 1962. *The Athenian Agora VIII. Late Geometric and Protoattic Pottery: Mid 8th to Late 7th Century B.C.* Princeton NJ: American School of Classical Studies at Athens.

Bronson, R. 1964. "A Re-examination of the Late Geometric Hydria no. 1212 in the Museum of Villa Giulia." *AJA* 68:174–78.

Buboltz, L.A. 2002. *Dance Scenes in Early Archaic Greek Vase-Painting*, Ph.D. diss., Harvard University.

Calame, C. 2001. *Choruses of Young Women in Ancient Greece. Their Morphology, Religious Role, and Social Functions.* Trans. by D. Colins and J. Orin. Lanham: Rowman & Littlefield.

Carter, J. 1972. "The Beginning of Narrative Art in the Geometric Period." *BSA* 67:25–58.

Catling, H.W. 1964. *Cypriot Bronzework in the Mycenaean World.* Oxford: Clarendon.

Charalambidou, X. 2011. "Developments in Euboea and Oropos at the End of the "Dark Ages" (ca. 700 to the Mid-Seventh Century BC)." In *The 'Dark Ages' Revisited, Acts of an International Symposium in Memory of W.D.E. Coulson, University of Thessaly, Volos 14–17 June 2007*, edited by A. Mazarakis Ainian, 831–55. Volos: University of Thessaly Press.

Coldstream, J.N. 1968a. *Greek Geometric Pottery. A Survey of Ten Local Styles and Their Chronology.* London: Methuen.

———. 1968b. "A Figured Geometric Oinochoe from Italy." *BICS* 15:86–96.

———. 1984. "A Protogeometric Nature Goddess from Knossos." *BICS* 31:93–104.

————. 1991. "The Geometric Style: Birth of the Picture." In *Looking at Greek Vases*, edited by T. Rasmussen and N. Spivey, 37–56. Cambridge: Cambridge University Press.

————. 1994. "A Figured Attic Geometric Kantharos from Kition." *RDAC*:155–59.

————. 2001. "The Early Greek Period: Subminoan to Late Orientalizing." In *Knossos Pottery Handbook. Greek and Roman*, edited by J.N. Coldstream, L.J. Eiring and G. Forster, 21–76. Athens: British School at Athens.

———— 2006. " 'The Long Pictureless Hiatus'. Some Thoughts on Greek Figured Art between the Mycenaean Pictorial and Attic Geometric." In *Pictorial Pursuits. Figurative Painting on Mycenaean and Geometric Pottery*, edited by E. Rystedt and B. Wells, 159–63. Stockholm; Svenska Institutet i Athen.

Cook, R.M. 1997. *Greek Painted Pottery*. 3rd ed. London: Routledge.

Coulié, A. 2013. *La céramique grecque aux époques géométrique et orientalisante (XIe–Vie siècle av. J.-C.)*. Paris: Picard.

Cremer, M. 1982. "Hieros Gamos im Orient und in Griechenland." *ZPE* 48:283–90.

Davison, J.M. 1961. *Attic Geometric Workshops*. Yale Classical Studies 16. New Haven: Yale University Press.

Denoyelle, M. 1996. "Le peintre d'Analatos: essai de synthèse et perspectives nouvelles." *AntK* 39:71–87.

Eustratiou, K. 1985. "Nea Makri." *Archaiologikon Deltion* 40:71–72.

Fittschen, K. 1969. *Untersuchungen zum Beginn der Sagendarstellungen bei den Griechen*. Berlin: Hessling.

Giuliani, L. 2013. *Image and Myth: A History of Pictorial Narration in Greek Art*. Trans. J. O'Donnell. Chicago: University of Chicago Press.

Hall, J.M. 2002. "Heroes, Hera and Herakleidai in the Argive Plain." In *Peloponnesian Sanctuaries and Cults. Proceedings of the Ninth International Symposium at the Swedish Institute at Athens, 11–13 June 1994*, edited by R. Hägg, 93–98. SkrAth 4°, 48. Stockholm: Svenska Institutet i Athen.

Hampe, R. 1936. *Frühe griechische Sagenbilder in Böotien*. Athens: Deutschen Archäologischen Instituts.

Haug, A. 2012. *Die Entdeckung des Körpers. Körper- und Rollenspiele im Athen des 8. und 7. Jahrhunderts v. Chr.* Image and Context 10. Berlin: de Gruyter.

Hildebrandt, F. 2011. "Die Loutrophoros - Form und Entwicklung." In *Kerameia: ein Meisterwerk apulischer Töpferkunst, Studien dem Andenken Konrad Schauenburgs gewidmet*, edited by K. Hitzl, 96–99. Kiel: Antikensammlung der Kunsthalle zu Kiel.

Huber, S. 2003. *L'aire sacrificielle au nord du Sanctuaire d'Apollon Daphnéphoros. Un rituel des époques géométrique et archaïque.* 2 vols. Eretria: fouilles et recherches XIV. Gollion: Infolio.

Hurwit, J.M. 2011. "The Shipwreck of Odysseus: Strong and Weak Imagery in Late Geometric Art." *AJA* 115:1–18.

Johansen, K.F. 1945. *Thésée et la danse à Délos.* Étude herméneutique 3.3. Copenhagen: Munksgaard.

Karageorghis, V. 1973. "A Representation of a Temple on an 8th Century BC Cypriote Vase." *Rivista di Studi Fenici*: 9–13.

Karageorghis, V., and J. Des Gagniers. 1974. *La céramique chypriote de style figure: âge du fer,1050– 500 av. J.-C.*, I-II. *Biblioteca di antichita cipriote* 2. Rome: Ateneo.

Kepinski, C. 1982. *L'arbre stylisé en Asie occidentale au 2e millénaire avant J.-C.* Paris: Editions Recherche sur les civilisations.

Kourou, N. 1985. "Musical Procession Scenes in Early Greek Art: Their Oriental and Cypriot Models." In Πρακτικά του 2ου Διεθνούς Κυπρολογικού Συνεδρίου, Λευκωσία, 20–25 Απριλίου 1982, Α, edited by Th. Papadopoulou and S.A. Chatzistylli, 415–22. Nicosia: Etaireia Kypriakon Spoudon.

———. 1998. "Euboea and Naxos in the Late Geometric Period. The Cesnola Style." In *Euboica. L'Eubea e la presenza euboica in Calcidica e in Occidente. Atti del convegno internazionale di Napoli, 13–16 novembre, 1996*, edited by M. Bats and B. D'Adostino, 167–77. *AION* 12. Naples: IstitutoUniversitario Orientale.

———. 2001. "The Sacred Tree in Greek Art: Mycenaean Versus Near Eastern Traditions." In *La questione delle influenze vicino-orientali sulla religione Greca. Stato degli studi e prospettive della ricerca. Atti del Colloquio Internazionale, Roma, 20–22 maggio 1999*, edited by S. Ribichini, M. Rocchi and P. Xella, 31–53. Rome: CNR-Servizio Pubblicazioni.

Kunisch, N. 1996. *Erläuterungen zur Griechischen Vasenmalerei* Cologne: Böhlau.

Langdon, S. 1993. *From Pasture to Polis: Art in the Age of Homer.* Columbia, MO: University of Missouri Press.

———. 1998. "Significant Others in Geometric Art: An Early Greek Image Lost and Found." *AJA* 102:251–70.

———. 2005. "Views of Wealth, A Wealth of Views: Grave Goods in Iron Age Attica." In *Women and Property in Ancient Near Eastern and Mediterranean Societies*, edited by D. Lyons and R. Westbrook. Cambridge, MA: Center for Hellenic Studies. http://chs.harvard.edu/chs/women_and_property.

———. 2006. "Maiden Voyage: From Abduction to Marriage in Late Geometric Art." In *Pictorial Pursuits. Figurative Painting on Mycenaean and Geometric Pottery. Papers from Two Seminars at the Swedish Institute at Athens in 1999 and 2001*, edited by E. Rystedt and B. Wells, 205–15. Skrifter utgivna av Svenska Institutet i Athen, 4°, 53. Stockholm: Svenska Institutet i Athen.

———. 2008. *Art and Identity in Dark Age Greece, 1100–700 B.C.E.*

Cambridge: Cambridge University Press.

Langlotz, E. 1932. *Griechische Vasen in Würzburg*. Munich: Obernetter.

Leach, S.S. 1987. *Subgeometric Pottery from Southern Etruria*. SIMA Pocket Book 54. Göteborg: Åströms.

Lebessi, A. 2009. "The Heterosexual Couple in Early Cretan Iconography." *Creta Antica* 10:539–61.

Mack, C. 1974. *Classical Art from Carolina Collections: An Exhibition of Greek, Etruscan, and Roman Art from Public and Private Collections in North and South Carolina, Columbia Museum of Art, Columbia, S.C., 3 Feb.–3 March, 1974; North Carolina Museum of Art, Raleigh, N.C., 24 March–21 April, 1974.* Columbia, SC: Vogue Press.

Marangou, E.-L.I. 1969. *Lakonische Elfenbein- und Beinschnitzereien*. Tübingen: Washmuth.

Mazarakis Ainian, A. 2011. "A Necropolis of the Geometric Period at Marathon: The Context." In *The 'Dark Ages' Revisited, Acts of an International Symposium in Memory of W.D.E. Coulson, University of Thessaly, Volos 14–17 June 2007*, edited by A. Mazarakis Ainian, 703–16. Volos: University of Thessaly.

Mikrakis, M. 2015. "Pots, Early Iron Age Athenian Society and the Near East: The Evidence of the Rattle Group." In *Pots, Workshops and Early Iron Age Society: Function and Role of Ceramics in Early Greece*, edited by V. Vlachou, 277–89. Études d'archéologie 8. Brussels: CReA-Patrimoine.

Morgan, C. 2006. "Ithaka between East and West: The Eighth Century Figured Repertoire of Aetos." In *Pictorial Pursuits: Figurative Painting on Mycenaean and Geometric Pottery. Papers from Two Seminars at the Swedish Institute at Athens in 1999 and 2001*, edited by E. Rystedt and B. Wells, 217–28. Skrifter utgivna av Svenska Institutet i Athen, 4°, 53. Stockholm: Svenska Institutet i Athen.

———. 2010. "Early Ithacesian Vase Painting and the Problem of Homeric Depictions. " In *Myths, Texts, Images. Homeric Epics and Ancient Greek Art, Proceedings of the 11th International Symposium of the Odyssey Ithaca, September 15–19, 2009*, edited by E. Walter-Karydi, 65–94. Ithaca: Centre for Odyssean Studies.

Mösch, R.M. 1988. "Le marriage et la mort sur les loutrophores." In *La parola, l'immagine, la tomba, Atti del Colloquio Internazionale di Capri*, edited by B. D'Agostino, 117–39. AION 10, Istituto universitario orientale. Naples: Istituto Universitario Orientale.

Mösch-Klingele, R. 1999. "Loutra und loutrophoros im Totenkult. Die literarischen Zeugnisse." In *Proceedings of the XVth International Congress of Classical Archaeology, Archaeology towards the Third Millennium: Reflections and Perspectives*,

Amsterdam, 12.–17.7.1998, edited by R. Docter and F.E.M. Moormann, 273–75. Amsterdam: Allard Pierson Museum.

Murray, O. 1993. *Early Greece*. 2nd ed. Cambridge: Cambridge University Press.

Oakley, J.H., and R.H. Sinos. 1993. *The Wedding in Ancient Athens.* Madison: University of Wisconsin Press.

Payne, H.G.G. 1927–28. "Early Greek Vases from Knossos." *BSA* 29:224–98.

———. 1933. *Protokorinthische Vasenmalerei.* Berlin: Keller.

Payne, H. G. G., and T. J. Dunbabin. 1962. *Perachora II. The Sanctuaries of Hera Akraia and Limenia. Pottery, Ivories and Other Objects from the Votive Deposit at Hera Limenia.* Oxford: Clarendon.

Perrot, G., and Ch. Chipiez. 1898. *Histoire de l'art dans l'antiquité.* Paris: Hachette.

Petrocheilos, I.E. 1996. "Frühe Phaleron-Oinochoen." *AM* 11:45–64.

Poulsen, F., and C. Dugas. 1911. "Vases Archaïques de Délos." *BCH* 35:350–422.

Rehm, E. 1997. *Kykladen und Alter Orient: Bestandskatalog des Badischen Landesmuseums Karlsruhe.* Karlsruhe: Das Landesmuseum.

Rombos, T. 1988. *The Iconography of Attic Late Geometric II Pottery.* SIMA 68. Jonsered: Åströms.

Sabetai, V. 1993. *The Washing Painter: A Contribution to Wedding and Genre Iconography in the Second Half of the Fifth Century B.C.* Ph.D. diss., University of Cincinnati.

———. 2009. "Marker Vase or Burnt Offering? The Clay Loutrophoros in Context." In *Shapes and Uses of Greek Vases (7th–4th centuries B.C.),* edited by A. Tsingarida, 291–306. Études d'Archéologie 3. Brussels: CReA-Patrimoine.

Shapiro, H.A. 1995. *Greek Vases in the San Antonio Museum of Art,* edited by H.A. Shapiro, C.A. Picón and G.D. Scott, III. San Antonio, Texas: San Antonio Museum of Art.

Shapiro, H.A., M. Iozzo, and A. Lezzi-Hafter, eds. 2013. *The François Vase: New Perspectives.* Akanthus Proceedings 3. Kilchberg, Zurich: Akanthus.

Sheedy, K. 1992. "The Late Geometric Hydria and the Advent of the Protoattic Style." *AM* 107:11–28.

Shefton, B.B. 1989. "The Paradise Flower, a "Court Style" Phoenician Ornament: Its History in Cyprus and the Central and Western Mediterranean." In *Cyprus and the East Mediterranean in the Iron Age. Proceedings of the Seventh (i.e. Twelfth) British Museum Classical Colloquium, April 1988,* edited by V. Tatton-Brown, 97–117. London: British Museum Publications.

Simantoni-Bournia, E. 1998. "Kleinfunde aus dem Heilingtum von Iria auf Naxos." *AM* 113:61–74.

Skilardi, D. 2011. "Νεκρόπολη Γεωμετρικής περιόδου στην Κηφισιά." In *The 'Dark Ages' Revisited, Acts of an International Symposium in Memory of W.D.E. Coulson, University of Thessaly, Volos 14–17 June 2007*, edited by A. Mazarakis Ainian, 675–702. Volos: University of Thessaly.

Smith, A.C. 2012. "Marriage in the Greek World." In *ThesCRA VI. Stages and Circumstances of Life: Work, Hunting, Travel. Contexts and Circumstances of Cultic and Ritual Activities*, edited by A. Hermary, and B. Jaeger, 83–94. Los Angeles: Getty Publications.

Smith, W.S. 1958. *The Art and Architecture of Ancient Egypt*. London: Penguin.

Snodgrass, A. 1998. *Homer and the Artists*. Cambridge: Cambridge University Press.

Stansbury-O'Donnell, M.D. 1995. "Reading Pictorial Narrative: The Law Court Scene of the Shield of Achilles." In *The Ages of Homer. A Tribute to Emily Townsend Vermeule*, edited by J.B. Carter and S.P. Morris, 315–34. Austin: University of Texas Press.

Swift, L.A. 2006. "Mixed Choruses and Marriage Songs: A New Interpretation of the Third Stasimon of the *Hippolytos.*" *JHS* 126:125–40.

Tölle, R. 1964. *Frühgriechische Reigentänze*. Waldsassen: Stifland Verlag.

Vlachou, V. 2011. "A Group of Geometric Vases from Marathon: Attic Style and Local Originality." In *The 'Dark Ages' Revisited, Acts of an International Symposium in Memory of W.D.E. Coulson, University of Thessaly, Volos 14–17 June 2007*, edited by A. Mazarakis Ainian, 809–29. Volos: University of Thessaly.

———. 2012. "Aspects of Hunting in Early Greece and Cyprus: A Re-examination of the 'Comb Motif.'" In *Cyprus and the Aegean in the Early Iron Age. The Legacy of Nicolas Coldstream*, edited by M. Iacovou, 345–70. Nicosia: Bank of Cyprus Cultural Foundation.

———. 2015. "From Pots to Workshops: The Hirschfeld Painter and the Late Geometric I Context of the Attic Pottery Production." In *Pots, Workshops and Early Iron Age Society: Function and Role of Ceramics in Early Greece*, edited by V. Vlachou, 49–74. Études d'archéologie 8. Brussels: CReA-Patrimoine.

———. Forthcoming a. «Nuptial Vases in Female Tombs? Aspects of Funerary Behavior during the Late Geometric Period in Attica." In *Embodied Identities in the Prehistoric Eastern Mediterranean: Convergence of Theory and Practice, Archaeological Research Unit, University of Cyprus, Nicosia, 10–12 April 2012*, edited by M. Mina, Y. Papadatos, and S. Triantafyllou.

———. Forthcoming b. "Early Iron Age Female Burials in Attica:

Ladies and Maidens, Wealthy and Deprived." In *The Archaeology of Inequality: Tracing the Archaeological Record*, edited by O. Cerasuolo. *IEMA Proceedings* 4.

————. Forthcoming c. *Burials and Society in Early Iron Age Marathon (Attica), 10th to early 7th Century B.C. Études d'archéologie* 9. Brussels: CReA-Patrimoine.

Von Freytag, B. 1974. "Ein spätgeometrisches Frauengrab vom Kerameikos." *AM* 89:1–25.

Voyatzis, M. 1992. "Votive Riders Seated Side-saddle at Early Greek Sanctuaries." *BSA* 87:259–79.

Waldstein, C. et al. 1905. *The Argive Heraion.* Boston and New York.

Walter-Karydi, E. 1963. "Schwarzfigurige Lutrophoren im Kerameikos." *AM* 78:90–103.

Whitley, J. 1996. "Gender and Hierarchy in Early Athens." *Metis* 11:209–32.

Winkler, H. 1999. *Lutrophorie. Ein Hochzeitskult auf attischen Vasenbildern.* Freiburg: Hochschul.

Young, R.S. 1939. *Late Geometric Graves and a Seventh Century Well in the Agora. Hesperia* suppl. 2. American School of Classical Studies at Athens.

Ziskowski, A. 2014. "Bellerophon. Myth in Early Corinthian History and Art." *Hesperia* 83:81–102.

LIST OF CONTRIBUTORS

Sheramy Bundrick is Associate Professor at the University of South Florida. The recipient of the Postdoctoral Rome Prize in Ancient Studies, she is the author of *Music and Image in Classical Athens* (Cambridge 2005). She has published widely in journals, including *Hesperia* and the *American Journal of Archaeology* and is completing a book manuscript tentatively entitled *Athens, Etruria, and the Movement of Images*.

An Jiang is a Ph.D. candidate in Art History at Emory University. He has worked as the Andrew W. Mellon Intern in the Michael C. Carlos Museum at Emory University, where he also received a Mellon Fellowship. He has excavated since 2012 at Samothrace and has presented two papers at the Annual Meeting of the Archaeological Institute of America.

Kathleen Lynch is an Associate Professor of Classics at the University of Cincinnati. Her interest in Attic pottery from archaeological contexts has taken her to excavations in Athens, Albania, Troy, Olynthos, Thebes, and Gordion, although her archaeological "home" is the Excavations of the Athenian Agora. Her 2011 book on pottery from a house near the Athenian Agora, *The Symposium in Context*, won the 2013 AIA Wiseman Award.

Bice Peruzzi is a visiting Assistant Professor at Grand Valley State University and has recently completed her Ph.D. at the University of Cincinnati. She has done extensive fieldwork around the Mediterranean, including Gordion, Corinth, and numerous sites in Etruria and southern Italy. Her research focuses on burial customs, funerary ideology, and the creation of social identity in ancient societies.

Vivi Saripanidi a postdoctoral researcher at the Université libre de Bruxelles. She has been a member of excavation projects at Karabournaki, in Thessaloniki, and Itanos, in Crete. She is the author of the CVA volume on the vase collection of the Aristotle University of Thessaloniki (CVA Greece 13, 2012) and is working on a book project on the social and cultural history of the Archaic northern Aegean.

Tara M. Trahey is a recent graduate of Duke University and recipient of an Ertegun Scholarship for graduate study in classical archaeology at Oxford University. In addition to receiving several awards and fellowships, she has served as an Editorial Assistant for the *American Journal of Archaeology.* She has given papers at conferences at Duke, Ghent, and at the 2015 Annual Meeting of the Archaeological Institute of America.

Vicky Vlachou is a postdoctoral researcher at the Université libre de Bruxelles and is fellow at the University of Athens. She has worked a researcher in a variety of international research projects and has excavated at Xombourgo (Tenos, Cyclades), Skala Oropou (Attica), and Itanos (East Crete). Forthcoming publications include *Excavations at Skala Oropou: The Geometric Pottery and Marathon* and *Pottery Production, Gender Differentiation and Social Status in Iron Age Attica* (Études d'Archéologie).